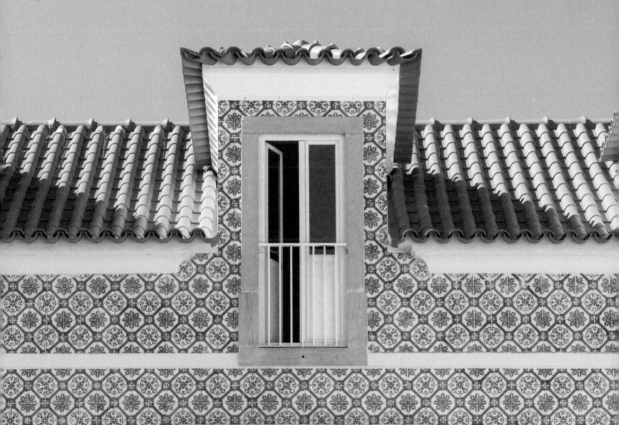

PATTERNS *of* PORTUGAL

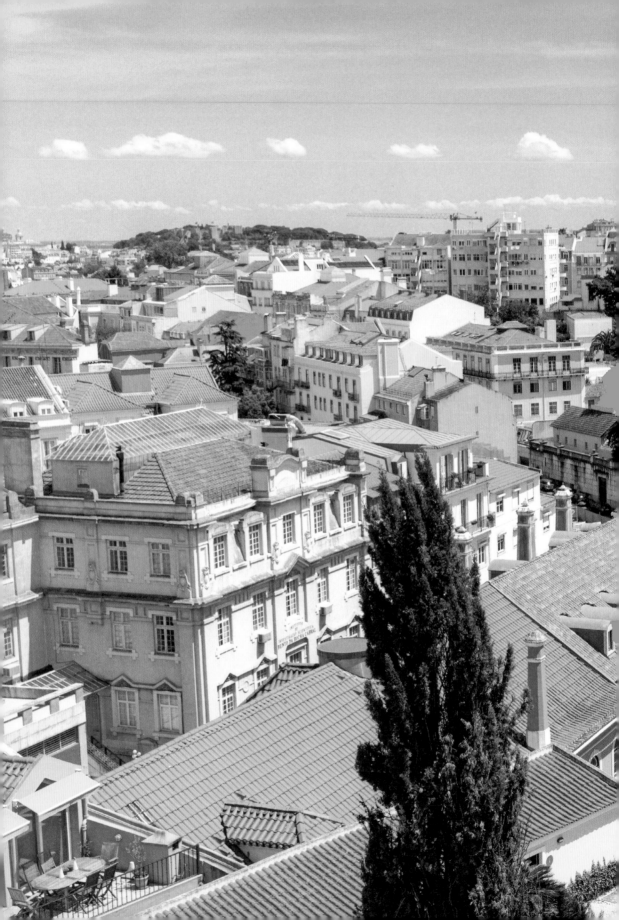

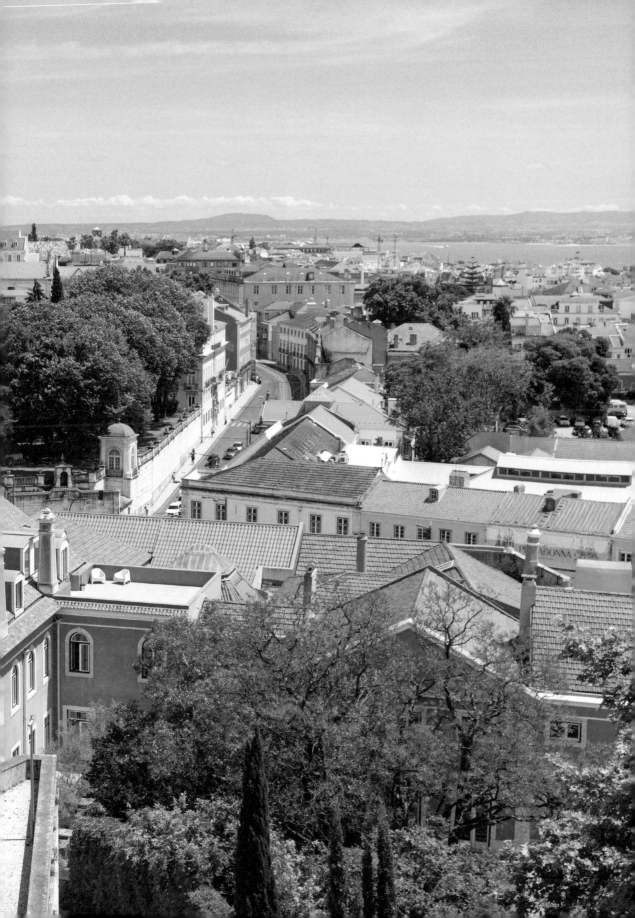

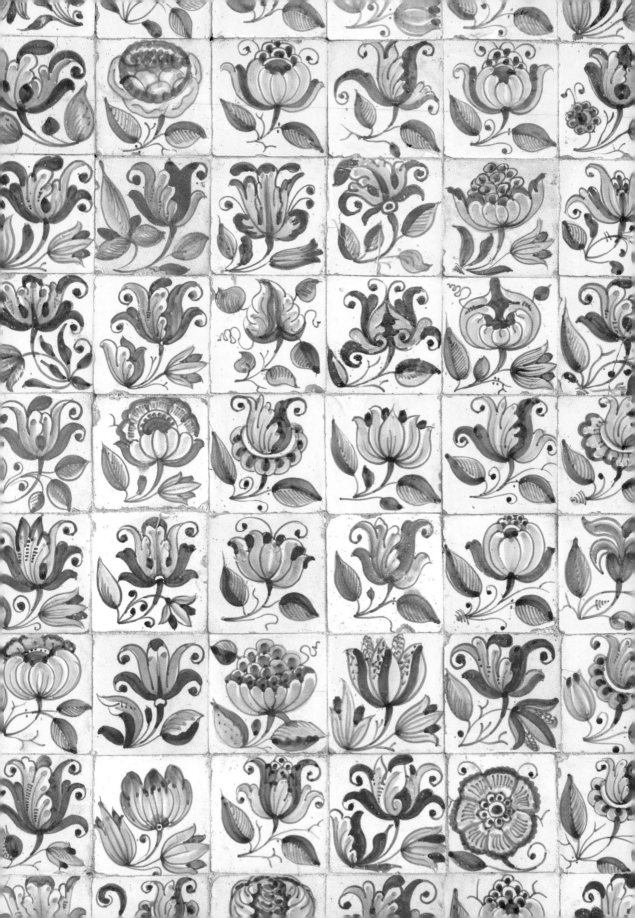

PATTERNS *of* PORTUGAL

A JOURNEY THROUGH COLORS, HISTORY, TILES, & ARCHITECTURE

CHRISTINE CHITNIS

CLARKSON POTTER/PUBLISHERS

NEW YORK

Cataloging-in-Publication Data is on file with the
Library of Congress.

ISBN 978-0-593-57819-3
eISBN 978-0-593-57820-9

Printed in China

Book and cover design by Mia Johnson
Cover photographs by Christine Chitnis

Editor: Sahara Clement
Designer: Mia Johnson
Production editor: Sohayla Farman
Production manager: Heather Williamson
Compositor: Merri Ann Morrell
Copyeditor: Maureen Clark
Proofreader: Alisa Garrison
Cold reader: Sarah Etinas
Marketer: Andrea Portanova

10 9 8 7 6 5 4 3 2 1

First Edition

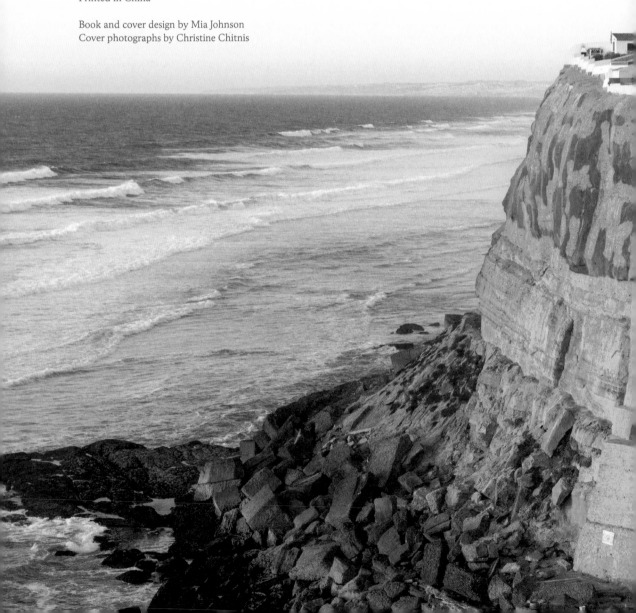

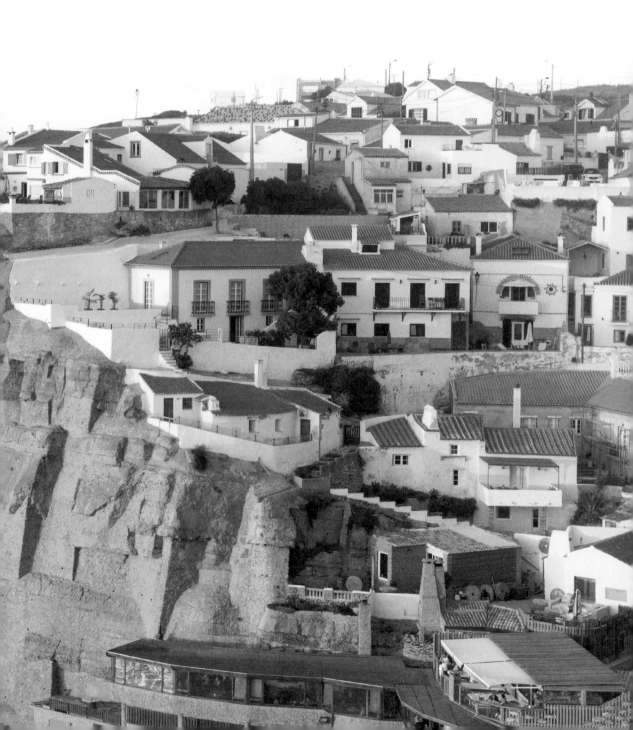

FOR VIJAY, VIKRAM, AND MEERA
ALWAYS AND FOREVER

AÇORES

MADEIRA

PORTO E NORTE

● Porto

CENTRO

LISBOA

● LISBOA

ALENTEJO

ALGARVE

OCEANO ATLÂNTICO

CONTENTS

INTRODUCTION 11

AZUL 19
AZULEJOS: A BRIEF HISTORY 39

SUN BLEACHED 81
THE ROLE OF THE CHURCH 109

BOUGAINVILLEA 137
EMBROIDERY, WEAVING, AND THE CLOTHING
OF VIANA DO CASTELO 153

TERRA-COTTA 183
PORTUGUESE ARCHITECTURE 211

VERDE 229
CUISINE: INFLUENCES AND FLAVORS 243

RESOURCES 283
ACKNOWLEDGMENTS 284

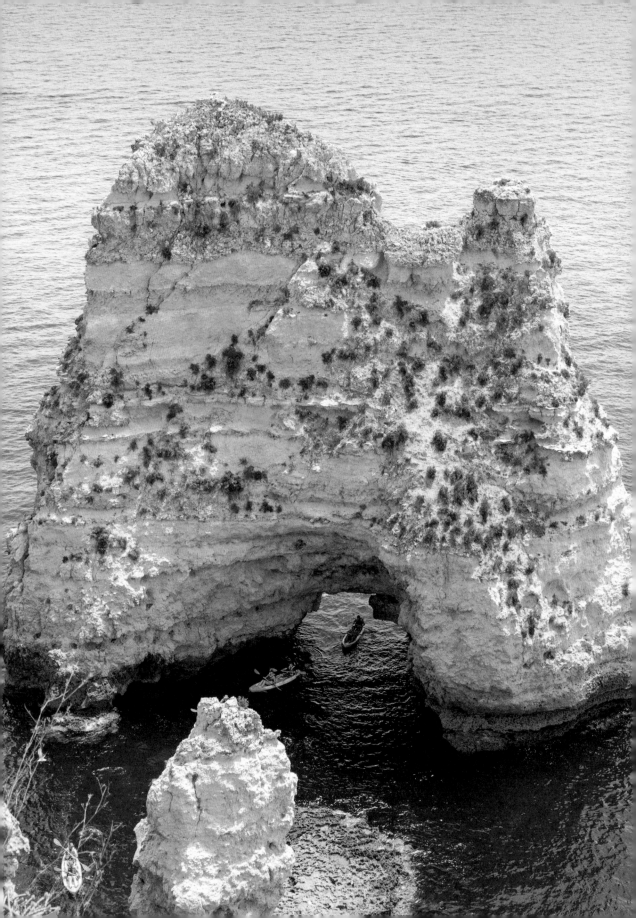

INTRODUCTION

Tucked away on the edge of the Atlantic, where dappled sunlight and ocean breezes kiss the shores and old-world romanticism abounds, Portugal's diminutive size defies its weighty historical significance. Tales of conquering heroes and seafaring legends are reflected through its richly tiled artworks, storied architectural elements, and the Roman and Moorish ruins that lie scattered throughout its bucolic countryside. Once one of the richest empires in Europe, Portugal has also been one of the continent's poorest countries, experiencing a drastic swing of fortunes through its centuries of civilization. Weaving from the honeyed fields of Alentejo and sparkling shores of the Algarve, to the heart of cosmopolitan Lisbon and verdant valleys of the Douro, color and pattern bring to life the complex history of Portugal, a country whose fortunes have always been tied to the sea.

In 1139, during the Reconquista—in which Christian crusaders reconquered the land from the Moors—the Kingdom of Portugal was founded by King Afonso Henriques and what followed was one of Europe's longest-lived, wealthiest empires. As the birthplace of the Age of Discovery and center of the first global empire, Portugal made its mark on every corner of the globe through colonization, trade, slavery, and commerce during its mighty and ruthless reign. Thanks to their famed explorers Bartolomeu Dias and Vasco da Gama, the Portuguese were the first Europeans to cross the Indian Ocean, a huge win in terms of gaining access to the lucrative spice route. By the sixteenth century, Portuguese rule had stretched around the globe, and because of the enormous wealth (and inspiration) drawn from Brazil, Goa, China, Mozambique, Angola, and the East Indies—to name just a

← Seven Hanging Valleys Trail, a scenic coastal hiking route, runs from
Praia da Marinha to Praia do Vale de Centeanes, and offers stunning views
of the Benagil and Carvalho beaches.

few—the country entered a golden age of art, most visible through the architecture and surface design of its lavishly commissioned palaces, churches, and monasteries, and its plentiful use of colorful ceramic tiles called *azulejos.*

As a photographer, I was instantly drawn to Portugal's unique palette and rich use of pattern, and especially intrigued by the way the same hues seem to echo throughout the country. The blue-and-white azulejos are reflected in the sunbaked beaches and enchanting blue water of the Atlantic coast. The fuchsia and gold of bougainvillea in bloom are mirrored, though timeworn and softened, in the colorfully painted facades of pastel homes. Many of Portugal's decorative motifs include elements from battles, sea voyages, conquests, village life, and Catholicism, the country's predominant religion. A famous example can be seen at Porto's São Bento Railway Station, where Jorge Colaço, one of Portugal's foremost azulejo artists, created blue-and-white panels of tiles illustrating scenes of daily life, such as the hay harvest, alongside murals of the country's history, including one particularly detailed rendering of Prince Henry the Navigator during the conquest of Ceuta in North Africa.

Many of the colors seen in the country's architecture and art find their inspiration in the palette of Portugal's natural world. From Costa Azul to the Algarve, the southern coast is known for its strikingly blue waters, pristine beaches, and plunging sandstone cliffs. The landscape is echoed in the bleached white buildings, terra-cotta roofs, and simple architecture of the area's charming coastal towns. Clean lines and soothing colors abound. The Mediterranean color scheme creeps into urban life as well, with Lisbon's sunny yellow trams winding through the streets, and its buildings covered in sea-green and sky-blue azulejos. As you venture north, the palette drifts toward the lush greens of the terraced Douro Valley and verdant Vinho Verde region, and the deep golds, burgundies, and olives of the area's abundant harvests. The result is a fluidity of color that meanders through Portugal's countryside, coast, small towns, and cities.

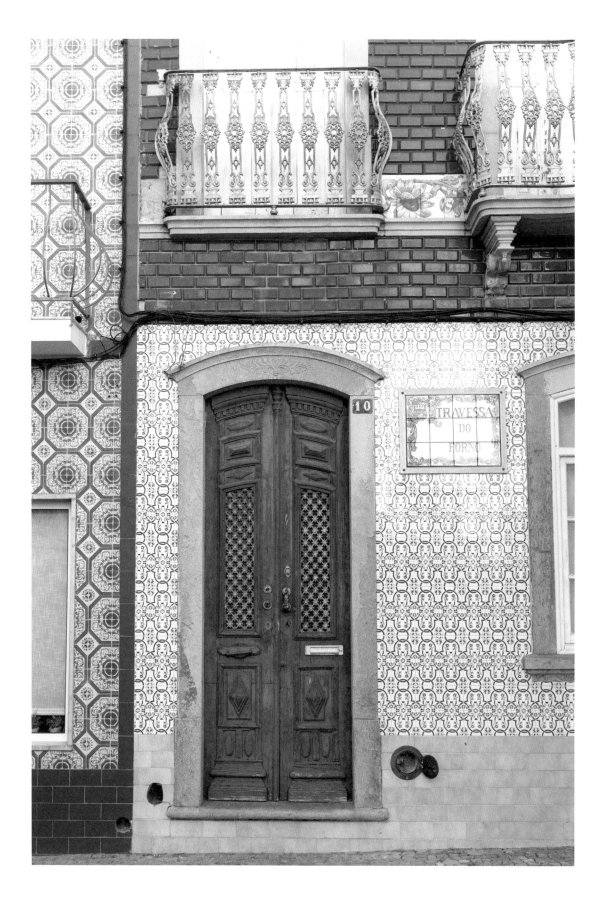

As is the case with so much of my work, this book is personal in nature. I am drawn to stories that help us understand our interconnectedness. While writing my last book, *Patterns of India*, I began researching the family history of my husband, Vijay. Blanche Coutinho, Vijay's mother, was a Catholic whose family originated from the Konkan region of India. Portuguese colonization lasted for over 450 years from 1505 to 1961 in the Konkan region and heavily influenced the culture, architecture, cuisine, and religion. Under the colonial caste system, there were three designations: *castiço* (Indians who converted to Christianity but had no Portuguese bloodline), *mestiço* (a blend of Indian and Portuguese), and *descendentes* (Portuguese who settled in Goa, India). We believe Blanche's father, Albert, was mestiço, and that Albert's father was a descendente from Portugal. Our documentation is limited, so we're relying on family lore and burial locations to try to piece together the lineage. But imagine my shock upon learning my children's roots possibly include a Portuguese lineage—one that dates back only a few generations.

It needs to be noted that during the Portuguese colonization of India, many Hindu families were forced by Portuguese-Catholic missionaries to convert against their will. In doing so, these families had to take on a Catholic surname. Therefore, it is impossible to know exactly how my husband's family came to the Coutinho name. Vijay's family history offers an example of how colonization not only influences entire cultures, but also impacts one's understanding of their own family's history.

Nowadays, my family and I find ourselves immersed in Portuguese culture. We live in Rhode Island, a state with a robust Portuguese population. In fact, southeastern Massachusetts and Rhode Island together have the highest concentration of Portuguese people in the United States. The Portuguese have a long history here in New England, starting in the sixteenth century with the whaling boom, with a second wave of immigration arriving in search of economic opportunity in the textile mills and fishing industry. My son, Vikram, plays soccer at an

elite level and the majority of his teammates are Portuguese. Every summer they return to Portugal on holiday to visit their extended family. When the team reunites in the fall, their sun-drenched travel tales paint a picture of a country akin to paradise. All of this had intrigued me to the point of wondering, Could I apply the same approach—connecting culture and history through the visual world—to Portugal as I did to Rajasthan in my previous book? You are holding the answer to that question in your hands today.

My travels throughout Portugal were shaped by the people I met along the way, who extended to me the warmest reception I could have imagined. Hospitality seems steeped into the very core of what it means to be Portuguese. I was plied with sparkling, incandescent wines, I feasted on fish pulled from the waters before me and grilled over a beach fire, and I was personally guided through artist studios, working farms, homesteads, and vineyards. Having been steered away from tourist traps, I instead found myself dining with families in their homes, lingering as they told me stories of their lives in Portugal. It became clear that the Portuguese take great pride in their country, and they are eager to show off its many gifts. Much of the country's allure is rooted in its nostalgic charm—its centuries-old winemaking, medieval villages, and haunting fado music—and yet my coast-to-coast travels brought to life a present-day Portugal that beautifully marries tradition and innovation.

⟶ The National Palace of Sintra dates back to the tenth or eleventh century when it was inhabited by Moorish rulers. It is now a sprawling complex of buildings thanks to construction campaigns undertaken during the reigns of Portuguese kings Dinis, João I, Manuel I, and João III.

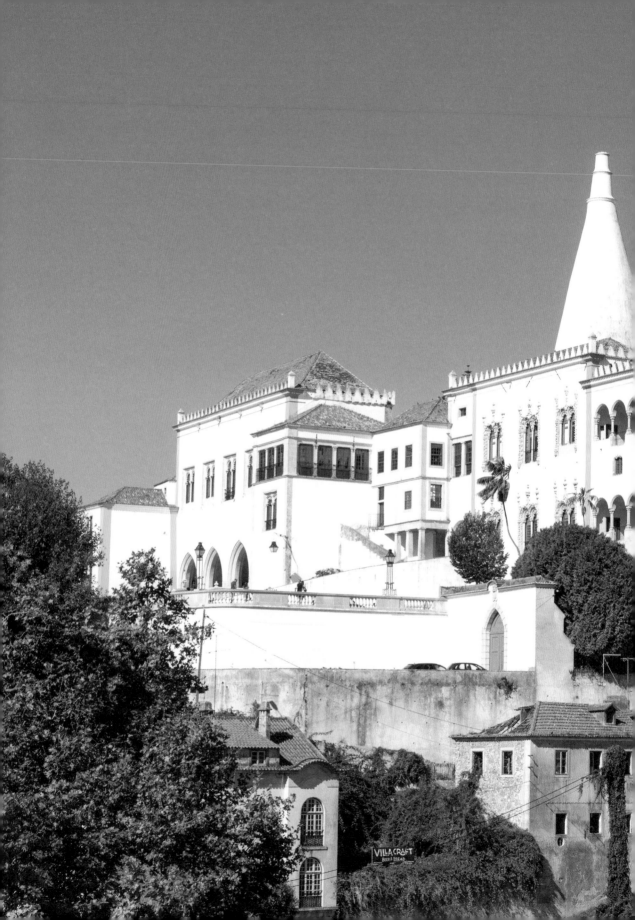

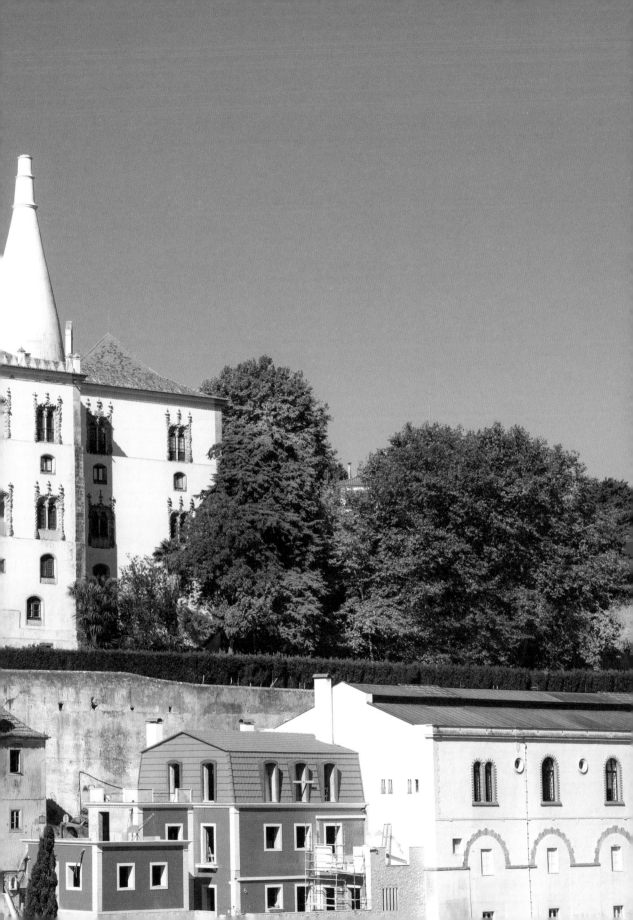

AZUL

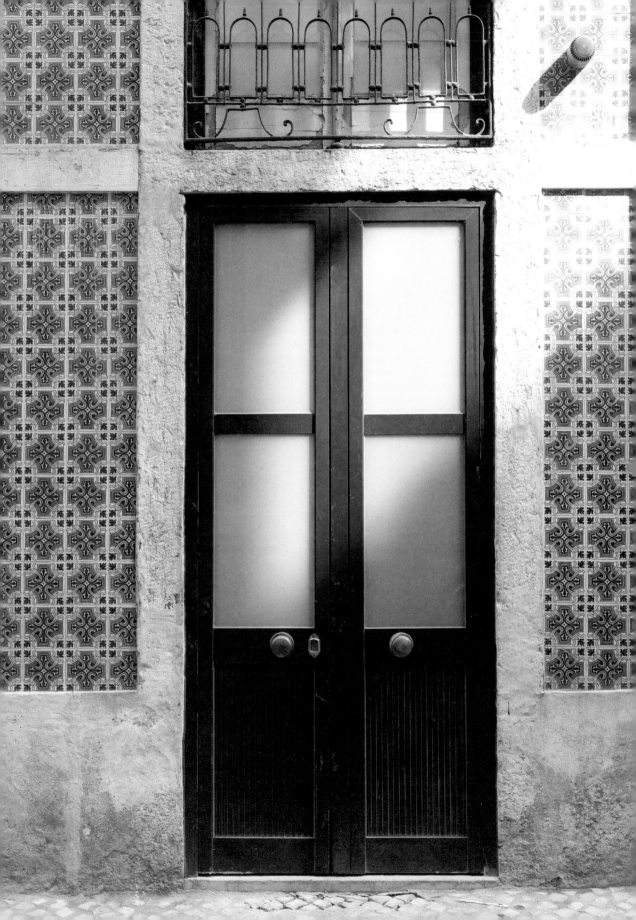

L ocated at the mouth of the Tagus River, Portugal's cosmopolitan capital is home to pastel-colored neighborhoods, winding cobblestone streets, and a buzzing cultural scene. Once the launch point of the Age of Discovery, Lisbon is a city steeped in history, a vibrant jewel on the Atlantic coastline. On the morning of All Saints' Day, November 1, 1755, a catastrophic earthquake rocked Portugal's capital city, triggering tsunamis and fires, and demolishing more than twelve thousand homes, as well as public buildings and historical landmarks. In rebuilding the city, it did away with frivolity. The ornate Gothic style—now reduced to rubble—was relegated to the past, and the Marquês de Pombal, chief minister to the king, rebuilt downtown Lisbon on a grid plan, with broad Neoclassical avenues and generous public squares designed to withstand future earthquakes.

Thanks to the red-eye flight from Boston, I usually land in Lisbon just before sunrise, ready to hit the cobblestone streets with my camera gear strapped on and sneakers laced for the steep, sloping miles I intend to cover over the course of the day. As the first rays of sun break the horizon, the warm morning light illuminates the tiled buildings of downtown and casts the entire city in a dreamlike glow. I appreciate how light and shadow shift across the azulejos throughout the day, and you'll see many stunning tile examples on these pages, ranging from classic geometric patterns and detailed murals to contemporary motifs and ornate works of public art. For first-time visitors to the country, I recommend beginning your trip at the National Tile Museum (Museu Nacional do Azulejo) so that as you travel throughout the country, you can fully appreciate the artistry of the tilework and understand its cultural significance.

Lisbon's Convento de Madre de Deus, which was founded in 1509, became the centerpiece of the Museu Nacional do Azulejo, a museum dedicated to preserving the history and craftsmanship from around Portugal. Its collection of historically significant azulejos dates from

← Azulejos were originally introduced to the Iberian Peninsula by the Moors, however it wasn't until the sixteenth century that the colorful ceramic tiles gained widespread popularity in Portugal. Throughout the centuries that followed, the Portuguese have used them more imaginatively and consistently than any other country.

the fifteenth century—with illustrious murals such as the *Nossa Senhora da Vida* and *Moses and the Burning Bush*—to the present day, with works from Maria Keil and Carlos Botelho. Within the museum, the chapel dedicated to Santo António, considered to be the patron saint of Lisbon, is a beautifully preserved example of Portuguese Baroque splendor, with gilded and carved wood, paintings by André Gonçalves, and exquisitely maintained tile panels. One of the museum's highlights is the *Great View of Lisbon* panoramic mural, which was crafted in the early 1700s from 1,300 blue-and-white tiles and depicts the cityscape before it was forever altered by the great earthquake.

Farther north, Porto, the country's second-largest city, was surprisingly unscathed by the violent quake, and so the city remained intact, and still today offers stunning examples of Baroque, Gothic, and Romanesque structures. Towering churches dot the skyline, while houses with red-tiled roofs tumble down the steep hills toward the banks of the Douro River, where flat-bottomed *rabelos*, traditional Portuguese wooden cargo boats used to transport goods, meander downstream stacked with barrels of port wine. Compared to Lisbon, Porto has a grittier feel, thanks in part to the hardworking industry of the riverfront. It is also home to some of the oldest and most well-preserved tiled facades in Europe, and in contrast, stunning modern architectural sights such as Casa da Música. Don't miss São Bento Railway Station, Capela das Almas, and Igreja do Carmo, all striking examples of the blue-and-white azulejos that were popular during the Baroque era. The prevalence of royal blue used in azulejos is thought to originally stem from the ancient Islamic belief that the prized semi-precious stone *lapis lazuli* ("stone of the sky") was connected with wisdom and power, hence its widespread use in the decorative arts of the time. From there, cobalt-blue glaze became popular in Islamic pottery and influenced future trends such as blue-and-white Ming dynasty-era Chinese porcelain and Dutch delftware.

→ The exterior of Igreja do Carmo in Porto features a tile mosaic that depicts the history of the Carmelite Order of the Roman Catholic Church.

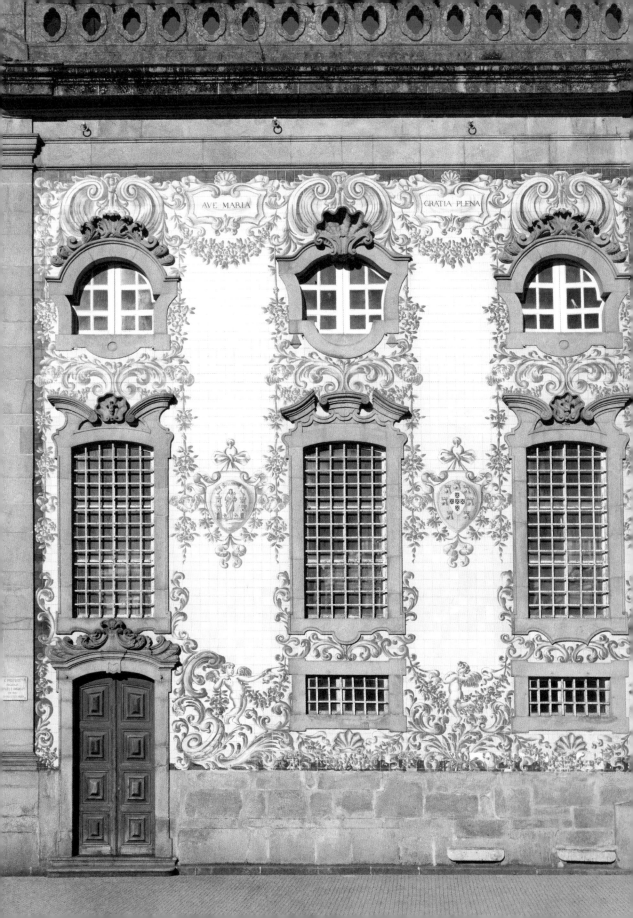

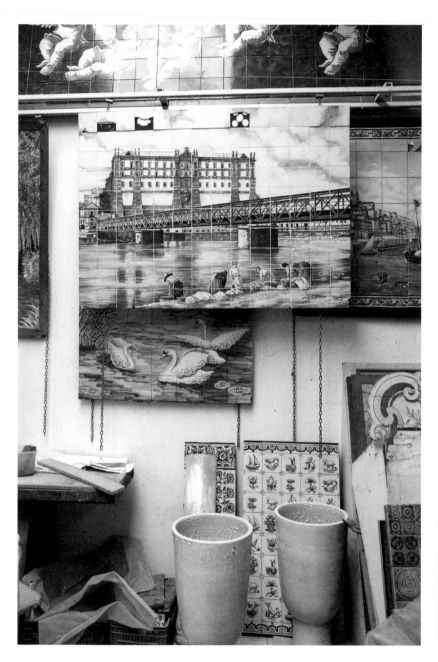

↑→ At his atelier outside of Porto, Joaquim Pombal continues the rich
tradition of azulejo artistry through his restoration of old tiles,
hand-painted tilework, and contemporary mural, ceramic, and tilework.

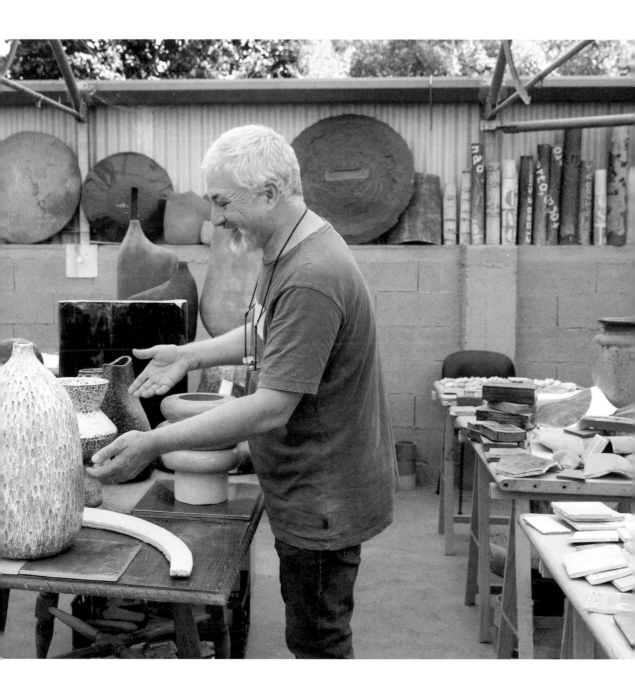

⟶ Founded in 1968, Porches Pottery is dedicated to preserving
the art of handmade, hand-painted pottery, which has a long and
rich history in the Algarve region.

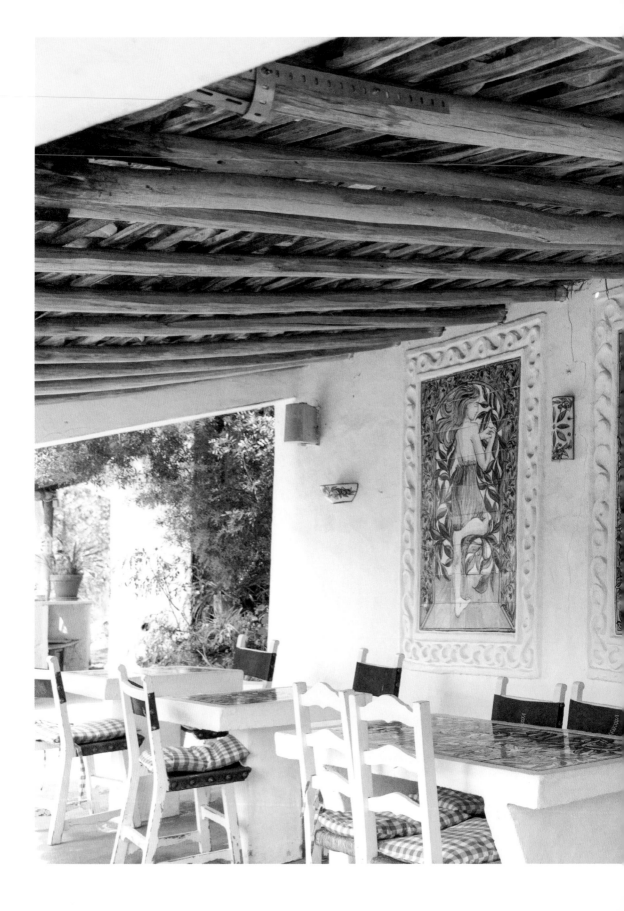

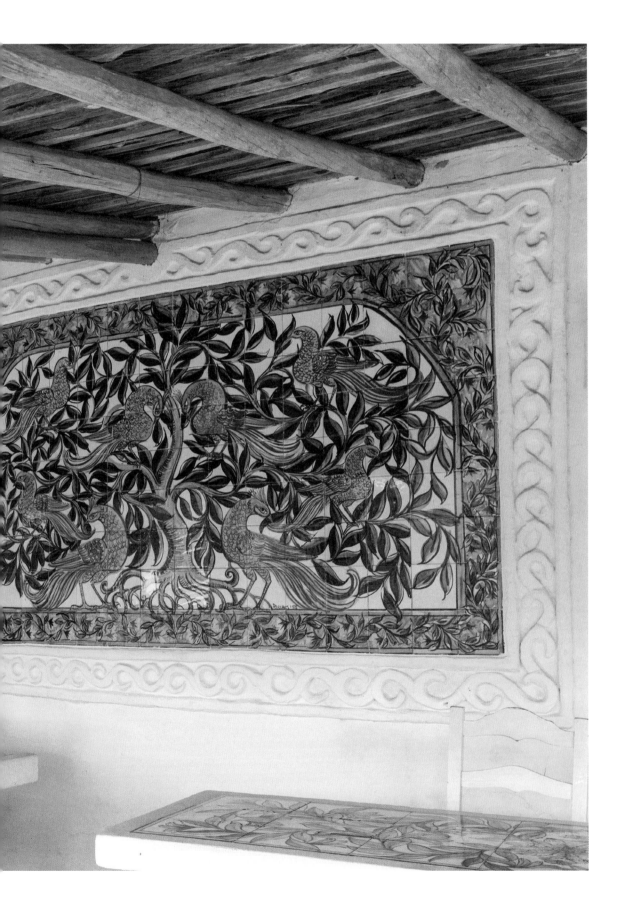

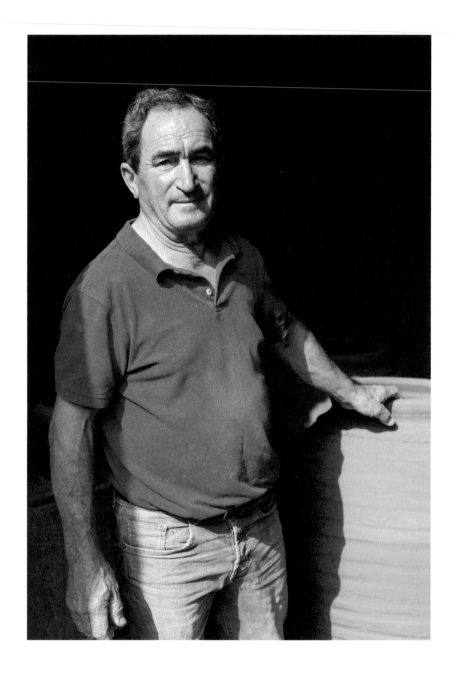

↑ In the tiny town of Beringel in the Alentejo region, António Mestre continues his work as one of the few master potters in the country who still handcrafts wine amphorae.

→ Hand-painted terra-cotta dishes wait for their glaze firing at Olaria Patalim, a pottery workshop in São Pedro do Corval.

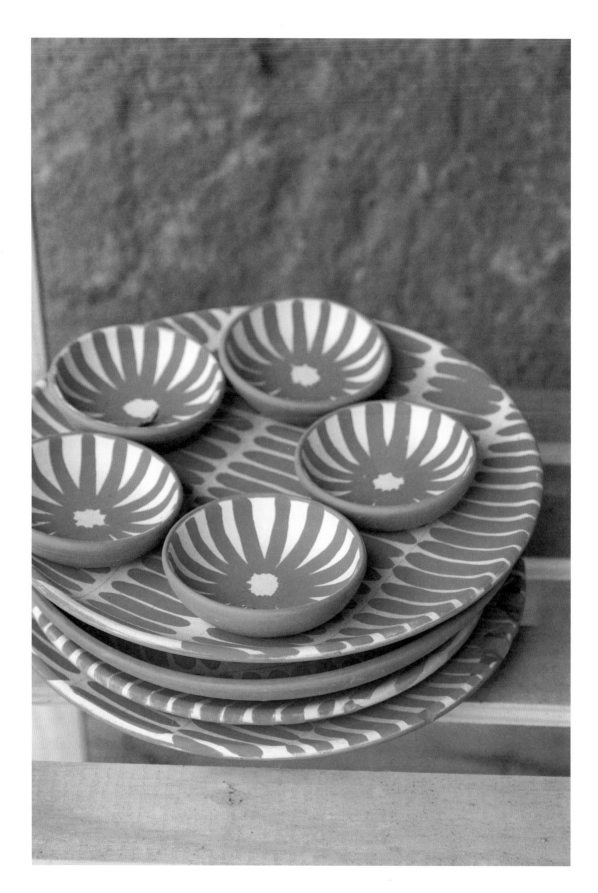

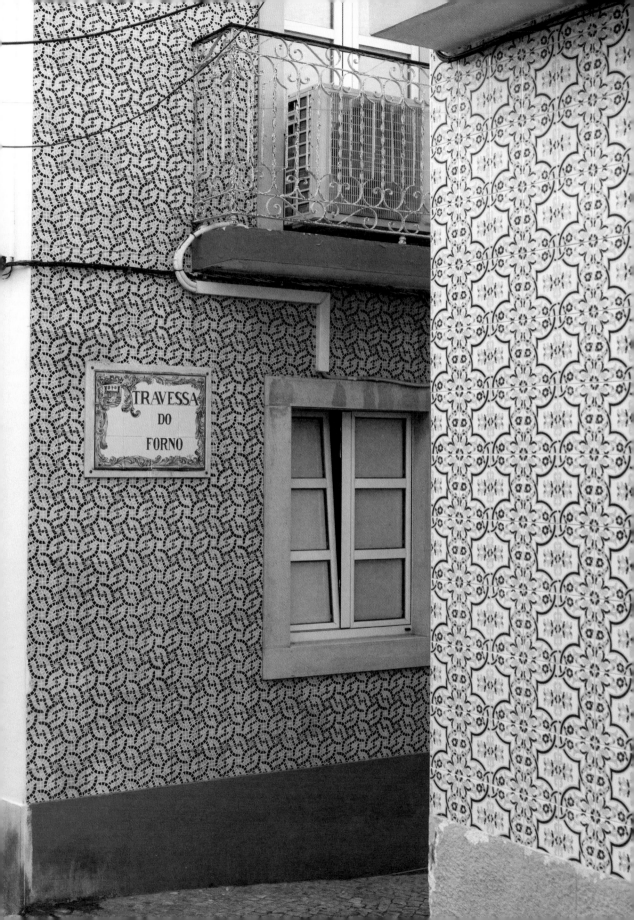

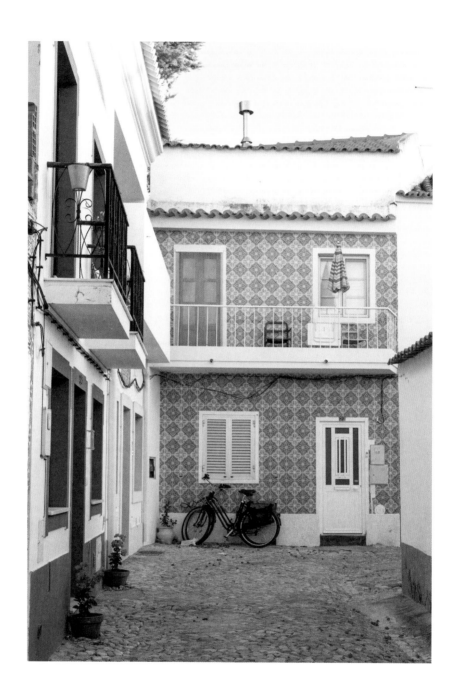

←↑ Though it was founded around 400 B.C., Tavira was largely
reconstructed following the great earthquake of 1755, hence the historic
streets lined with beautifully tiled eighteenth-century homes.

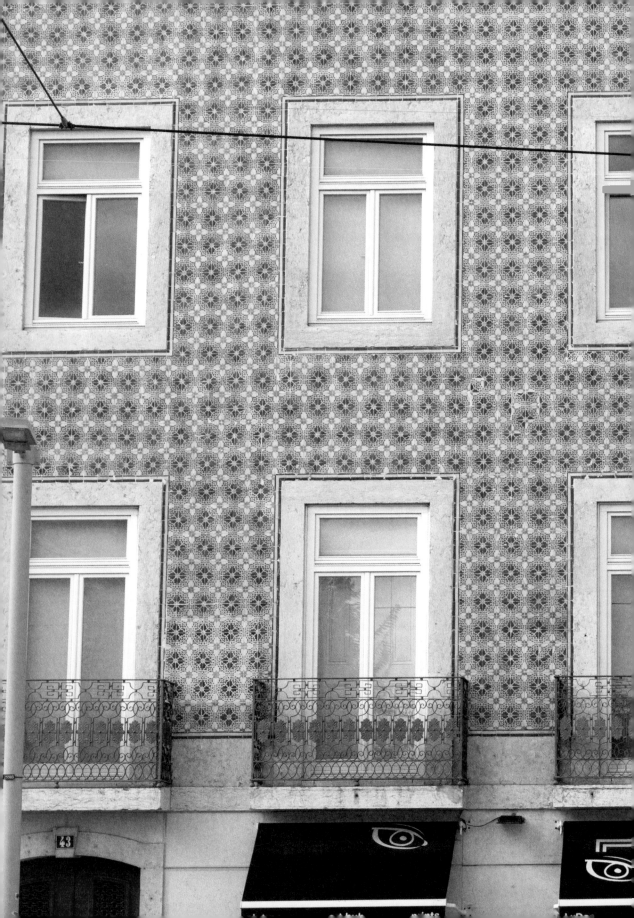

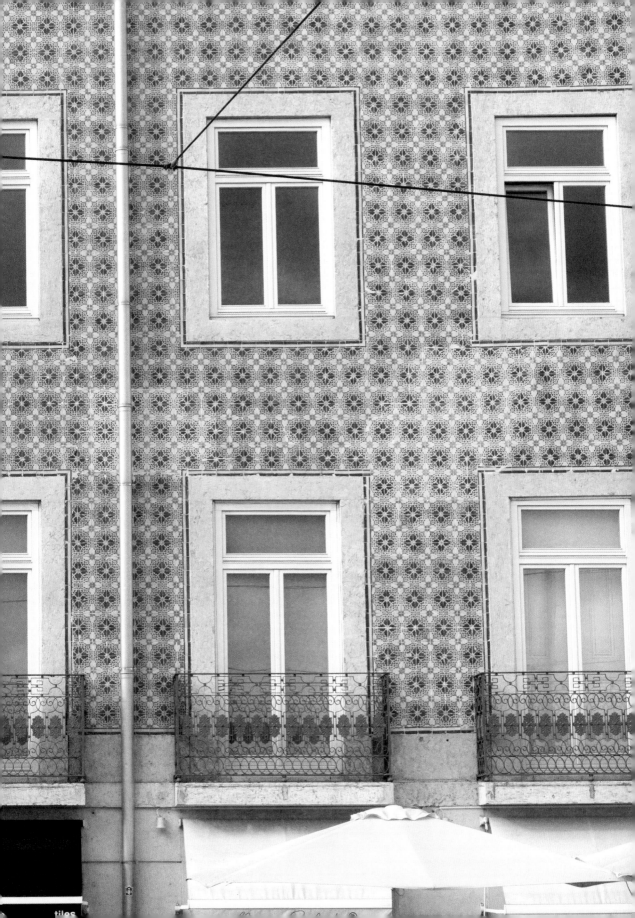

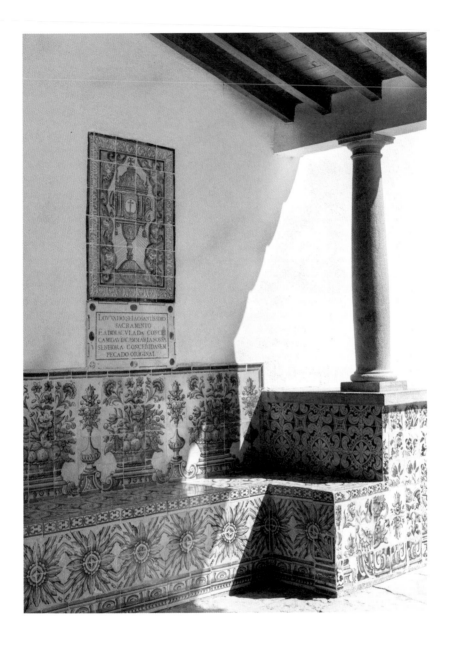

↑ The Capela de São Sebastião, located in the Marechal Carmona Park in Cascais, dates back to the seventeenth century, although the tiles depicting the life and deeds of Saint Sebastian were added later in the twentieth century.

→ The tiled facade of Capela das Almas in Porto depicts scenes from the lives of the saints, including the martyrdom of its namesake, Saint Catherine. The chapel dates back to the eighteenth century, though the tilework was added in the early twentieth century.

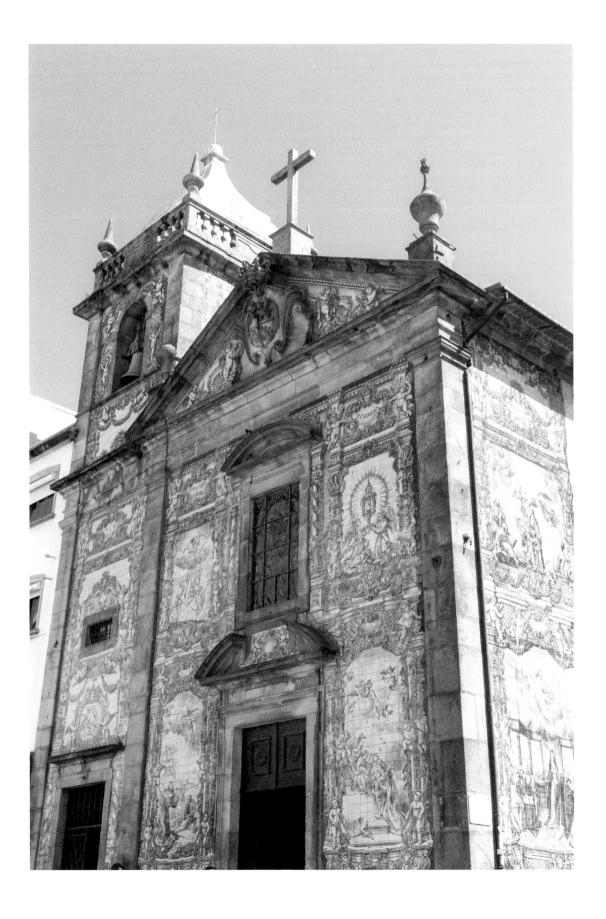

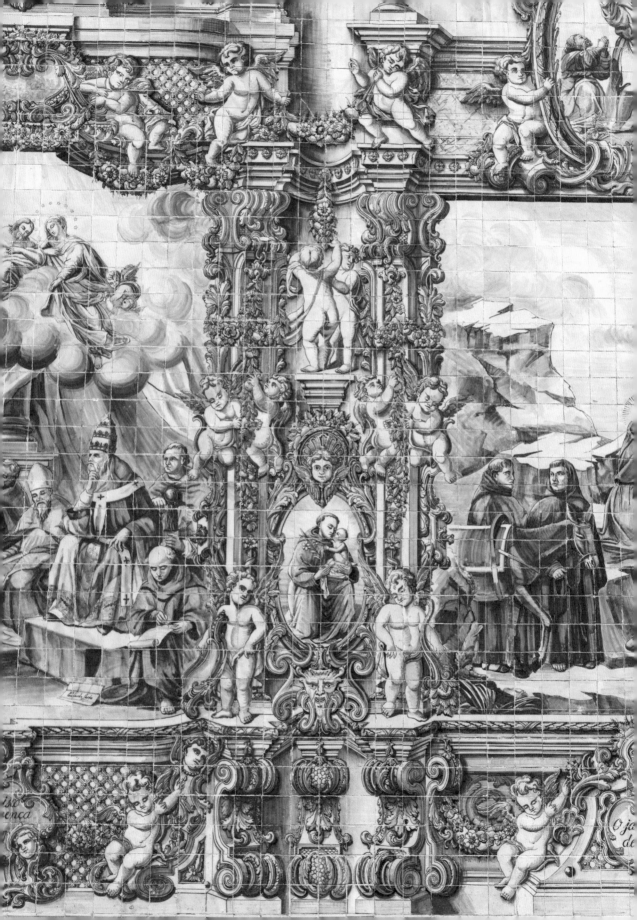

AZULEJOS: A BRIEF HISTORY

AZULEJOS—A WORD that was derived from the Arabic word *az-zulayj*, which means polished stone—were common in parts of the Iberian Peninsula that fell under Moorish rule, though the first known application of decorative ceramic tiles can be traced to ancient Egypt and Mesopotamia. The Moors favored simple ceramic tiles in neutral tones and Islamic geometric motifs. Artisans used the techniques of *corda seca* (filling in thick outlines of manganese oxide with various colors) and *aresta* (sculpting color wells directly into the tile).

In the early sixteenth century, during his visit to Spain, the Portuguese king Manuel I became enamored with the tilework of the Alhambra in Granada and decided to have his palace in Sintra decorated with the same tiles, which he imported from Seville, a major center of the Hispano-Moresque tile industry. Portugal continued to import its azulejos from Spain, as well as Italy and Holland, until Flemish craftsmen settled in Lisbon in the late sixteenth century and brought with them knowledge of a technique known as *faiança*: an undecorated tile is first baked, then covered with an opaque glaze that acts as a canvas for the painted design before a second firing. As the rest of Europe turned its artistic attention to frescoes, oil paintings, and sculptures, Portuguese artisans continued mastering and developing their azulejo art form, moving on from geometric shapes to tiles that depicted people, animals, and flora and fauna from Portuguese folklore, as well as murals that told stories of seafaring conquests and religious tales.

The golden age of azulejo art coincided with Portugal's colonial expansion, and as wealth poured in from China, Brazil, Goa, and the East Indies, tile production reached a fervor. While tile art is not entirely unique to Portugal, no other country can match its abundance, relevance, artistry, and scope of applications. Here tiles are considered to be not only an art form but also an important construction material prized for their cooling properties.

Enthusiasm for azulejos waxed and waned over time, surging back to popularity in the twentieth century through the work of prominent tile artists such as Maria Keil and Eduardo Nery. The popularity of azulejos has only increased in recent times, and a visit to the atelier of ceramic artist and painter Joaquim Pombal, located on the outskirts of Porto, illuminated the mastery and craftsmanship that goes into each tile. While Joaquim is dedicated to the conservation, restoration, and replication of historic azulejos, he is pushing the craft in a contemporary direction with his ceramic sculptures and home furnishings.

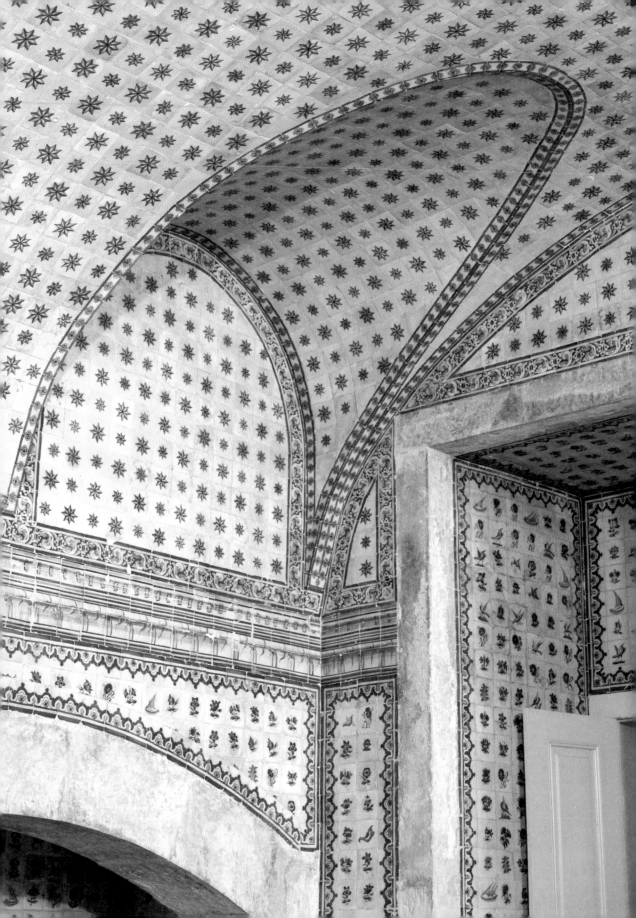

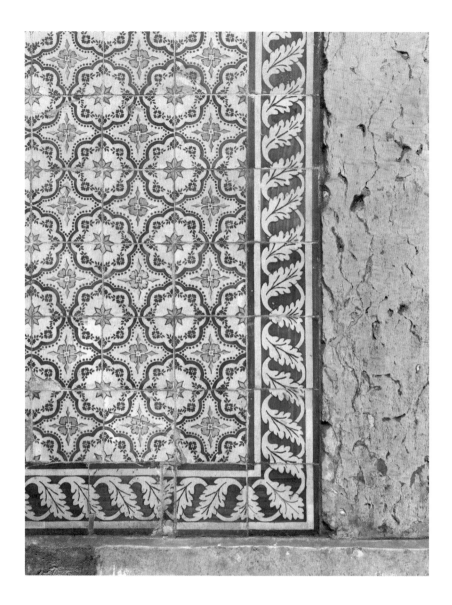

← Lisbon's historic Necessidades Palace, with its completely tiled kitchen and barrel vault ceilings, was once the official residence of the Braganza dynasty. The building now serves as headquarters of the Portuguese Foreign Ministry.

↑ One of the main difficulties in studying facade tiles is determining their place of origin—many of the production factories have closed, and their catalogs and references have been lost to time. However, we can gain valuable insight from *tardoz*, marks that factories made on the back of tiles while the clay was still wet. Introduced in the early 1900s to certify the origin of the tiles, tardoz can be recovered from buildings where the tiles are missing or loose.

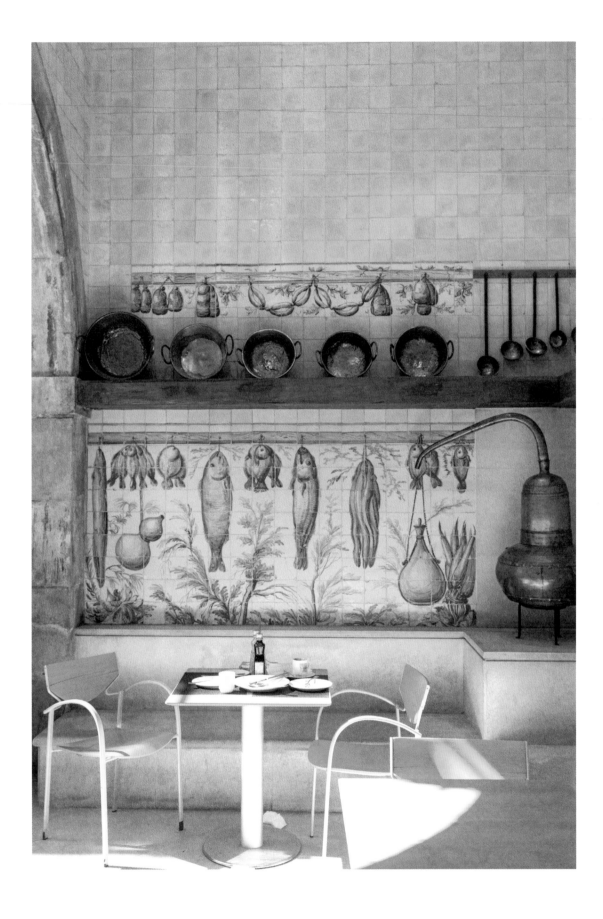

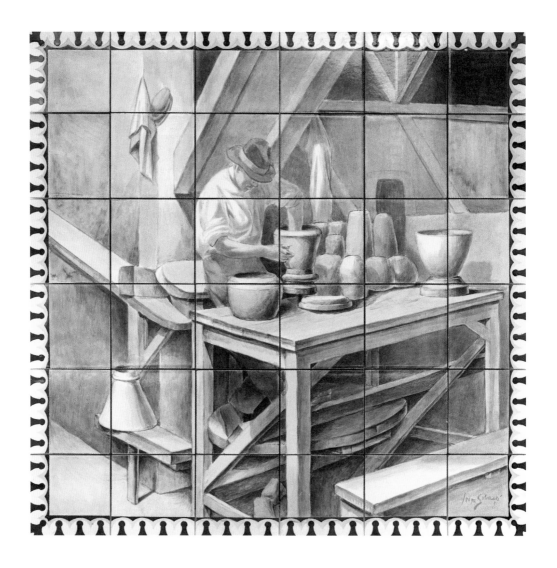

← In the Museu Nacional do Azulejo restaurant, which is housed in the former rectory, nineteenth-century azulejos depict the main foods used in Portuguese cooking: vegetables, meat, fish, poultry, sausages, and game.

↑ A tile panel in the Museu Nacional do Azulejo honors Portugal's artisan tradition of handmade pottery.

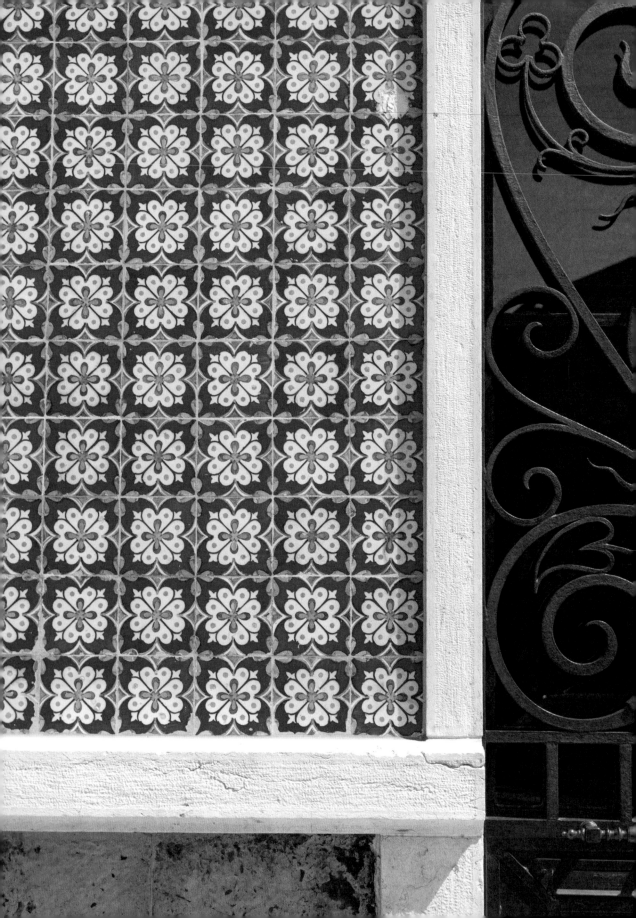

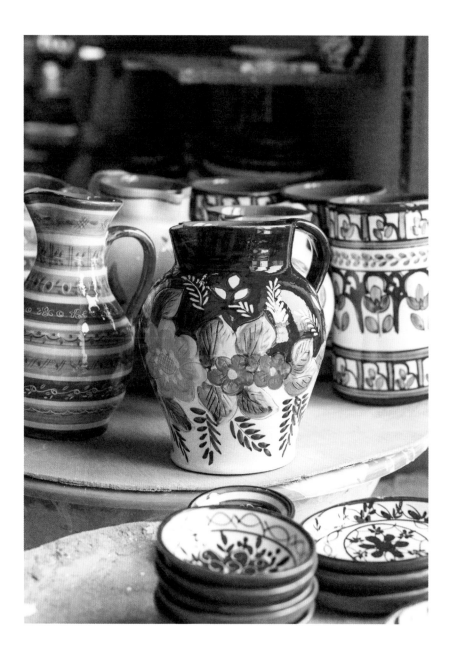

↑ The red clay pottery of the Alentejo region ranges from rustic terra-cotta bowls to whimsical hand-painted vases that are decorated with the flora and fauna of the region.

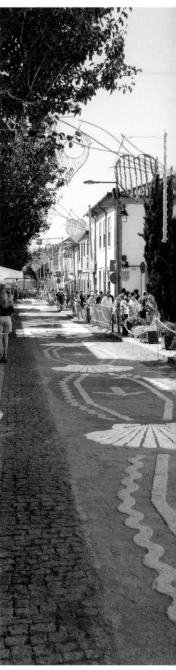

↑ → Parades, concerts, cultural performances, and religious processions make up the annual weeklong summer festival of Our Lady of Sorrow, known as the Romaria de Nossa Senhora da Agonia, which draws hundreds of thousands of attendees from across the country. Since it's a festival dedicated to the patron saint of fishermen, certain streets are decorated with salt "carpets" that feature nautical motifs.

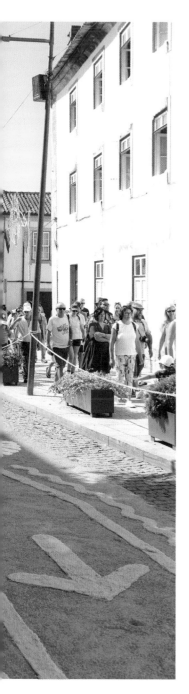

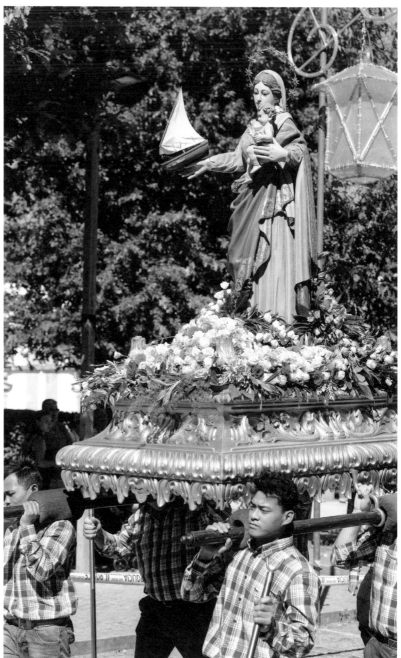

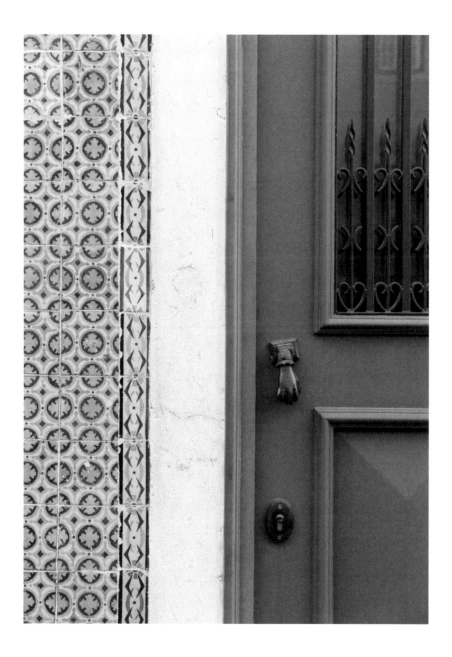

↑ Rooted in Moorish tradition, the "hand of Fatima" door knocker, with
its five fingers, alludes to the five pillars of Islam and is thought to ward off
the evil eye. These door knockers, which are most likely twentieth-century
reproductions of antique models, are prevalent throughout Portugal.

p. 52–56 The most traditional of color schemes; blue-and-white tiles
complemented by a hunter green door

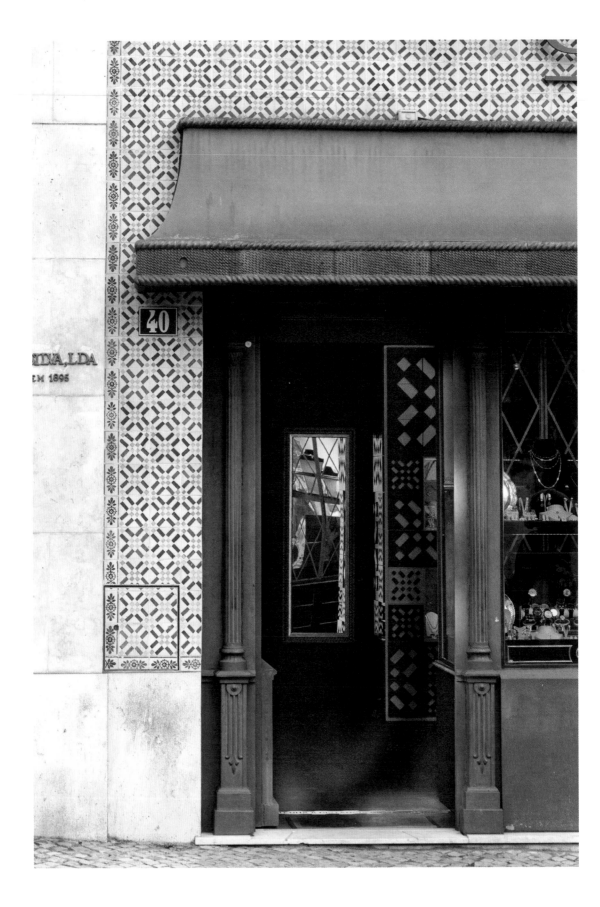

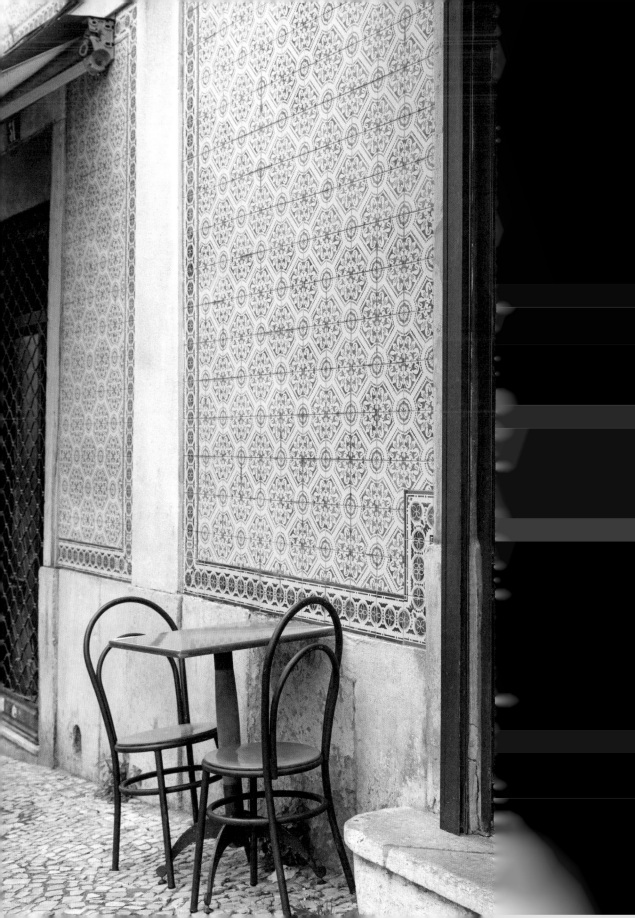

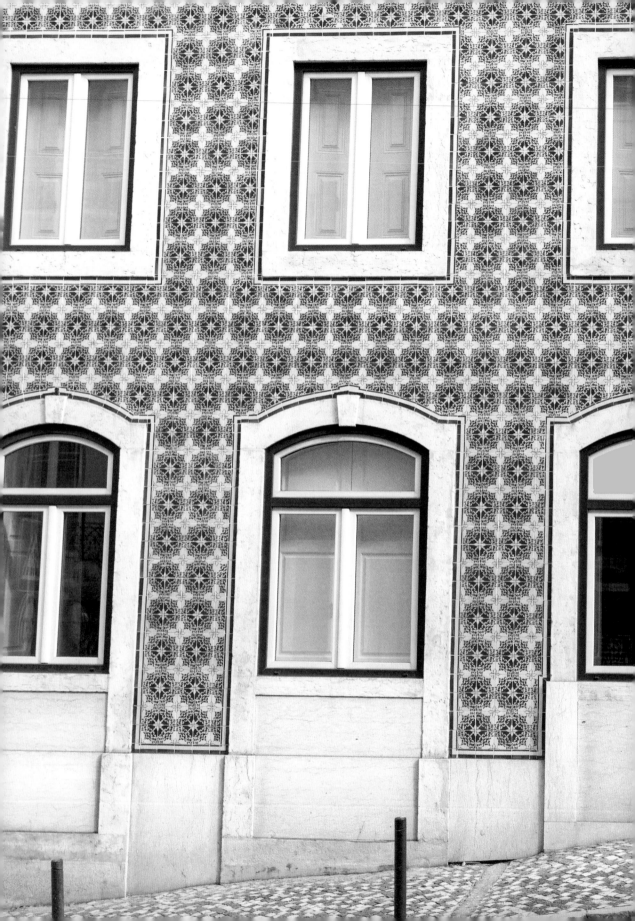

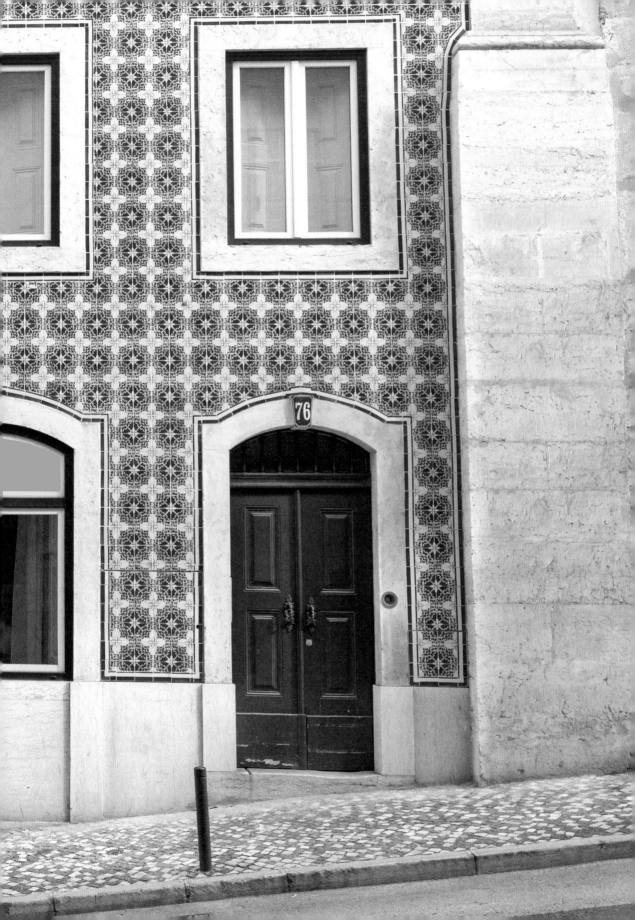

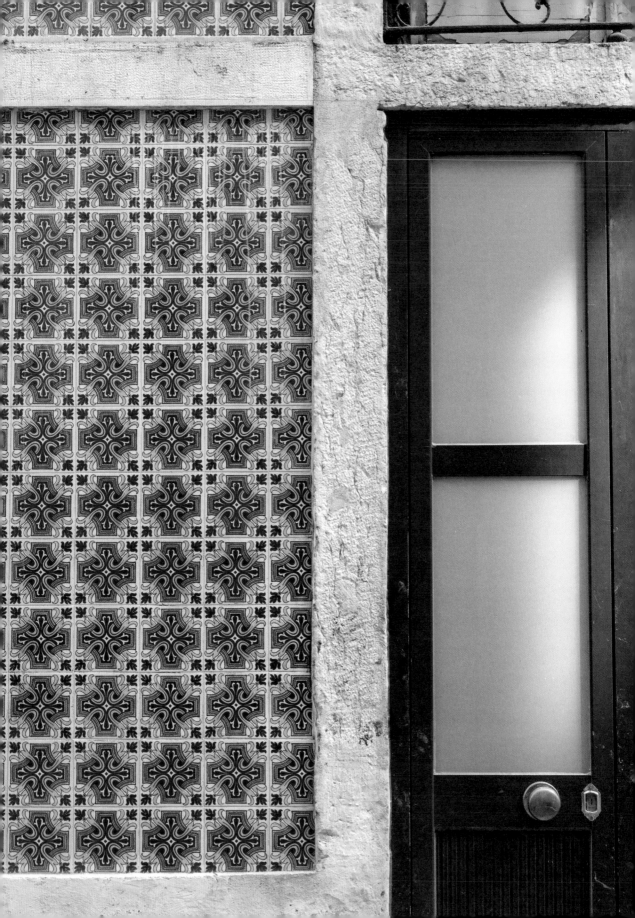

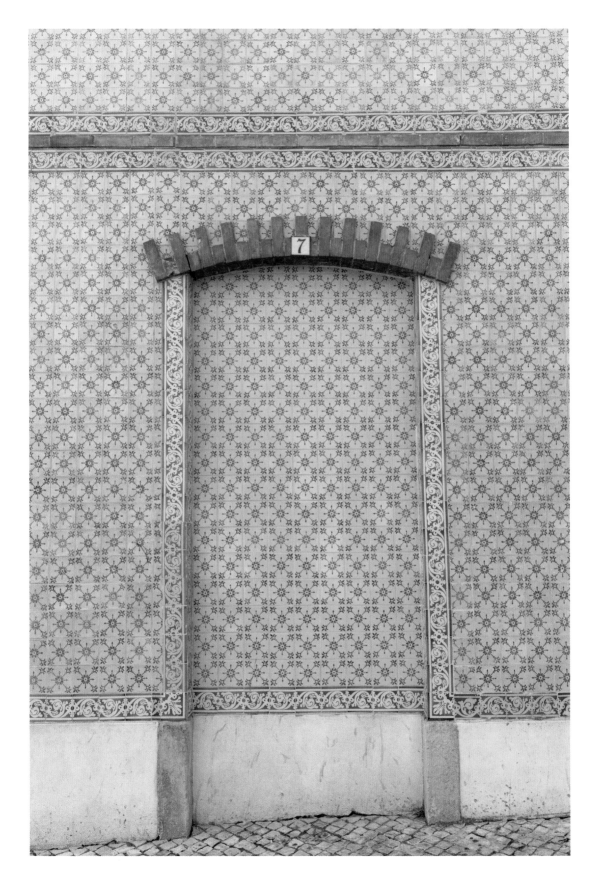

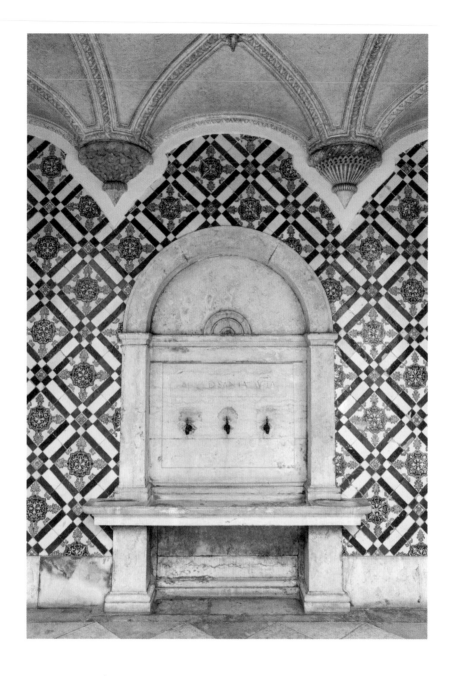

↑→ Throughout the Museu Nacional do Azulejo, hints of its
former life as a sixteenth-century convent, known as the
Convento de Madre de Deus, can be seen.

p. 60–61 Traditional architecture merges with modern monochromatic tile
facades in Porto's lively Cedofeita neighborhood.

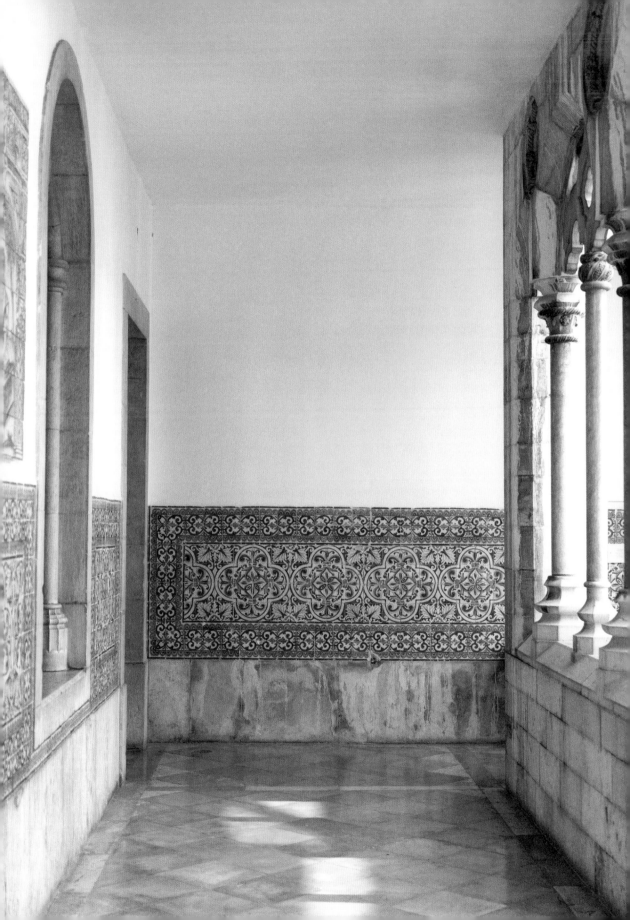

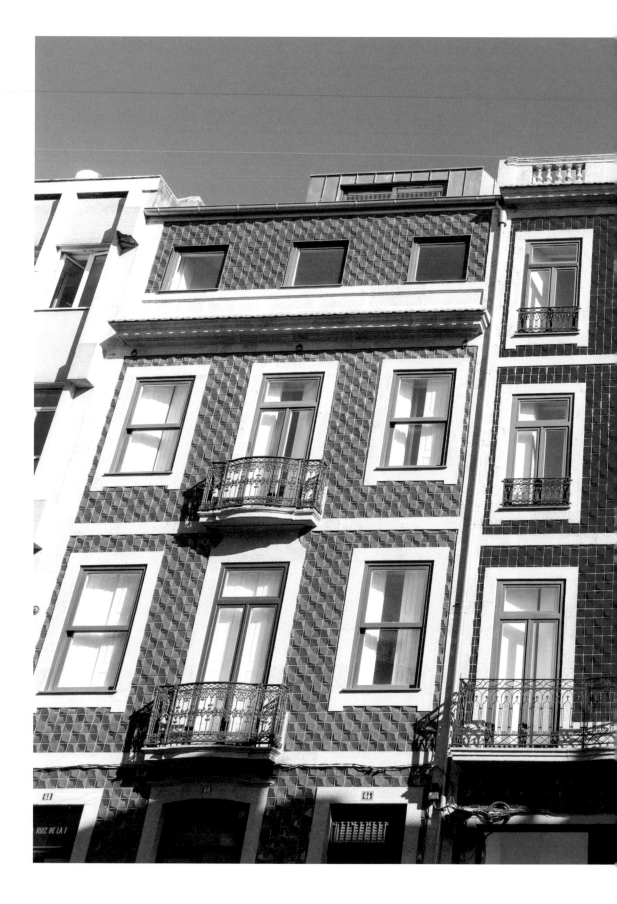

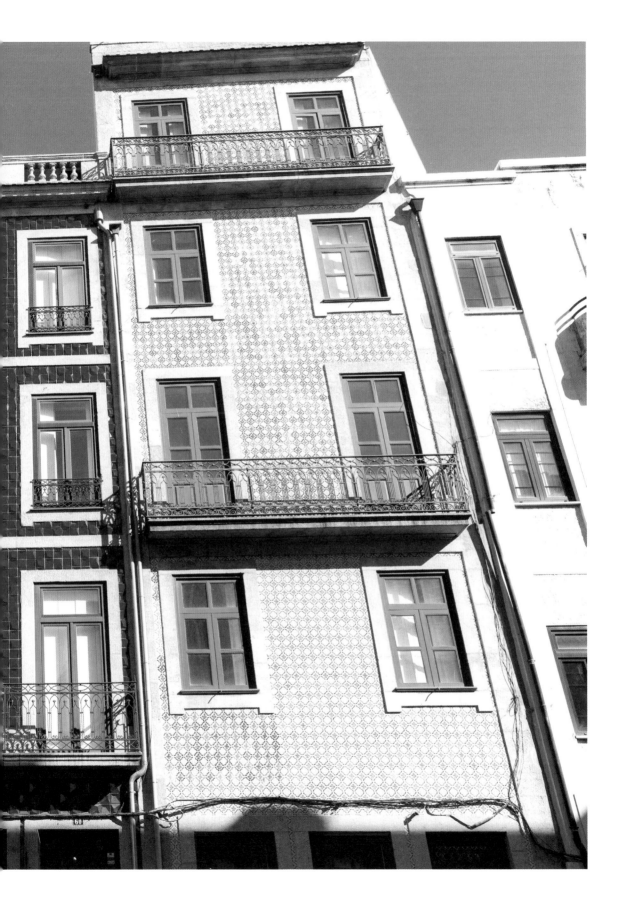

↑ → In the Algarve region, Moorish design details prevail,
such as whitewashed exteriors, blue accents, and boxy homes.

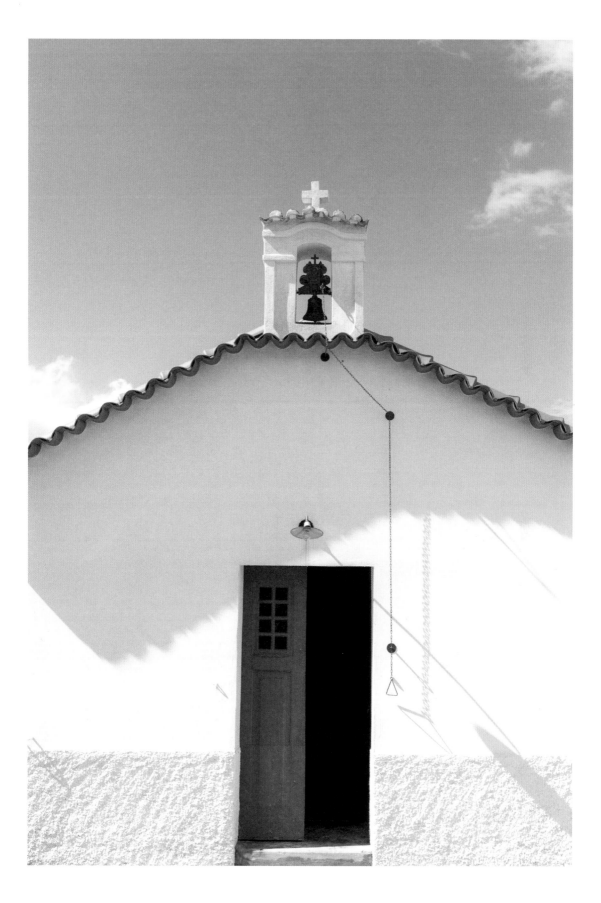

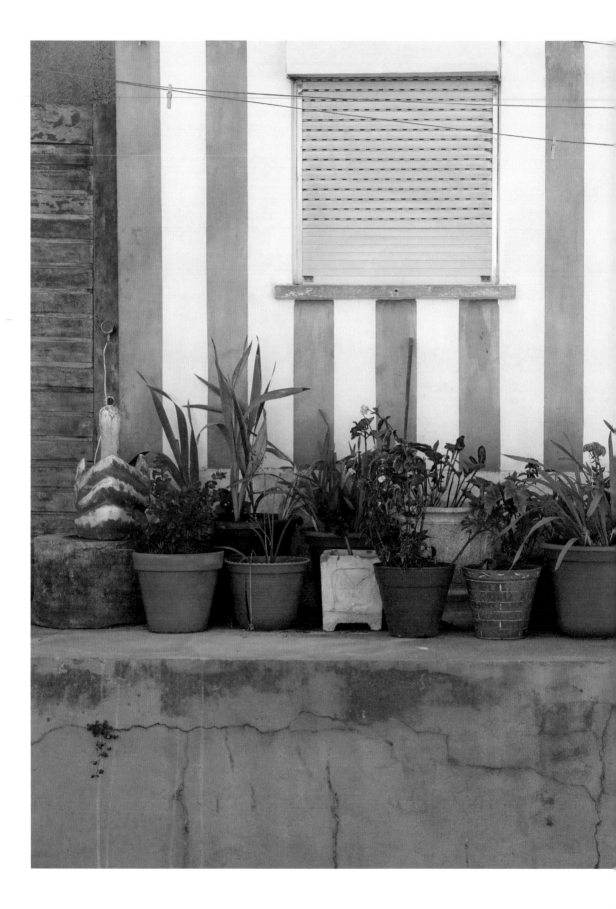

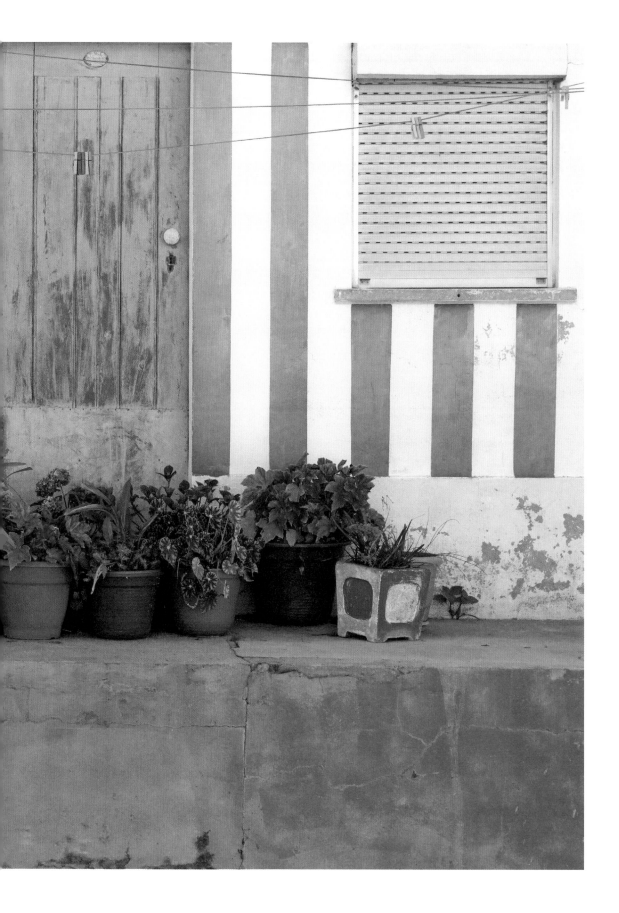

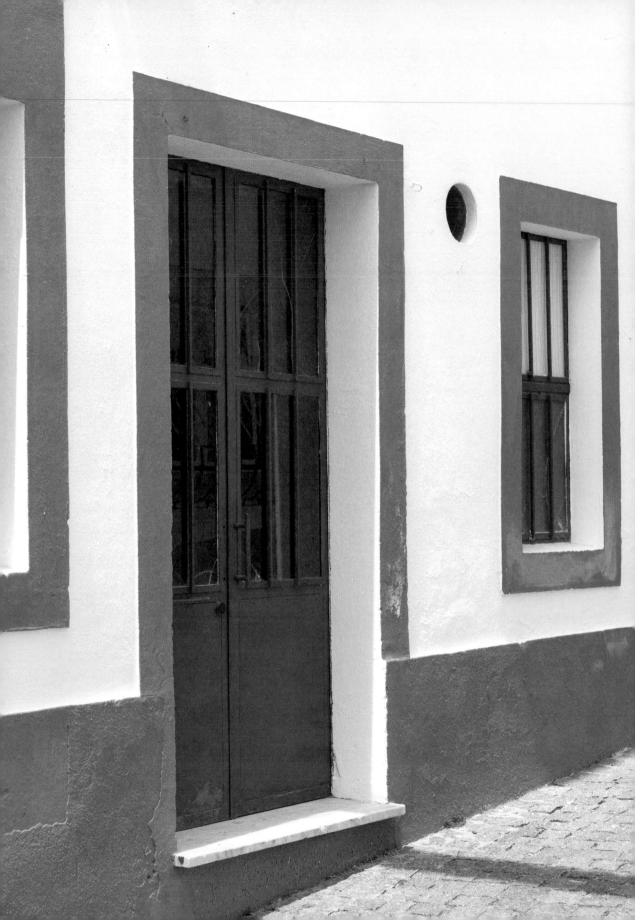

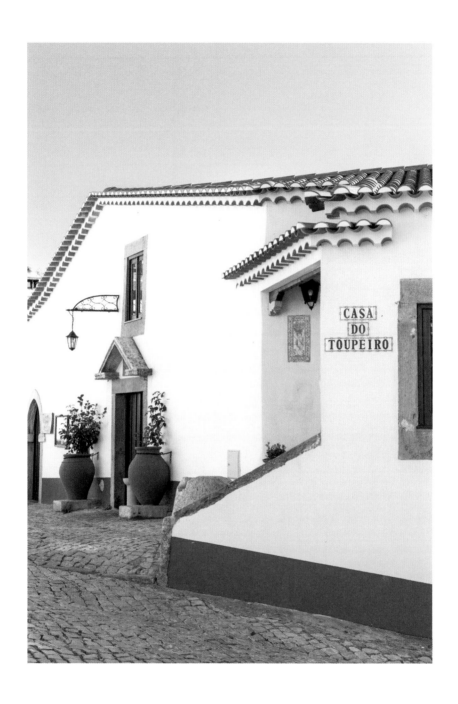

→ Colorful striped homes line the
boardwalk in Costa Nova.

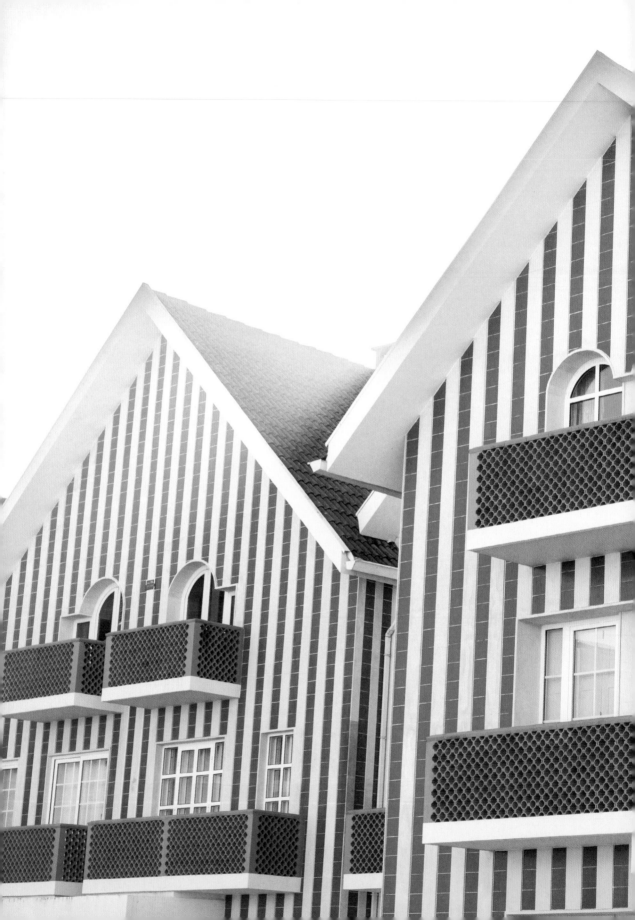

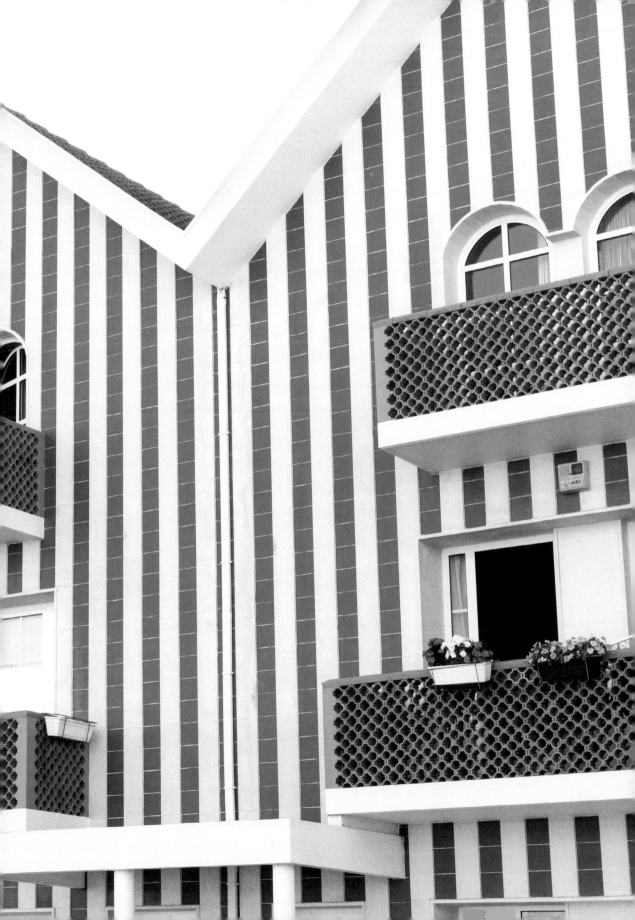

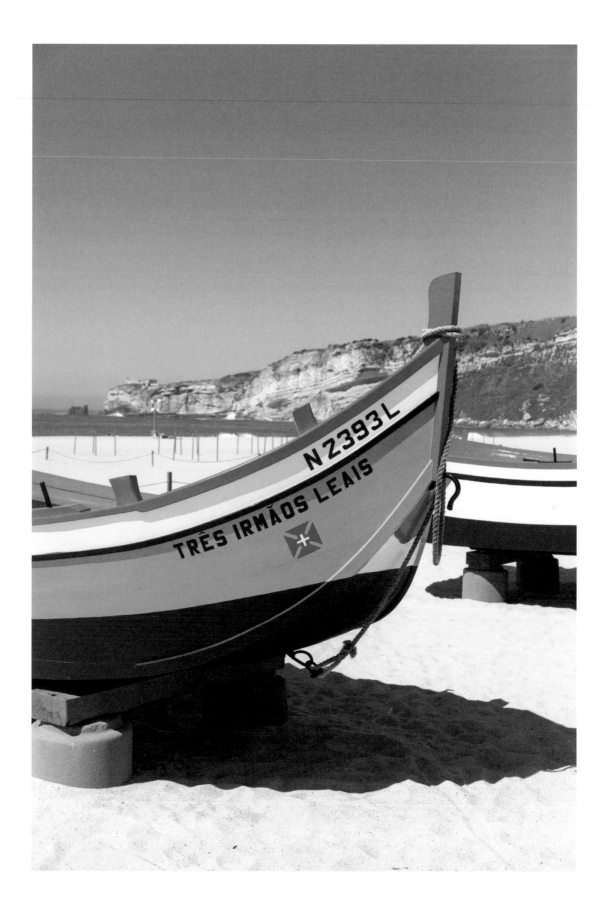

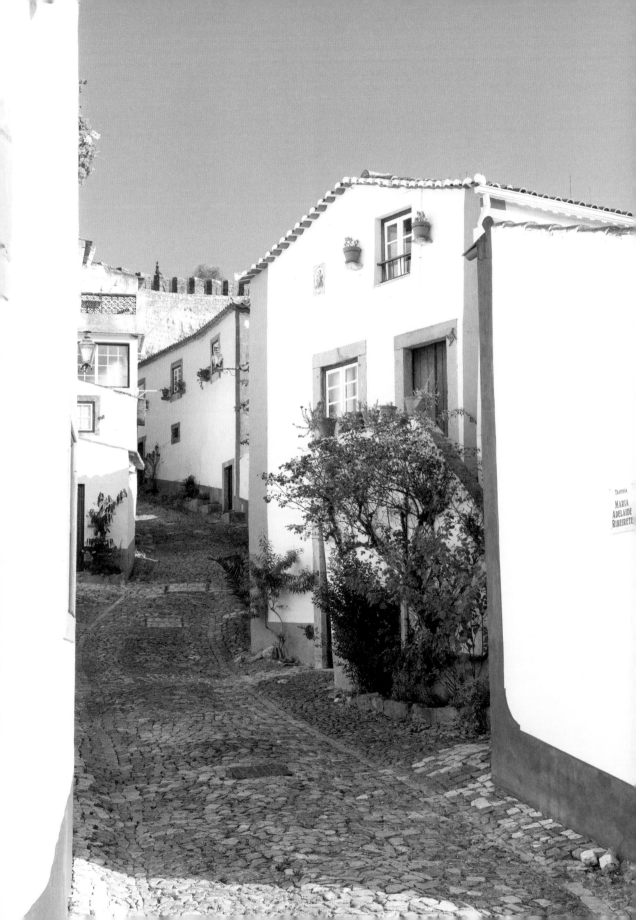

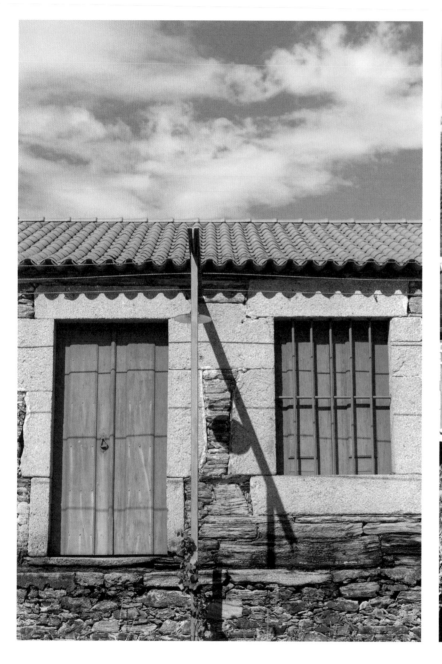
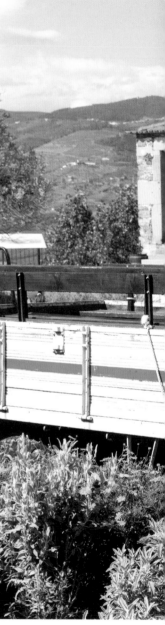

p. 70 Traditional wooden fishing boats line the shore in Nazaré.

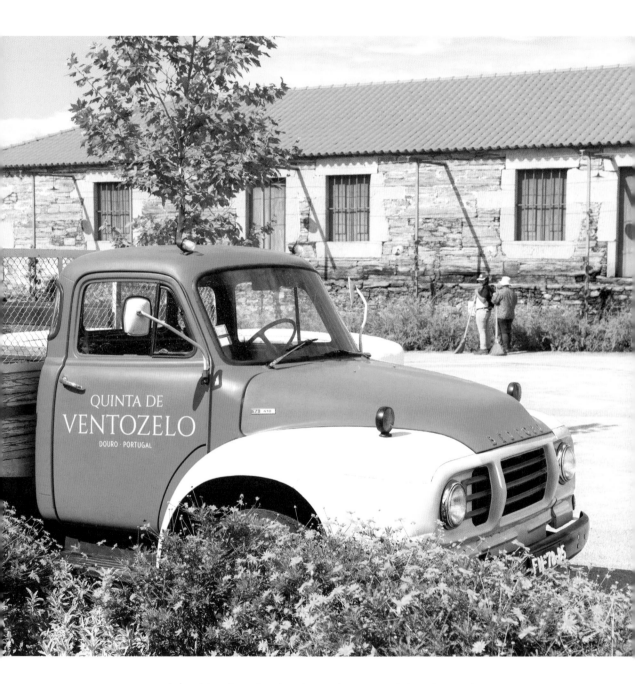

←↑ While still a working farm that produces wine and olive oil, many of Ventozelo Hotel & Quinta's converted farm buildings now serve as guest rooms. The property also includes a winery, olive oil press, restaurant, and visitor center, which contains exhibits dedicated to showcasing the history of the estate, the local flora and fauna, and the greater Douro Valley.

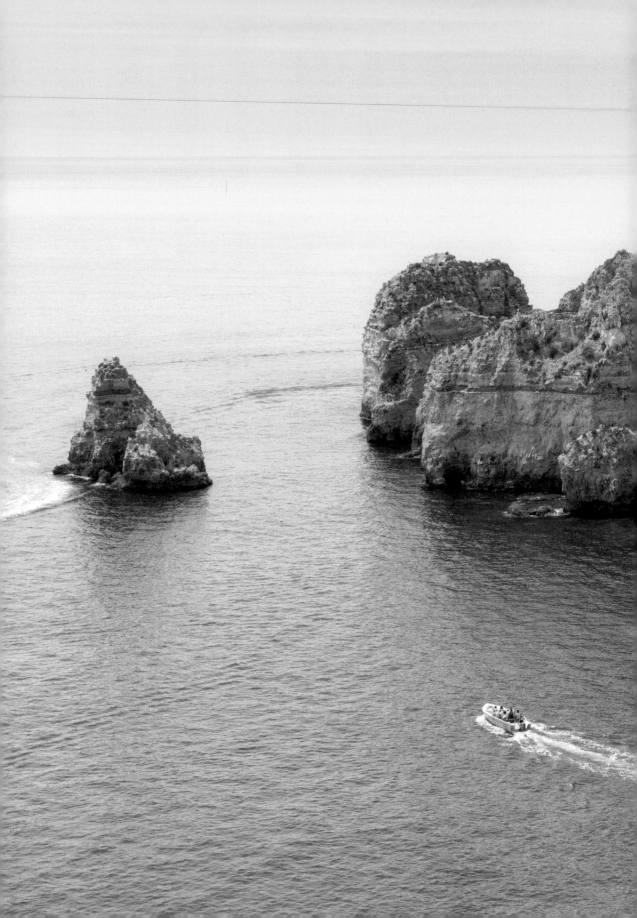

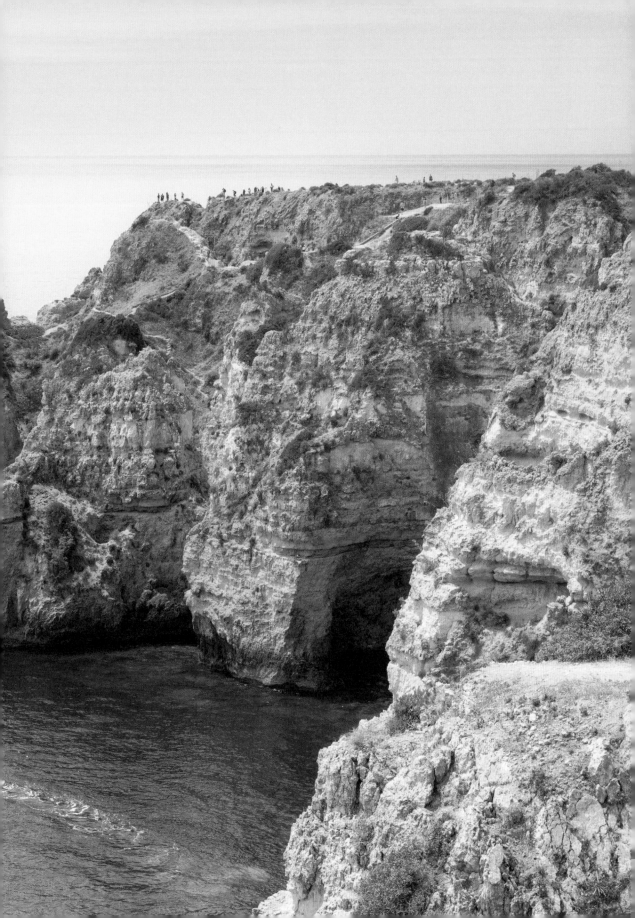

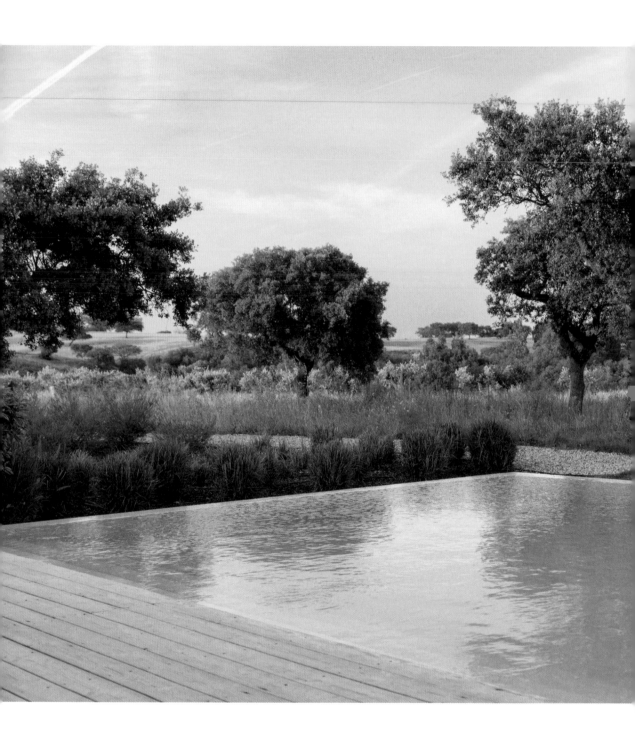

↑ ↗ From the bucolic solitude of Alentejo to the coastal beauty of the Algarve, it is no wonder that Southern Portugal continues to draw summertime crowds.

⟶ While driving along the winding, sometimes treacherous coast of São Miguel, vistas shift from verdant mountainous foothills to dense temperate forests to black sand coastal beaches.

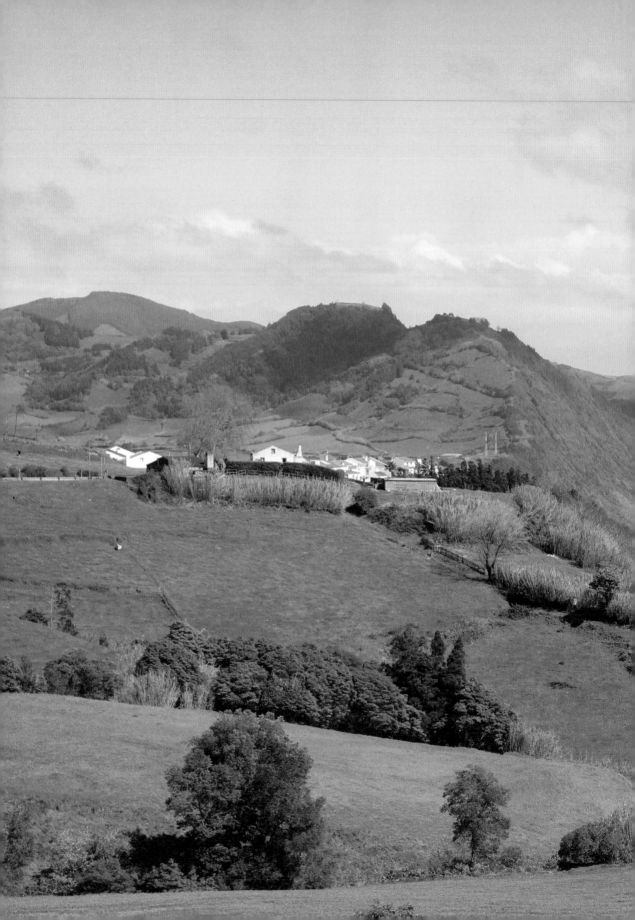

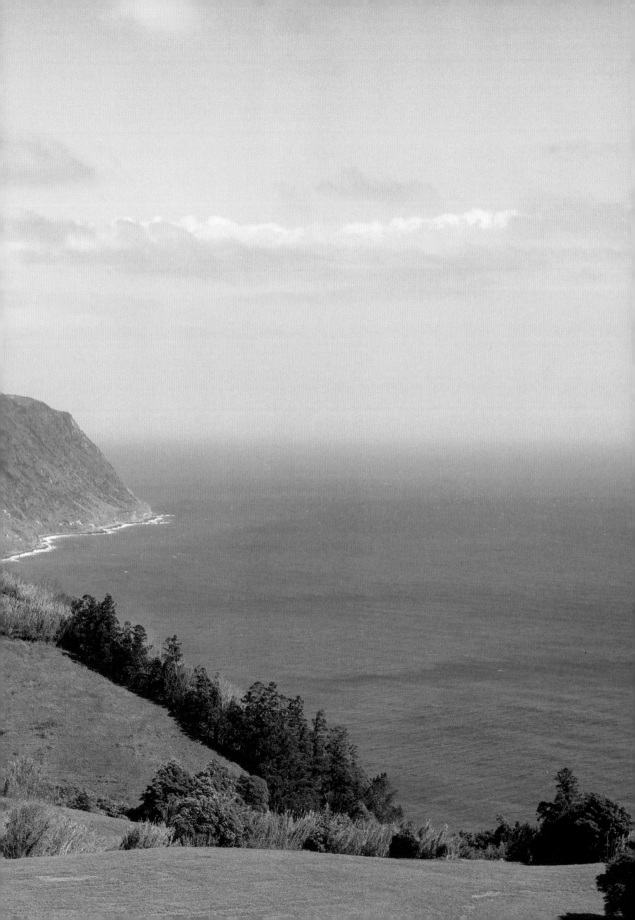

SUN BLEACHED

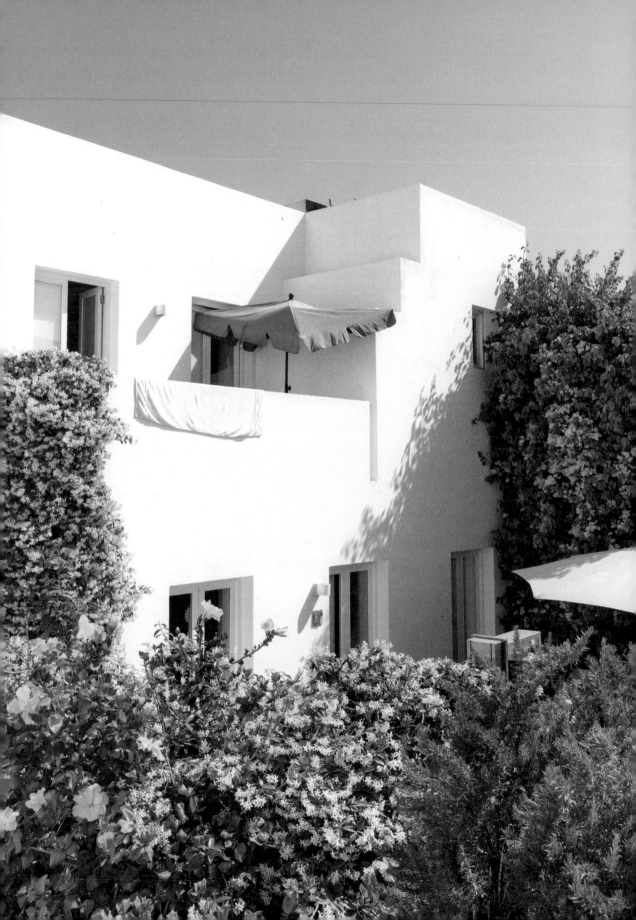

The southern coast of Portugal, with its mild climate and quaint, sun-drenched fishing villages, is home to some of Europe's most prized beaches and contains many of the country's oldest Moorish and Roman ruins. Soaring sandstone cliffs plunge dramatically into crystalline blue waters, and the entire region smells faintly of citrus groves and almond tree blossoms. Bougainvillea blooms in every corner, with fuchsia, cream, and gold bursts adorning homes, climbing wildly against their whitewashed walls. On summer evenings, the watercolor sunset slowly melts into the Atlantic as diners feast on seafood dishes at boisterous beachside cafés. Many of the Algarve's coastal towns and beaches—from Lagos to Faro—are packed during the high season. Slightly off the well-beaten path you'll find small villages, untouched wilderness, and expanses of white sand beaches.

When the Moors ruled what is now known as Portugal, they settled in the south, drawn to the warm weather and fertile land. Echoes of Moorish architecture are still visible in the white domed buildings with blue trim and intricate minaret-like chimneys. Impressive Moorish bastions, such as the imposing Castelo de Silves, reflect the region's tumultuous past. In fact, the coastal city of Albufeira was one of the last cities to fall to the Reconquista. In towns such as Olhão and Loulé, castles and fortress walls coexist with modern cafés and homes, creating a feeling of living history as you stroll the streets.

Dating back even further, to between the first and fifth centuries, evidence of Roman occupation can be seen throughout the region in the ruins of baths, cisterns, villas, and temples. A particularly well-preserved example can be seen at Cerro da Vila Museum and Archaeological Site, the ruins of a maritime villa in the seaside town of Vilamoura. Stone foundations give an indication of the ancient villa's footprint, while intricate mosaics hint at its decorative richness and the wealth of the noble family who once called this place home. The archaeological site offers insight into what life was like on the coast two millennia ago—the public baths, fish processing facility, and mausoleum provide cultural context, while personal artifacts such as pottery,

← With clean lines and a whitewashed exterior, this home in the tiny coastal village of Cacela Velha sits atop a hill overlooking the Ria Formosa lagoon.

hand mirrors, hair clips, and jewelry speak to more intimate moments.

History is deeply woven into the fabric of modern life here in the Algarve. Early one morning I stopped for a strong espresso in Cacela Velha, which sits on the edge of Ria Formosa Natural Park. While strolling through the quiet hillside village, where the ruins of an eighteenth-century fortress encircle the Almohad neighborhood of whitewashed houses trimmed in blue, I meandered out farther past the walls and down to the beach. At low tide the shore gives way to shallow, warm lagoons. In the hush of dawn, I watched from the sandy banks as the rising sun illuminated the towering buttresses surrounding the city, and I was briefly transported to a distant time, an experience that perfectly encapsulates the quieter side of the Algarve.

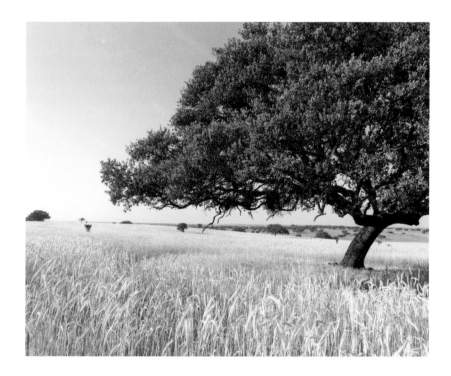

↑ The golden plains of the Alentejo region

→ Early-morning light warms the whitewashed building and cobblestone streets of Tavira.

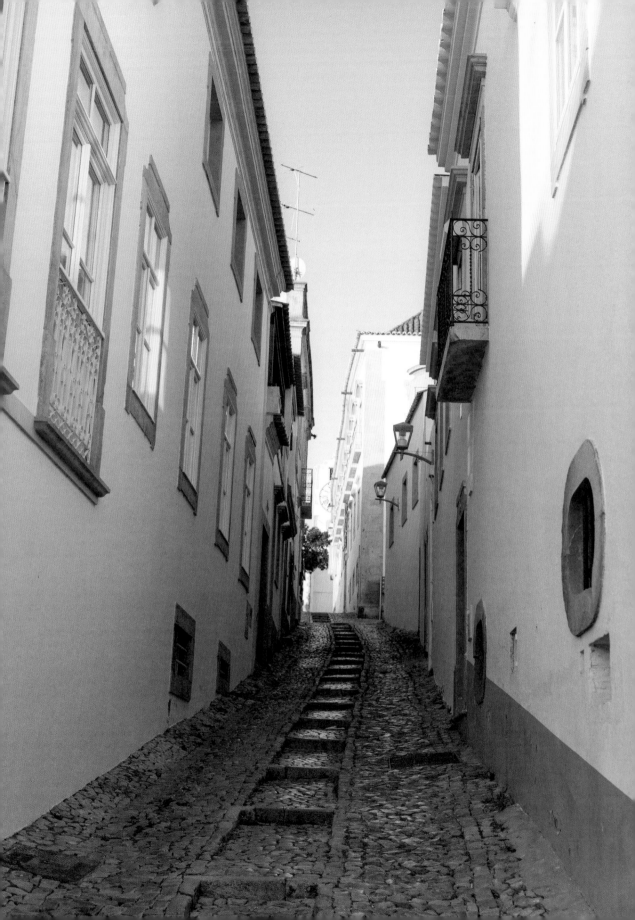

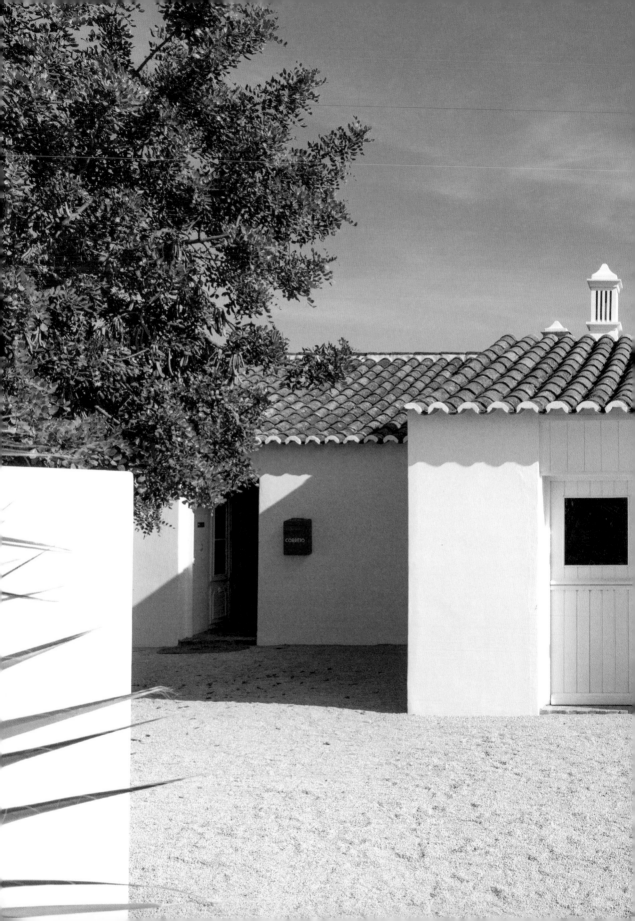

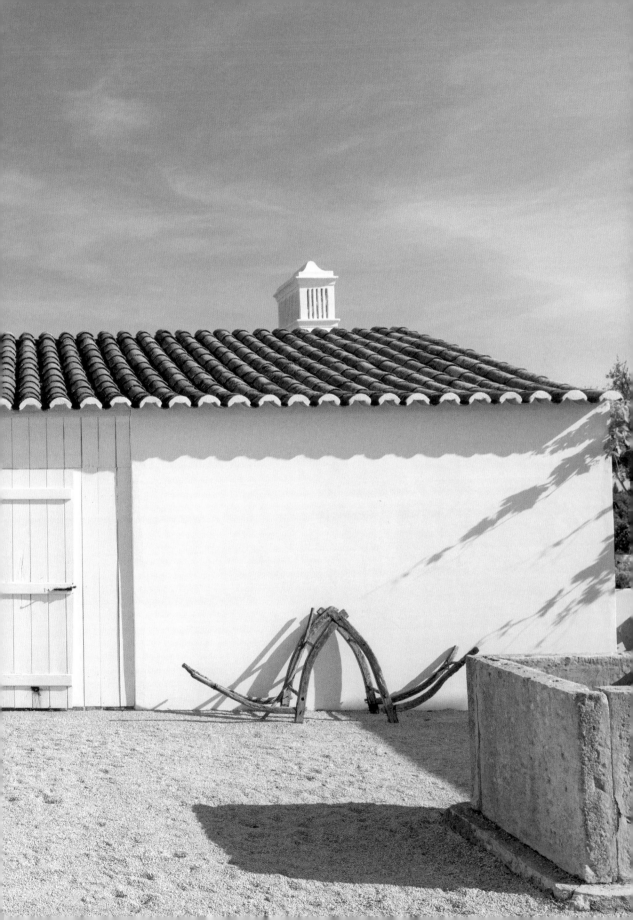

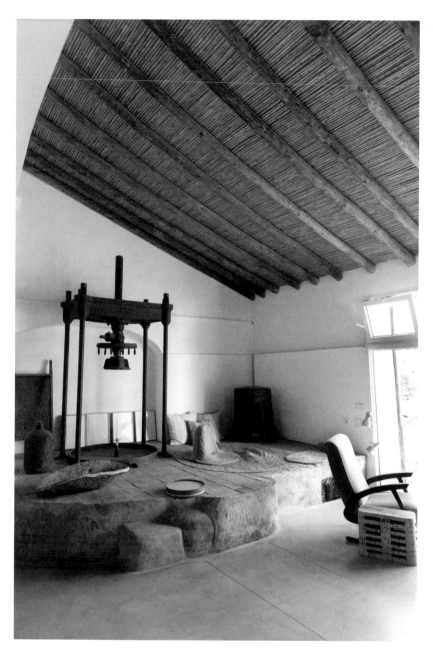

← Pensão Agrícola is a rural hotel in the bucolic eastern Algarve that is housed in a beautifully renovated 1920s farmhouse.

p. 88, 90–91 The interior of Companhia das Culturas, an eco-boutique hotel and spa in Castro Marim, highlights local and sustainable materials such as lime, cork, and reed for the thatched ceiling.

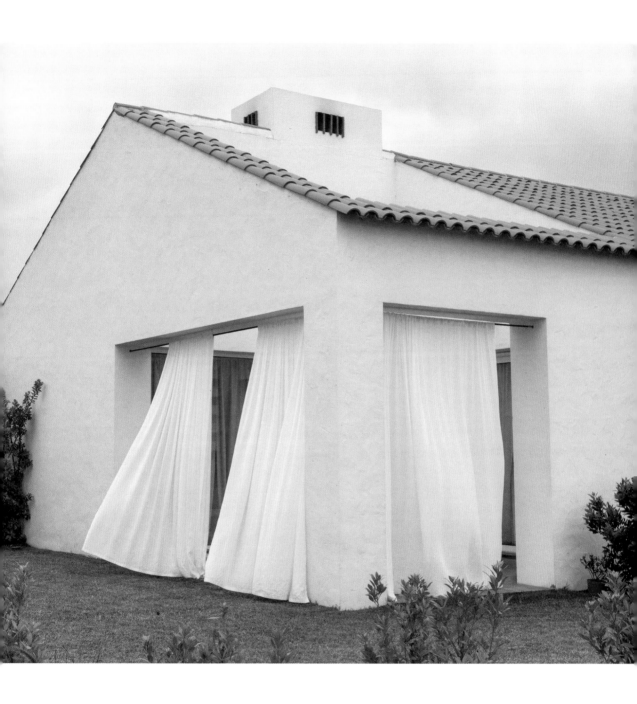

↑ The restoration of Herdade da Malhadinha Nova, a sprawling
quinta in the Alentejo region, included the use of heritage
techniques such as *casas caiadas*—an artisanal whitewashing
process that utilizes dissolved limestone.

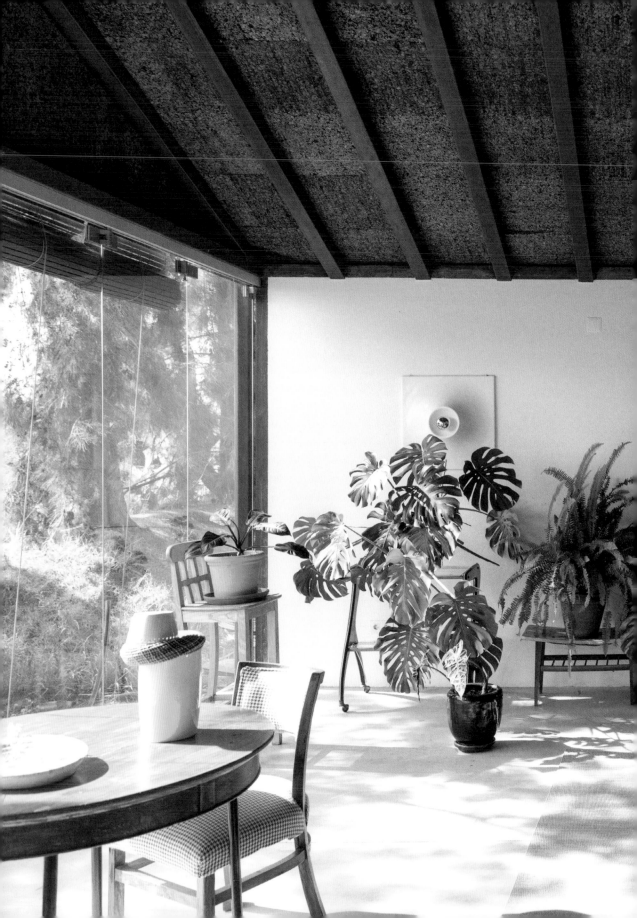

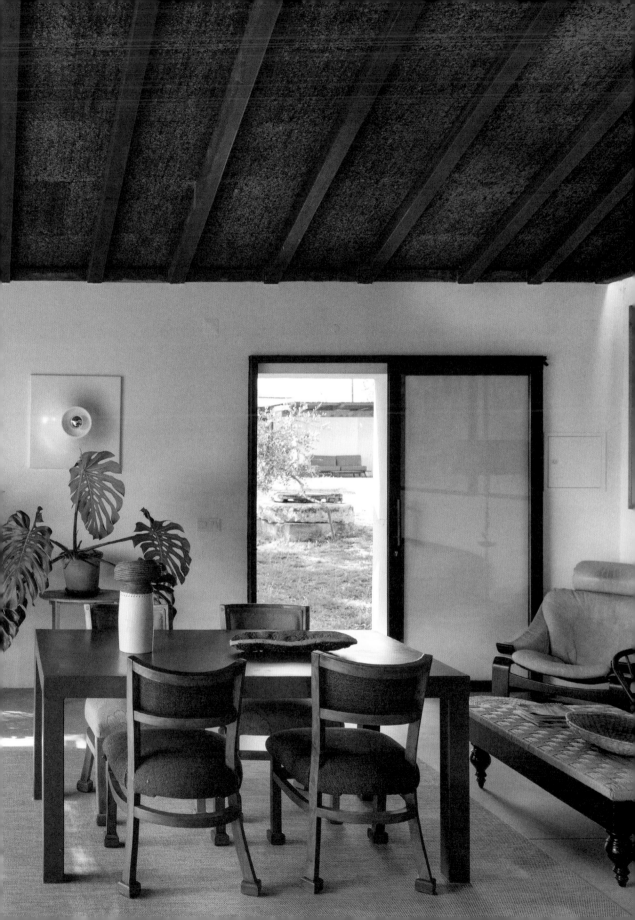

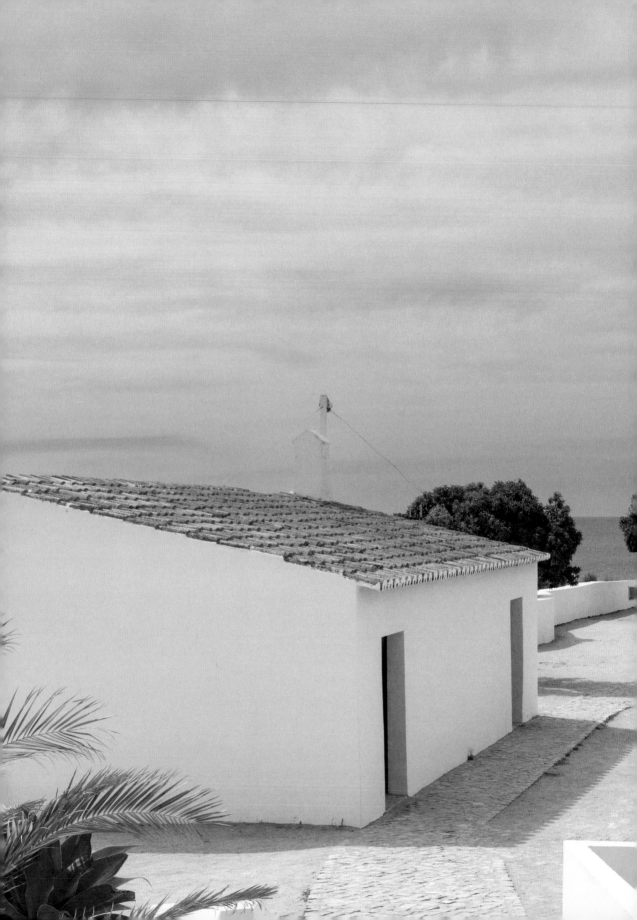

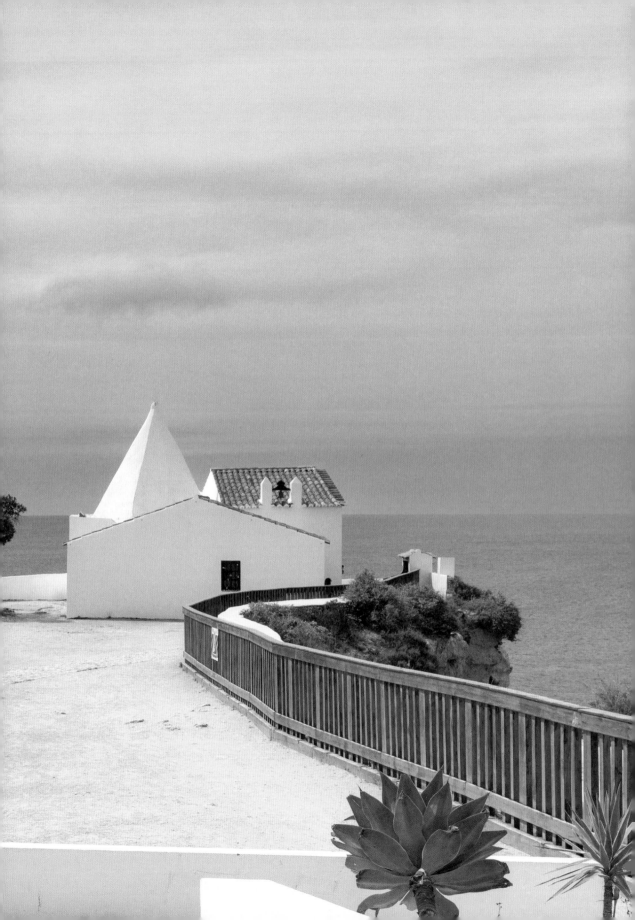

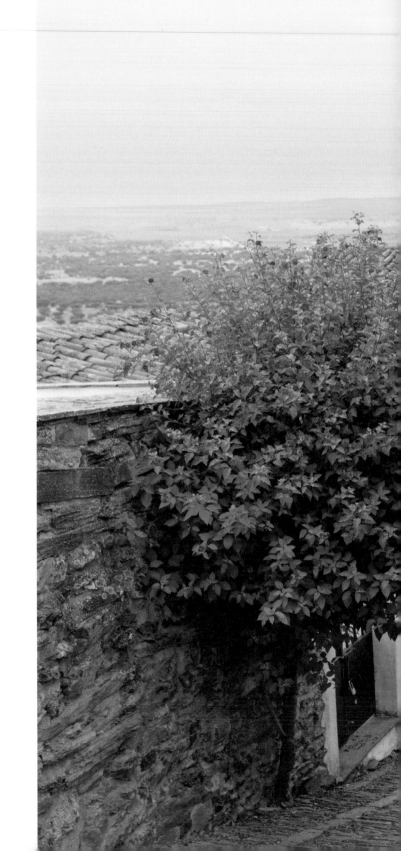

← From its location overlooking the
Atlantic, the Fort of Nossa Senhora da
Rocha helped to secure the Lagoa coast.
Inside the fort, which was most likely built in
the eighth century, sits the Chapel of Nossa
Senhora da Rocha.

→ Neolithic remains indicate that the tiny
walled village of Monsaraz dates back to
prehistoric times. Stunning views of the
surrounding Alentejo landscape abound
thanks to the village's hilltop location.

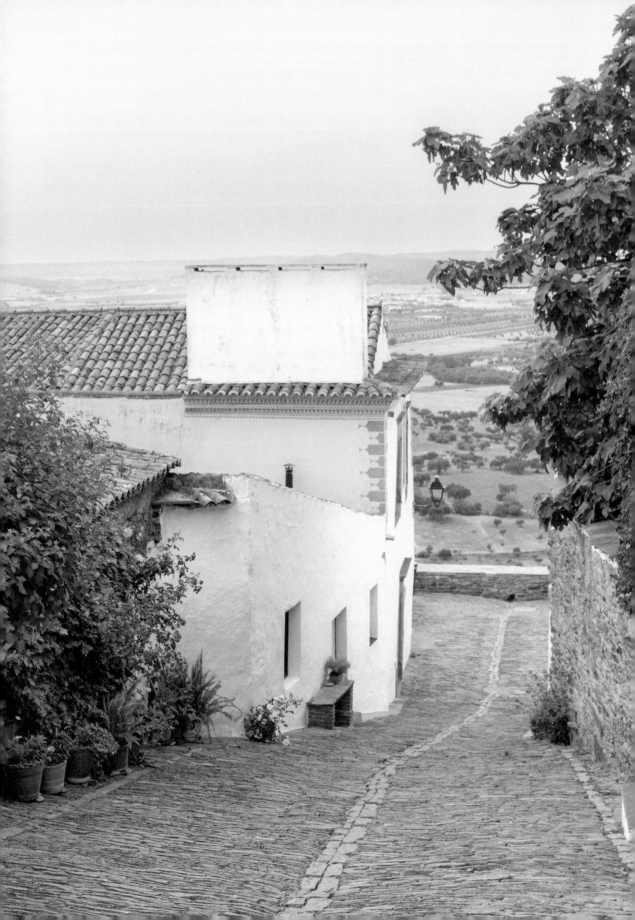

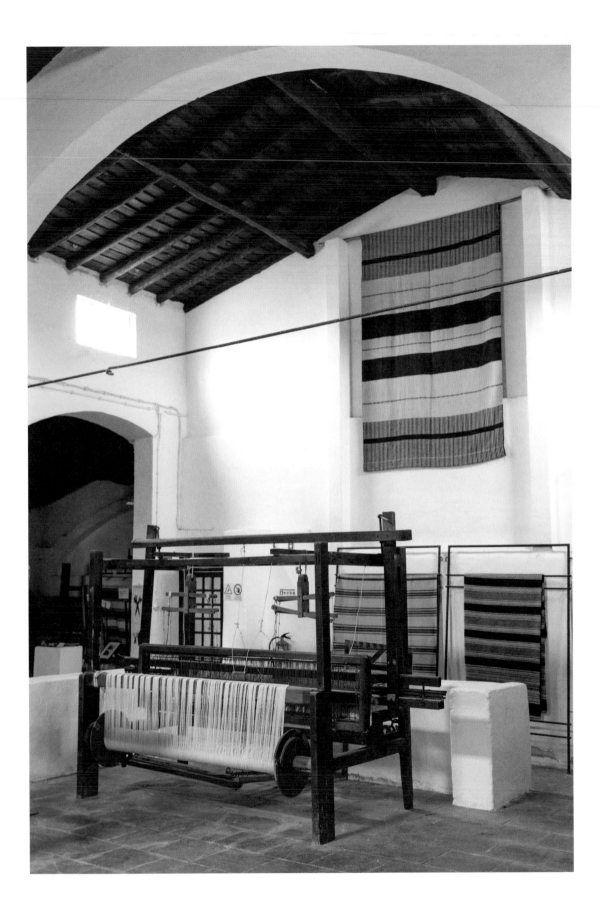

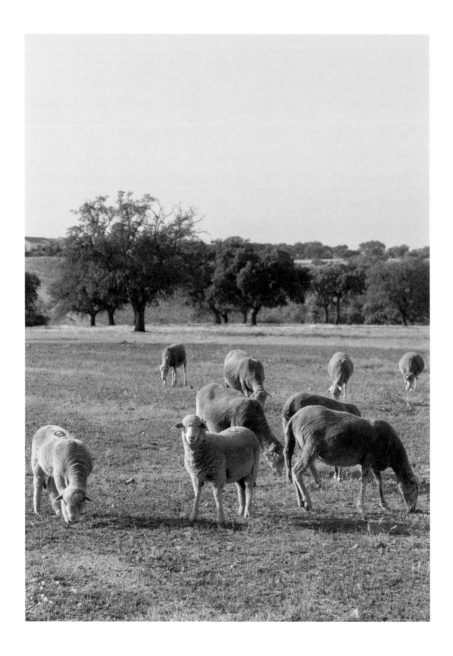

←↑ For centuries, flocks of Merino sheep—a breed celebrated for the quality of its wool—have roamed the fields of Alentejo. Fábrica Alentejana de Lanifícios preserves the area's traditional wool craftsmanship by using Portuguese wool, traditional weaving patterns, and old semimanual looms to make reguengos blankets, which were once used to keep shepherds warm as they tended their flock.

⟶ Pure Blood Lusitano horses at Herdade da Malhadinha Nova

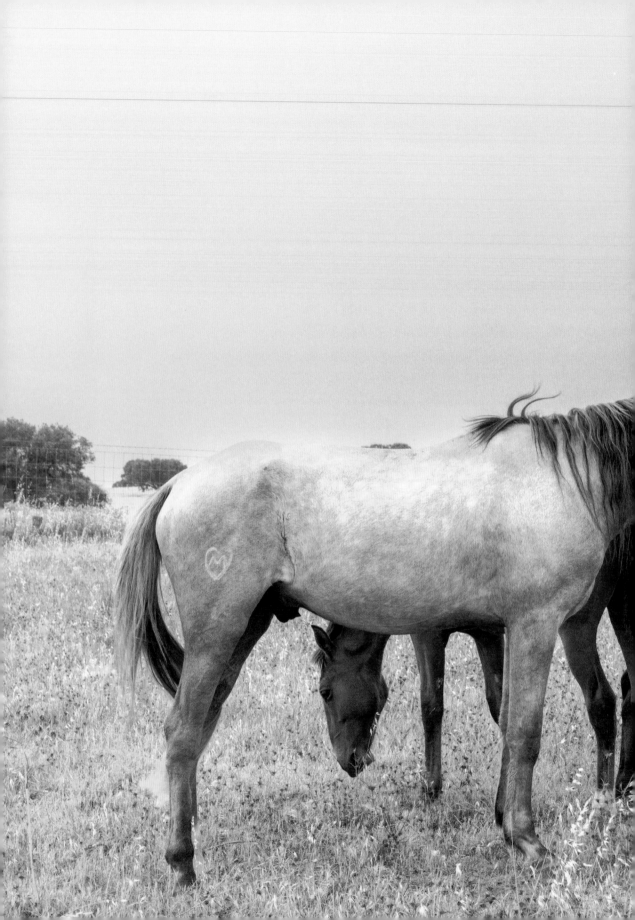

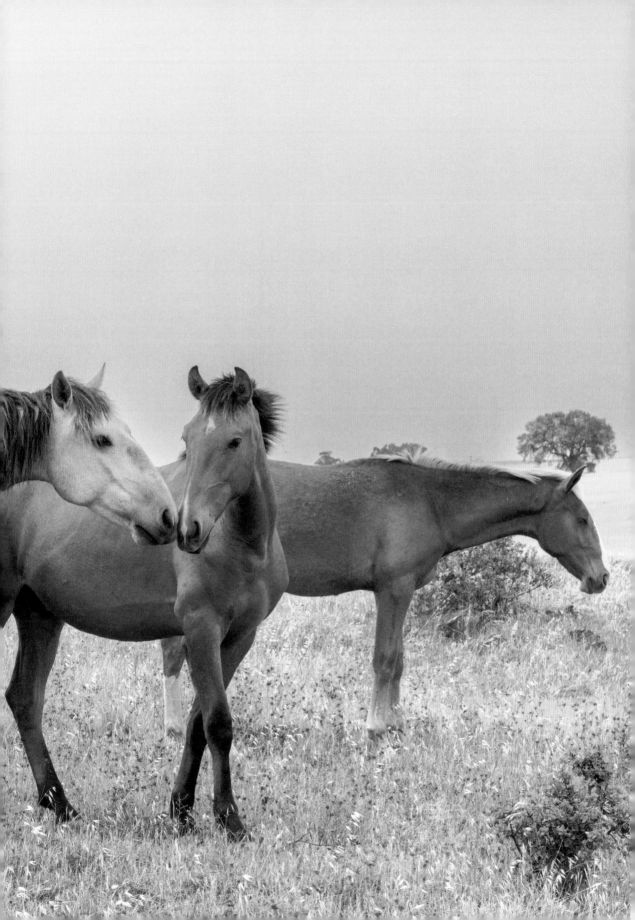

↑ A home in the Algarve region boasts touches of Art Nouveau,
which flourished in Portugal in the early 1900s.

→ The practice of whitewashing homes dates back to Moorish times
and is particularly prevalent in the southern region of Portugal, which
reaches warmer temperatures. White walls reflect more sunlight than
darker ones, which helps lower the internal temperature of the home.

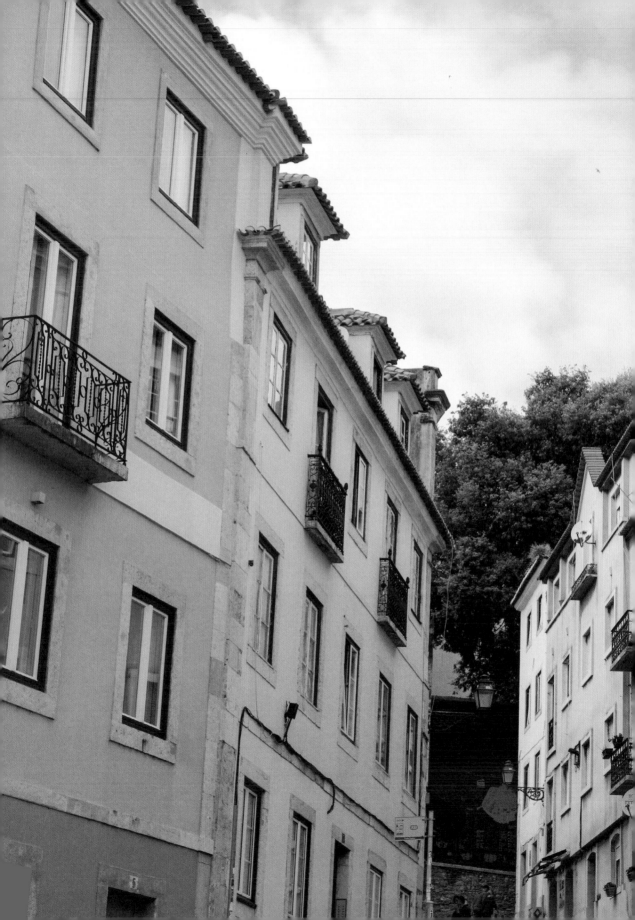

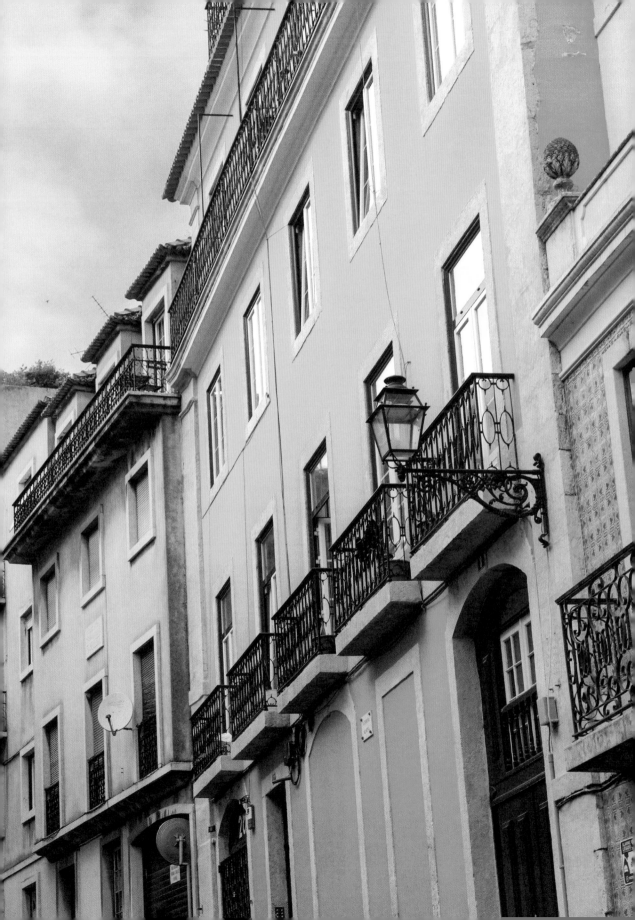

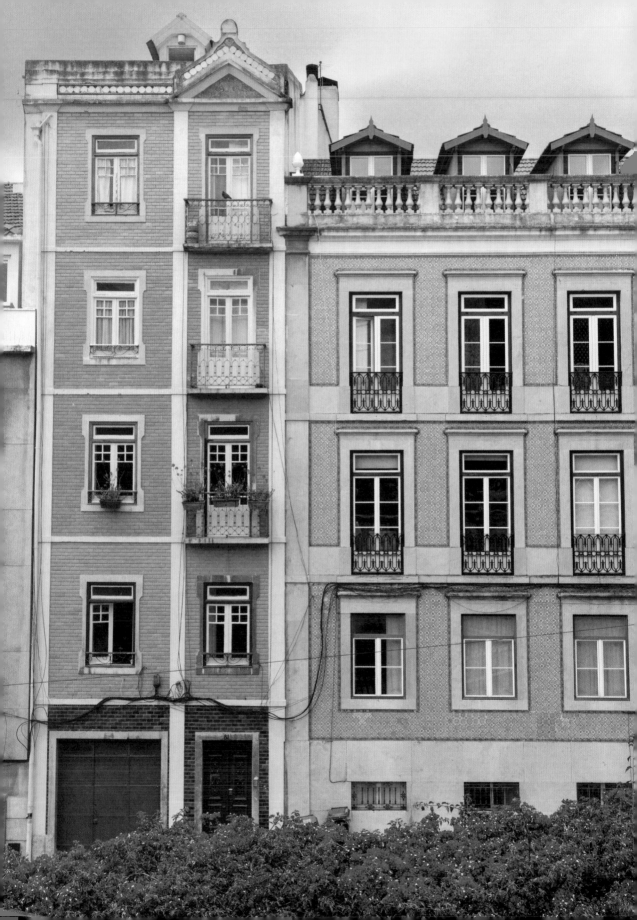

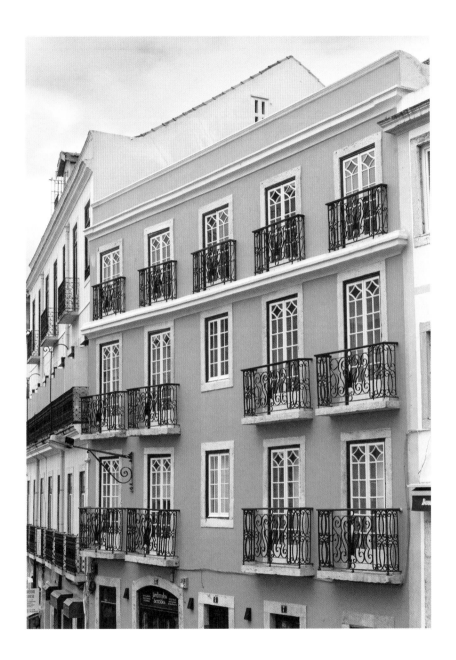

← ↑ Beautiful homes line the streets of Lisbon's upscale
Principe Real neighborhood.

⟶ Évora, a UNESCO World Heritage Site, has been shaped by more than twenty
centuries of history and contains Roman ruins, a twelfth-century cathedral, and the
small but macabre Chapel of Bones. Its historic center is also filled
with cafés where people gather between visiting the city's numerous sites.

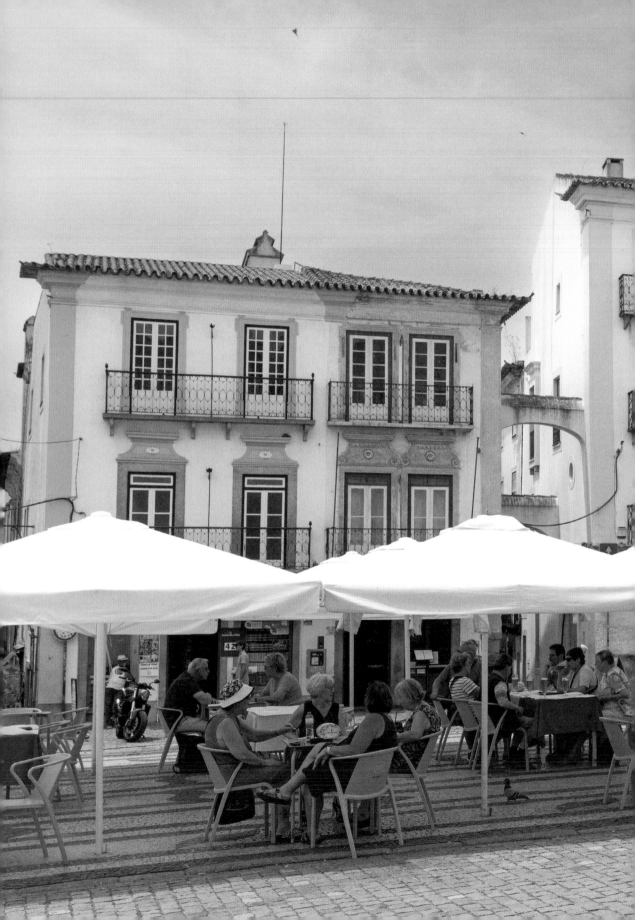

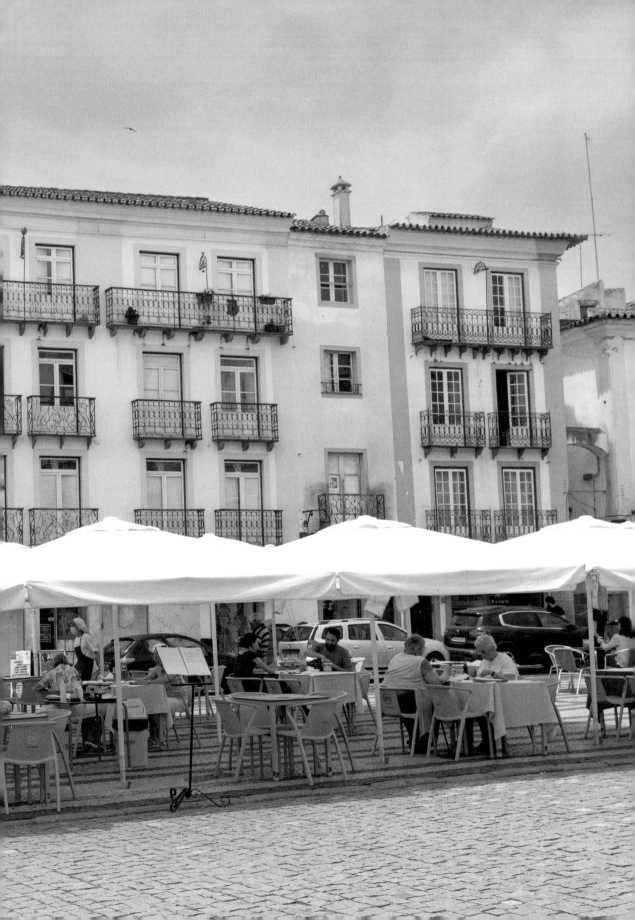

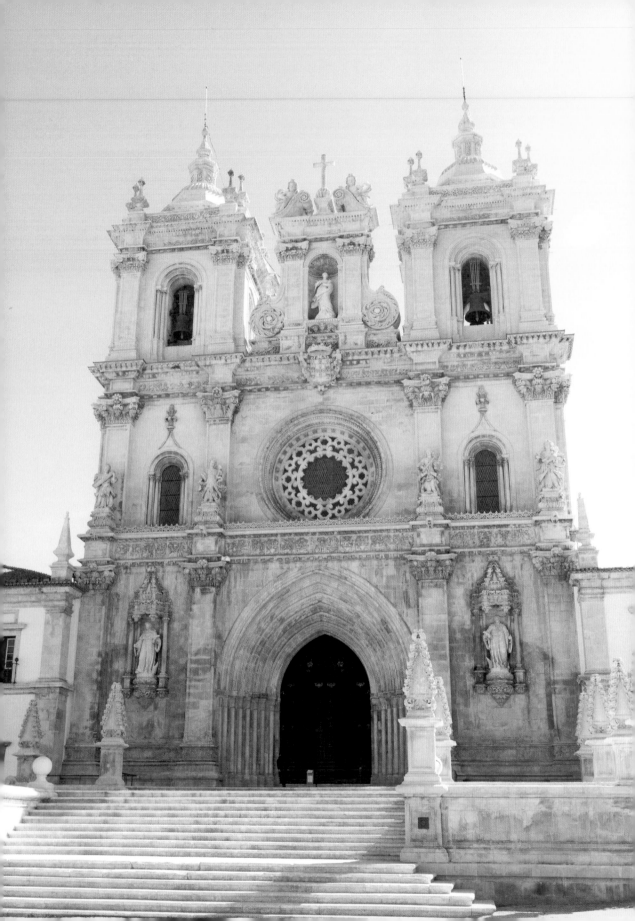

THE ROLE OF THE CHURCH

SINCE THE RULE OF THE Roman Empire, Catholicism has been the dominant religion in Portugal. Despite a minor interruption during Moorish rule, more than 80 percent of the Portuguese population identifies as Catholic today. Portugal is the birthplace of Pope John XXI and home to the Miracle of Fátima, a sacred Catholic pilgrimage site. The northern city of Braga, one of the oldest Christian cities in the world, contains the Sé de Braga, a cathedral that is older than the country itself. The Church's influence runs deep, and it has played a significant role in shaping the history, culture, and moral fabric of the country. Its influence has swayed popular architecture, surface design, and fine arts, as well as the very layout of most villages and towns, which have ornate and elaborate churches and monasteries at their center.

The physicality of churches often reflects the economic fortunes of the times, ranging from somewhat austere examples, such as Igreja Matriz de Santa Maria in Lagos, to Lisbon's Igreja de São Roque, whose deceptively plain facade gives way to a lavish interior dripping with gold and art in the Rococo style. Throughout the country, from Bom Jesus do Monte, the Baroque hillside masterpiece in Braga, to Batalha Monastery, a breathtaking example of Gothic architecture, the ebb and flow of wealth, as well as the influences of Portuguese rulers and colonies, can be traced through church design. In particular, the eighteenth century was a time of extraordinary ostentation as gold poured in from Brazil. Competition was fierce between the Church, the Crown, and nobility as they competed to build extravagantly gilded chapels in a quest for heavenly rewards.

In one of the country's darkest periods, the Inquisition, a campaign of Church-sanctioned terror against so-called heretics, began in 1536 and lasted for more than two hundred years. A separation of church and state was declared under the rule of the Marquês de Pombal, and Portugal enjoyed religious freedom until António de Oliveira Salazar took power in 1932 and once again centered Catholicism.

After the Revolution of the Carnations in 1974, religious freedom was reiterated through the new Constitution and there was a true separation of church and state. While attendance at Mass is on the decline and the Church's sway has faded, there is still a church at the heart of nearly every town square, and the Christ statue that towers over Lisbon—*Cristo Rei*—still dominates the city's skyline and speaks to the Church's enduring influence.

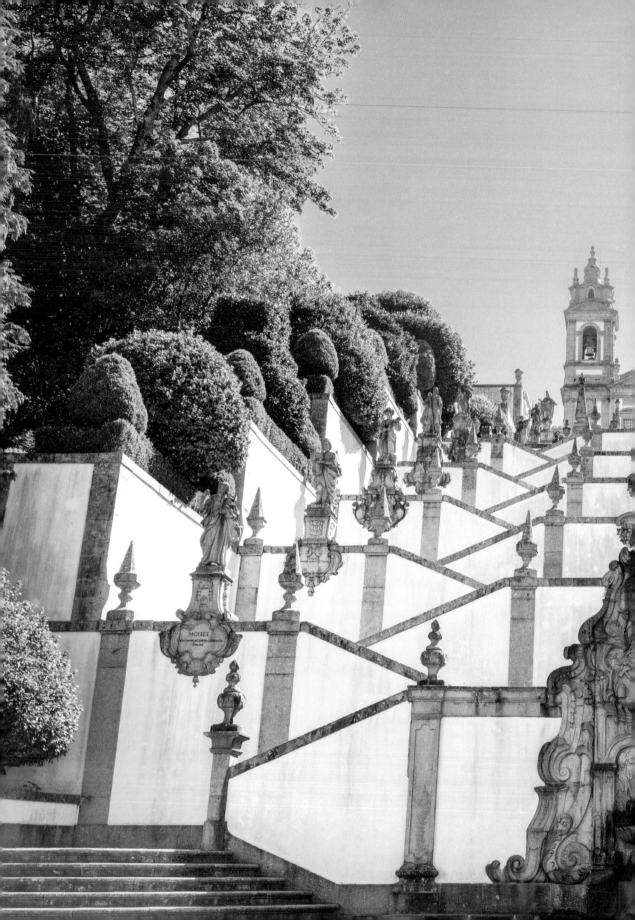

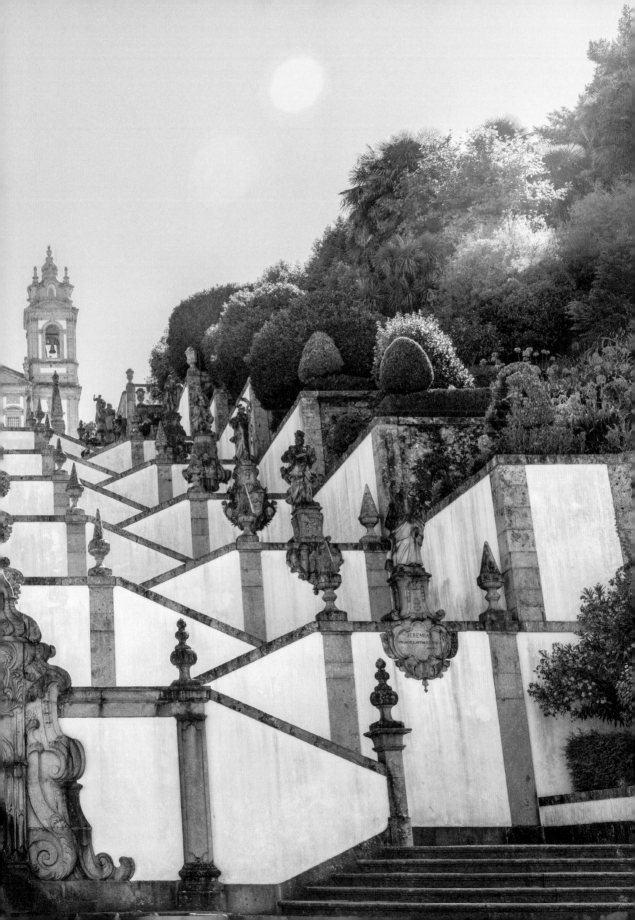

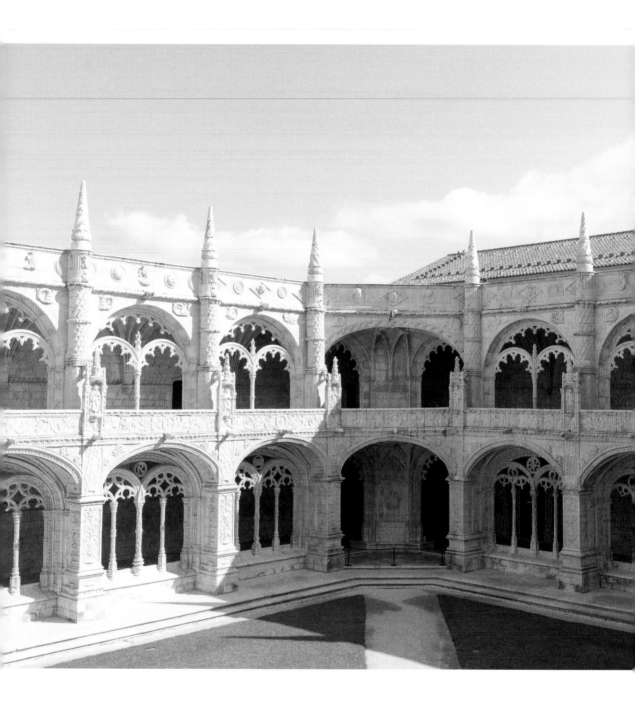

← The Sanctuary of Bom Jesus do Monte, located in the
historic city of Braga, is a striking neoclassical church that sits
atop a seventeen-flight stairway.

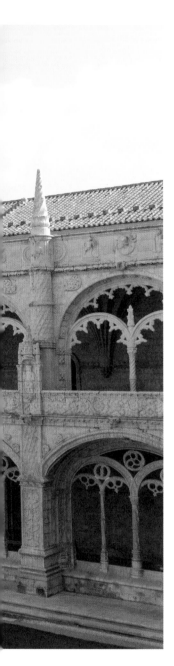

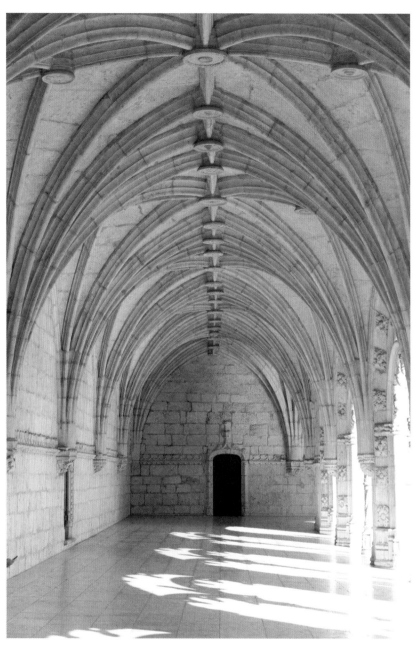

↖ ↑ Built in the sixteenth century, the Jerónimos Monastery is a stunning example of the Portuguese late Gothic style of architecture, known as the Manueline style. The two-story cloisters with vaulted ceilings and archways feature nautical elements that keep in line with the Manueline style, in addition to European, Moorish, and Eastern motifs.

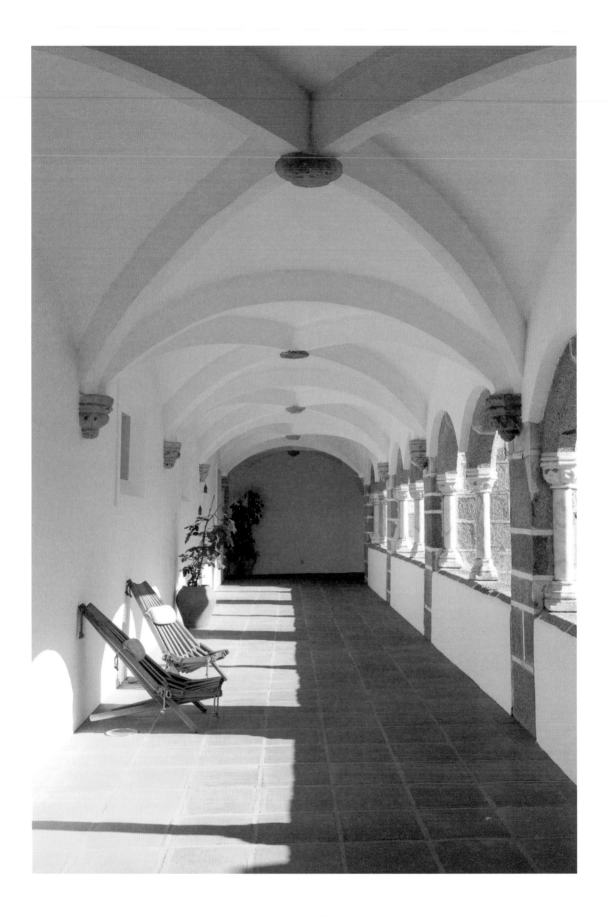

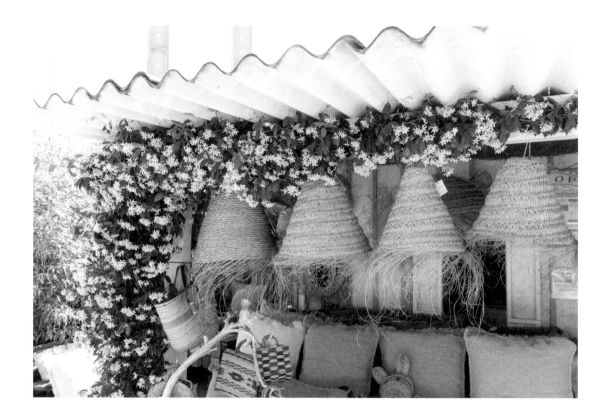

← Convento do Espinheiro, which was once inhabited by monks from the Order of Saint Jerome, is one of the earliest examples of Renaissance architecture in the city of Évora. It now serves as a luxury hotel.

↑ Jasmine blooms at a tiny outdoor storefront in Carvalhal, a coastal village near the popular tourist town of Comporta.

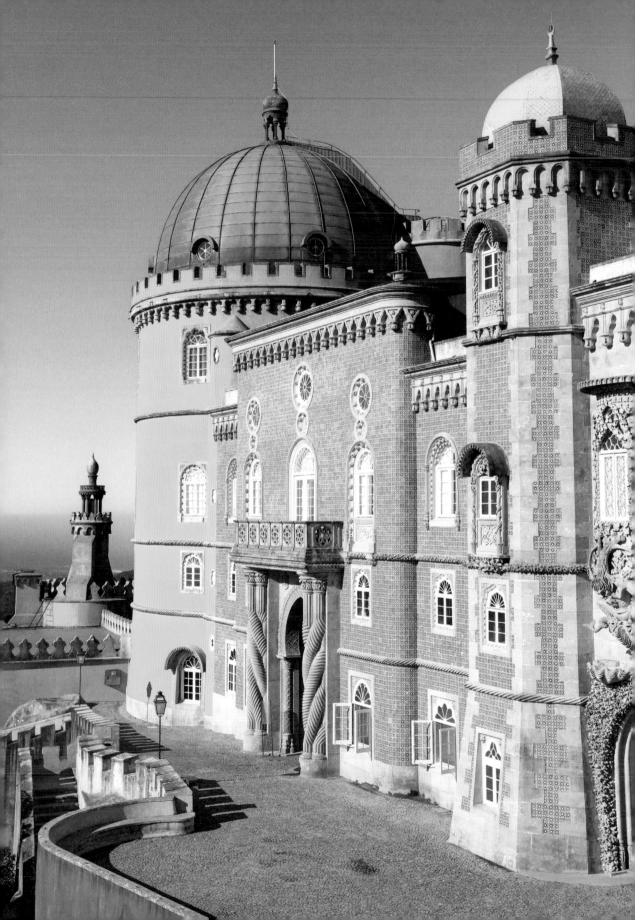

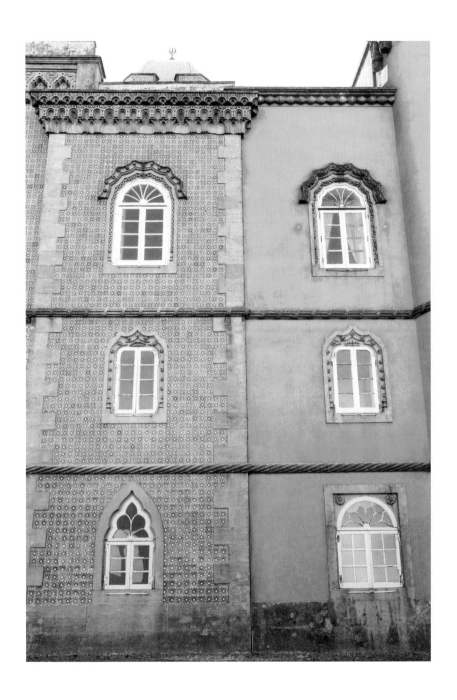

←↑ Palácio da Pena in Sintra, which was built in the Romanticism style,
is the legacy of King Ferdinand II. With Gothic towers, Moorish minarets,
Manueline carvings, an azulejo-covered exterior, and Renaissance domes,
the castle is an eclectic mix of architectural styles.

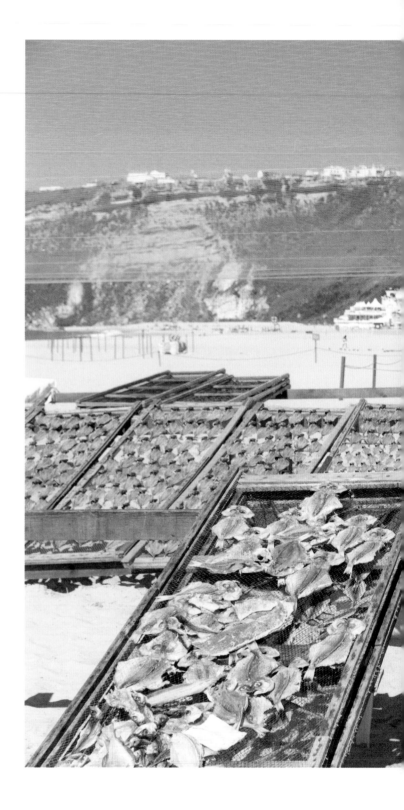

→ The Dry Fish Museum of Nazaré, located in one of the oldest fishing villages in Portugal, is a living museum dedicated to the tradition of sun-drying fish. This technique was used to preserve excess fish, which was especially important in times of scarcity.

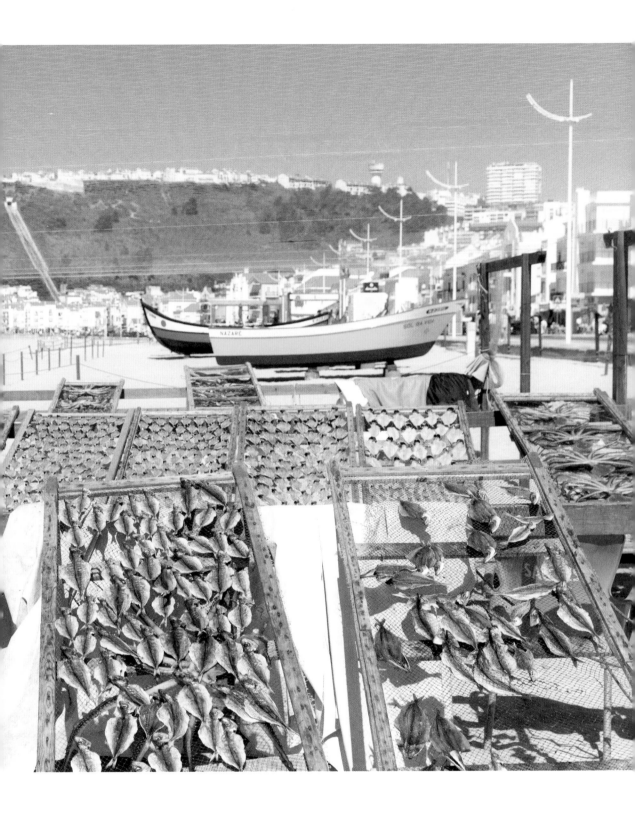

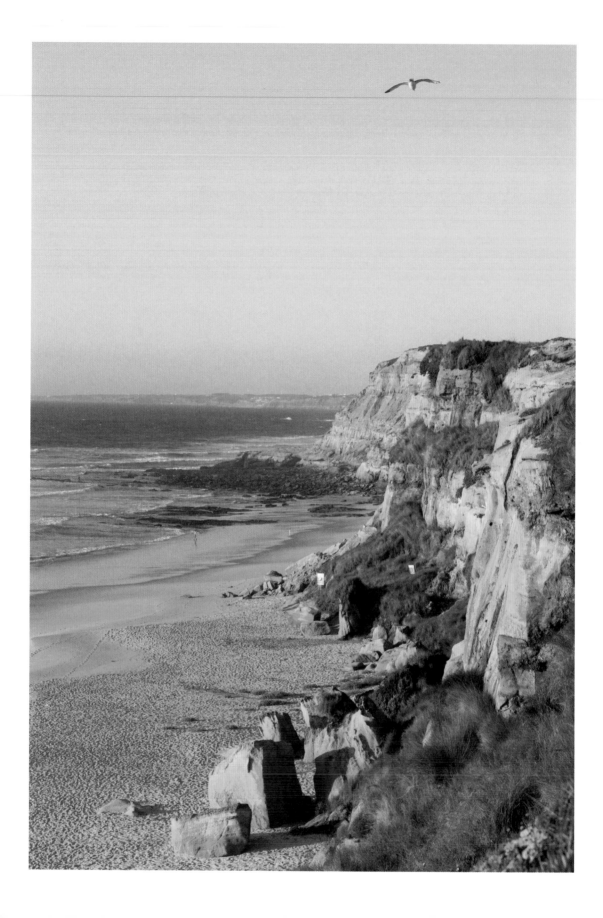

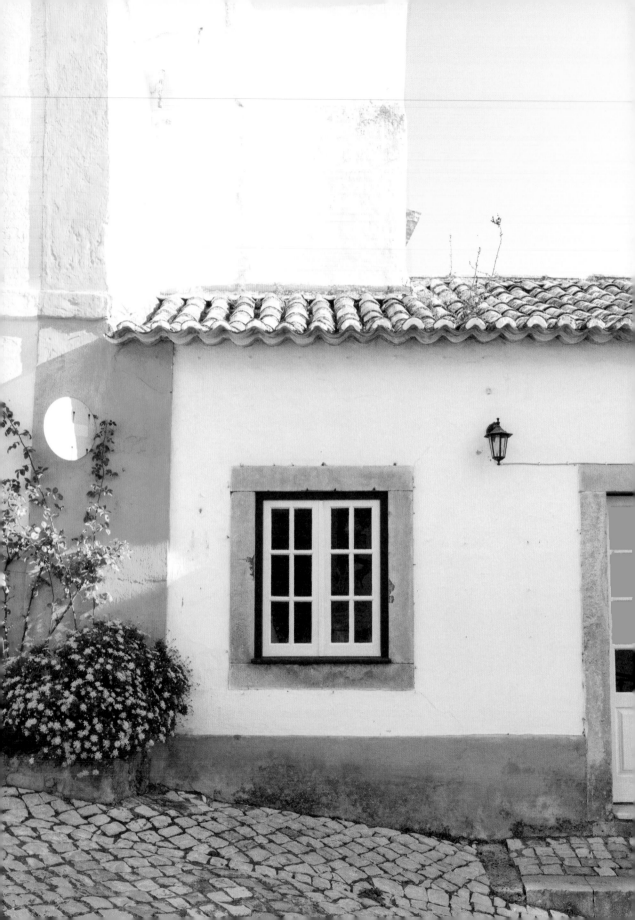

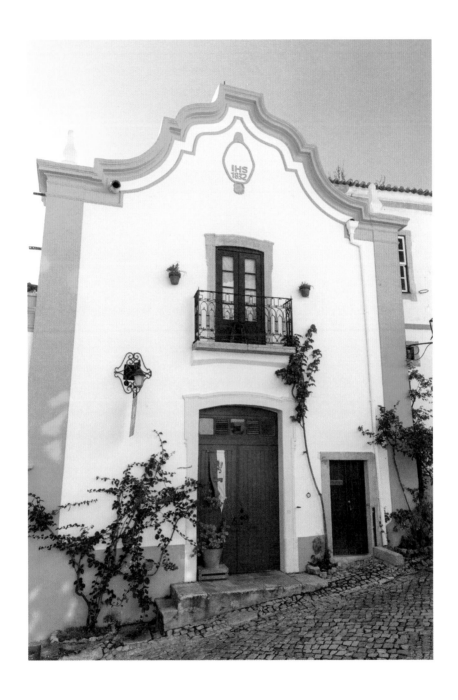

p. 120 Nazaré, a beach town on Portugal's Costa de Prata (Silver Coast), is home to the biggest surfable waves on the planet.

→ The Santa Marta Lighthouse, which is still in operation, is located within the Santa Marta Fort on the coast of Cascais. The restored fort now serves as a lighthouse museum.

p. 126 Located on the coast of Belém, the Padrão dos Descobrimentos (Monument to the Discoveries) was designed to commemorate the Portuguese Age of Discovery. Prince Henry the Navigator leads the ship with thirty-three figures behind him, including Vasco da Gama, King Afonso V, Saint Francis Xavier, and others.

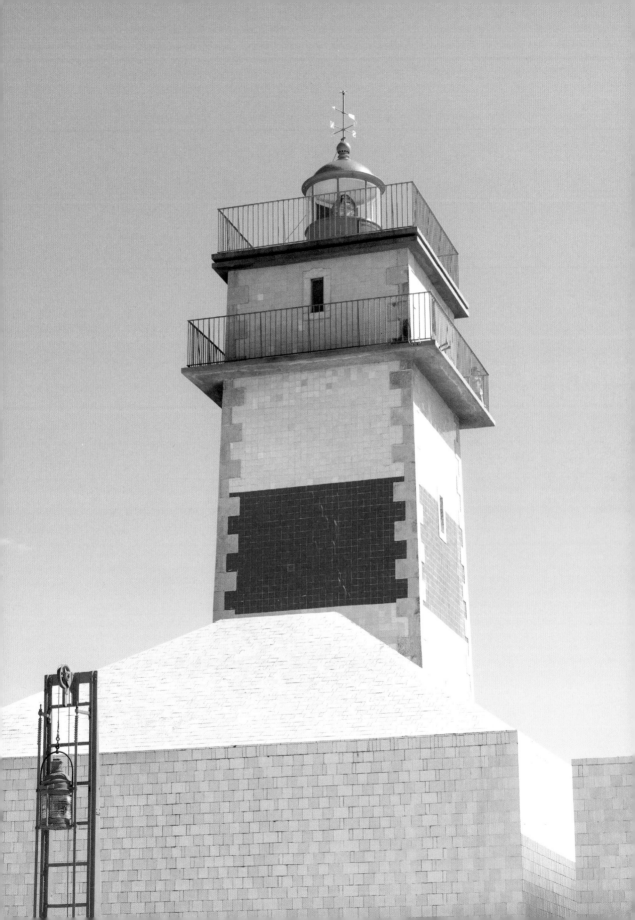

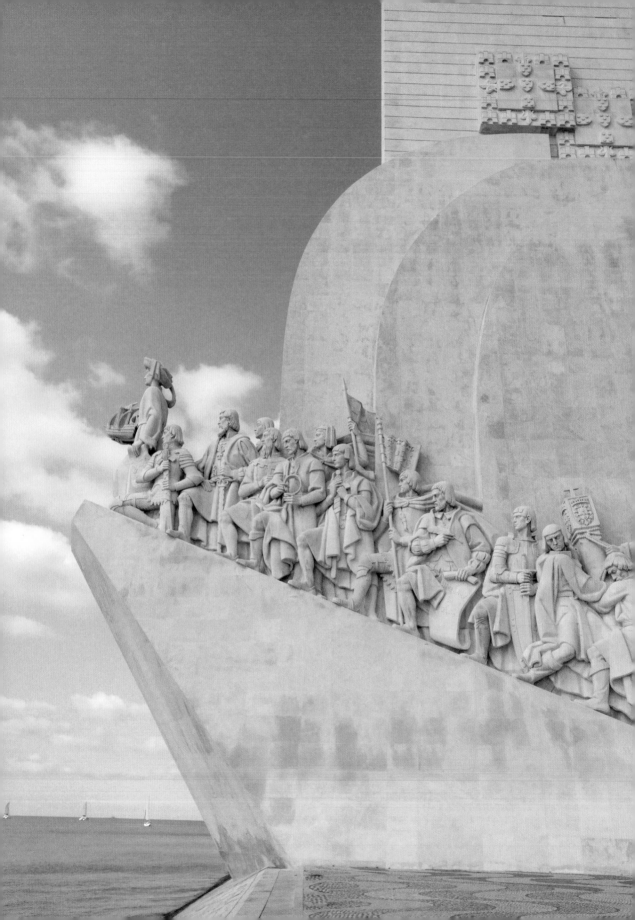

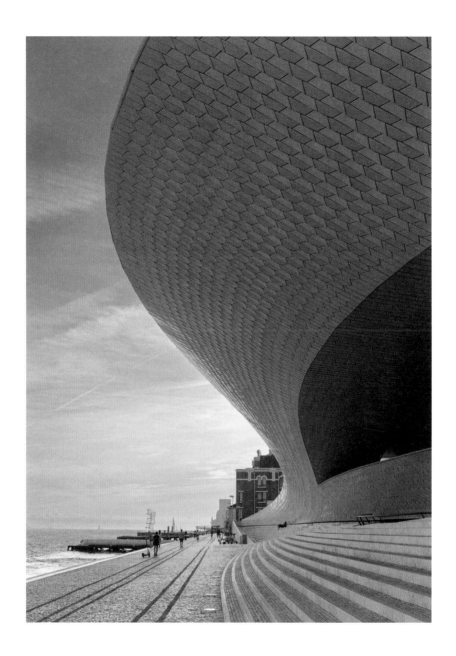

↑ The Museum of Art, Architecture and Technology, designed by architect Amanda Levete, is a stunningly modern building that sits on the Tagus River.

⟶ Praça do Comércio, one of the largest plazas in all of Portugal and home to the Rua Augusta Arch, dominates the Baixa waterfront and is an example of the Pombaline style, which emerged after the great earthquake of 1755.

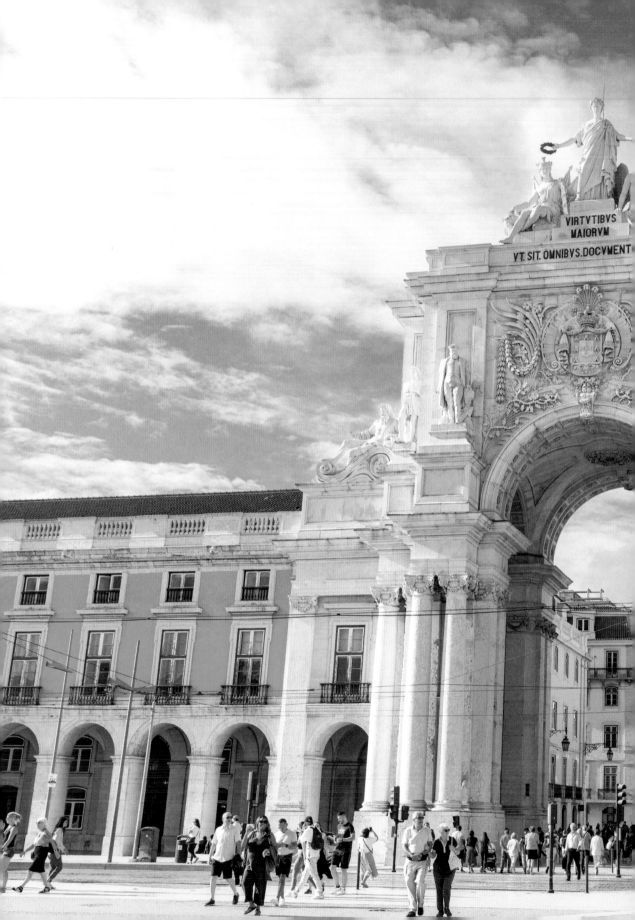

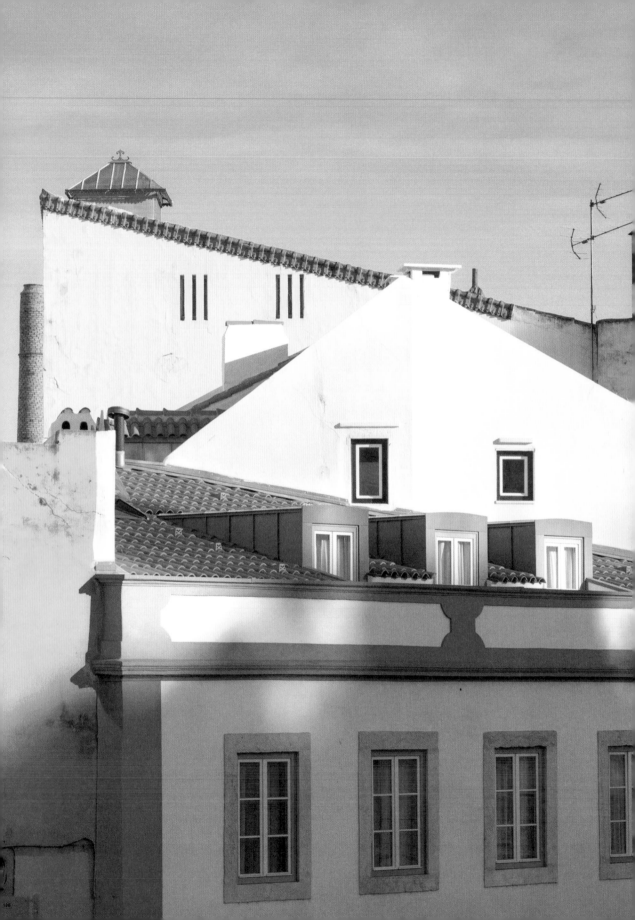

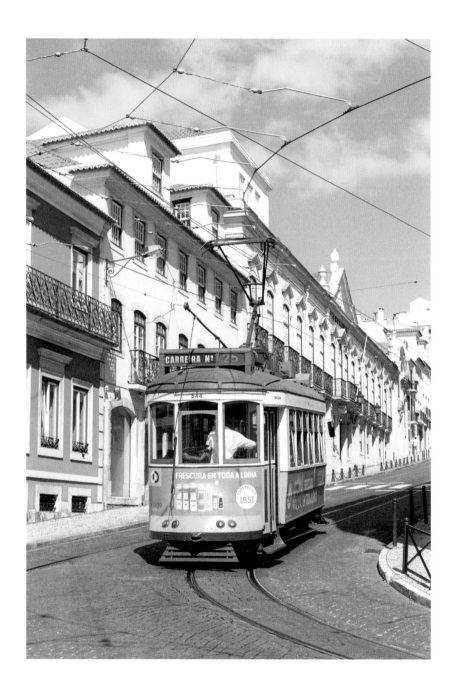

←↑ The cheerful yellow of Lisbon's famous tram is
echoed in the cityscape.

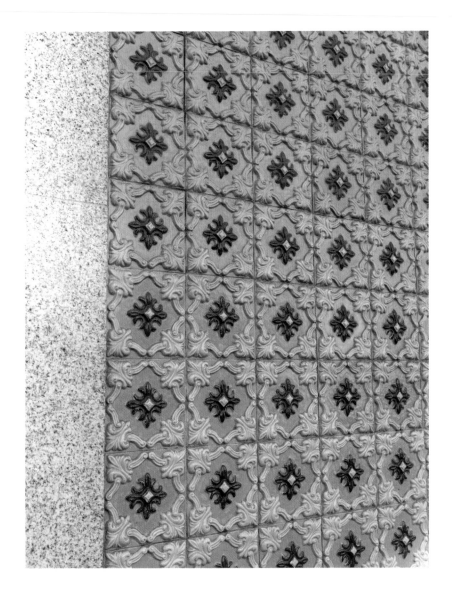

↑ These Art Nouveau tiles are a striking example of high-relief tilework, notable by their raised design and sunken background. This technique dates back to the late tenth century, when relief tiles were made by pressing stamps into clay before firing.

→ After the great earthquake of 1755, the rebuilding of Lisbon meant azulejos began to be mass produced and combined industrial and artisan techniques. From the nineteenth century on, azulejos acquired greater visibility as they were applied generously to facades.

p. 134–35 The slow-flowing Gilão River flows through the small town of Tavira and reaches the sea through the lagoons of Ria Formosa Natural Park.

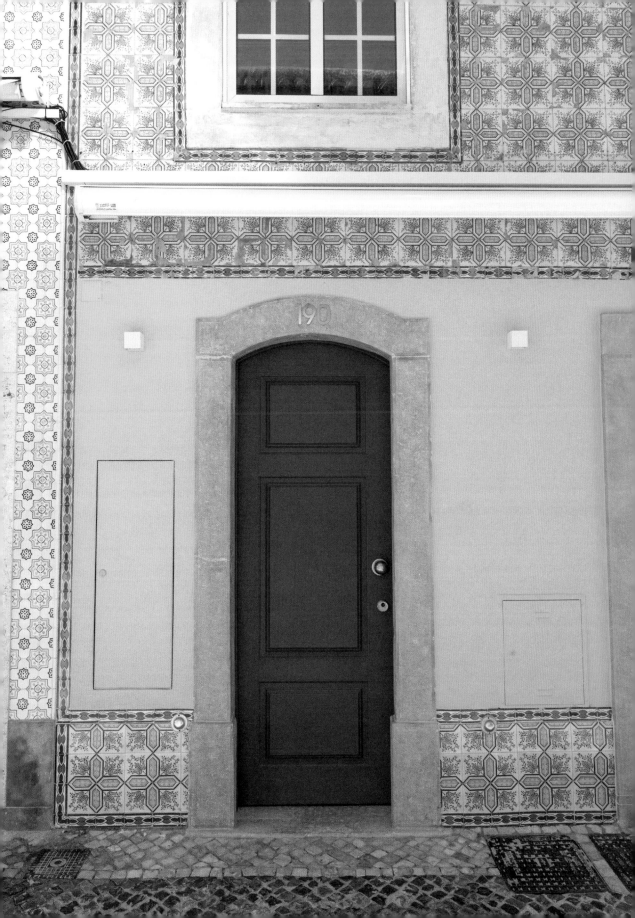

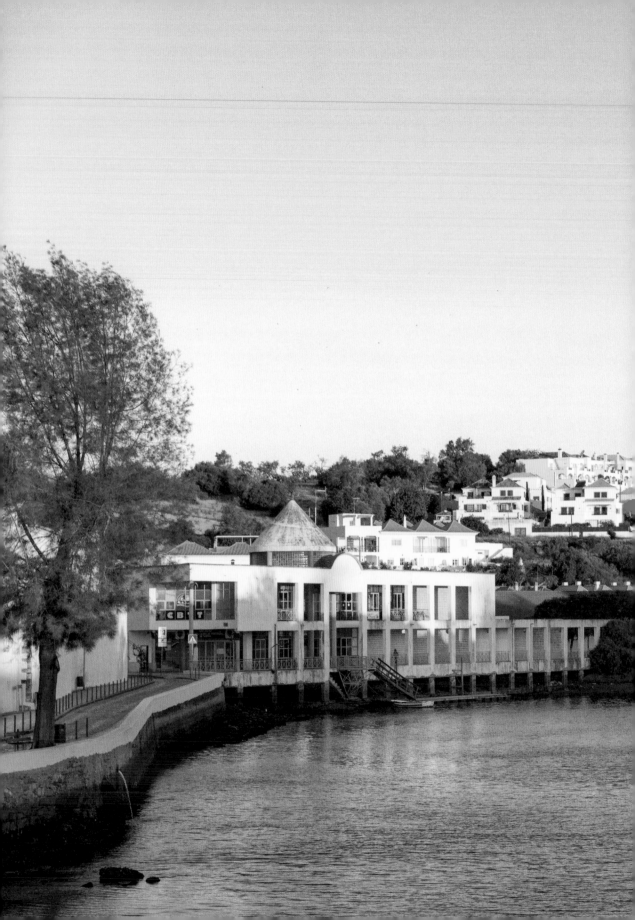

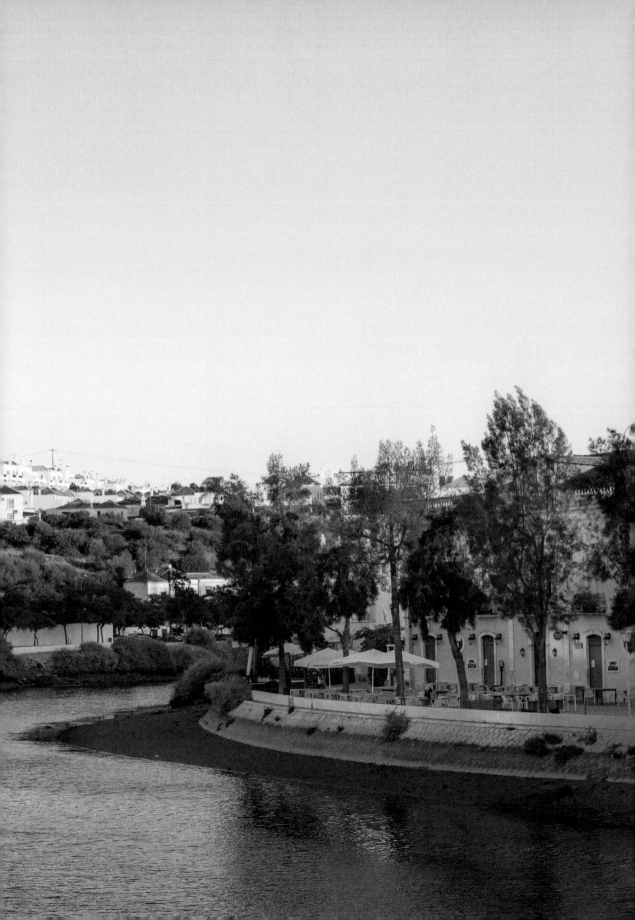

BOUGAINVILLEA

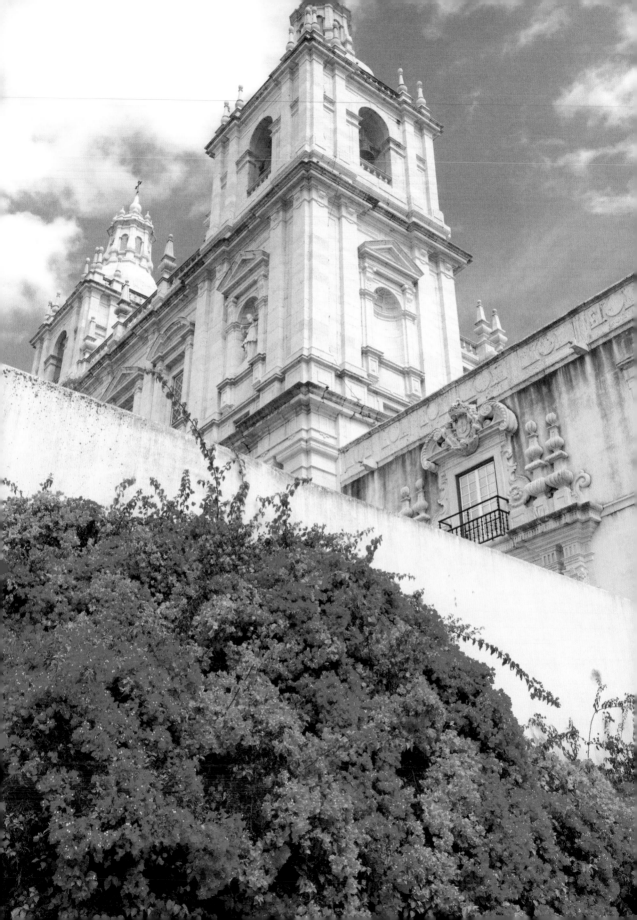

The Azores (or Açores) are an archipelago of nine volcanic islands located about 900 miles off the coast of Portugal that rise from the Atlantic like enchanted secret gardens. Verdant agricultural land sweeps down to meet the sea, bubbling hot springs send steaming plumes skyward, dense temperate forests abut scraggly basalt mountains, and cerulean crater lakes lie hidden around the island's interiors. Claimed by Portuguese navigators in the fifteenth century, this autonomous region has its own government. Despite being influenced by Portuguese culture, the Azorean people have their own unique culture forged from their geographical isolation. Azoreans speak Portuguese with a local accent, and their food is also Portuguese but with local variations.

It's quite simple to ferry among the five central islands (Faial, Graciosa, Pico, São Jorge, and Terceira) and between the western (Flores and Corvo) and eastern islands (São Miguel and Santa Maria), but a short flight is necessary when hopping between island groups. The Azores boast Europe's highest concentration of thermal springs, and with the presence of twenty-six active volcanoes, each island is a world unto itself. Their distinct landscapes range from the fertile hills and cascading waterfalls of Flores to the lava-covered moonscape of Pico, which is Portugal's most unique wine-growing region. Pico's 550-year-old vines make it a UNESCO World Heritage Site.

Getting to São Miguel, the largest and most populated island of the Azores, is just a short flight from the East Coast of the United States. To experience the island in its entirety, I suggest a winding, cliff-hugging drive along the coast where vistas shift from lush foothills to black sand beaches to quaint whitewashed villages in a matter of minutes. A visit to the Parque Terra Nostra in Furnas was the highlight of my trip to São Miguel. Thanks to a healthy water system of small springs and stream, gardens have been growing in the Furnas Valley for over 200 years. Terra Nostra began in 1775 when Thomas Hickling, a Bostonian, built Yankee Hall. The sprawling botanical gardens were maintained and renovated by generations of gardeners, horticulturists,

← The Church and Monastery of São Vicente de Fora in Lisbon

and arboriculturists. Nowadays, it is a wonderland of more than 3,000 species of endemic and imported trees, flowers, ferns, and shrubs. The property contains an extensive system of walking trails that weave through a variety of gardens; a vibrant camellia collection, a ginkgo garden, a stunning azalea collection, a fern collection, and a cycad garden.

In gardens across Portugal, nature, history, and culture merge, from public gardens and parks to botanical gardens, private quintas, and monastic courtyards. These spaces hold the beauty of the natural world and the stories of the past, making them valuable repositories of knowledge, a fact celebrated by the creation of the Portuguese Historical Gardens Routes by the Associação Portuguesa dos Jardins Históricos. The routes span the entire country, as well as Madeira and the Azores.

→ The Cascais Cultural Centre, beautifully restored by the architect Jorge Silva, was previously the site of the former convent of Our Lady of Mercy.

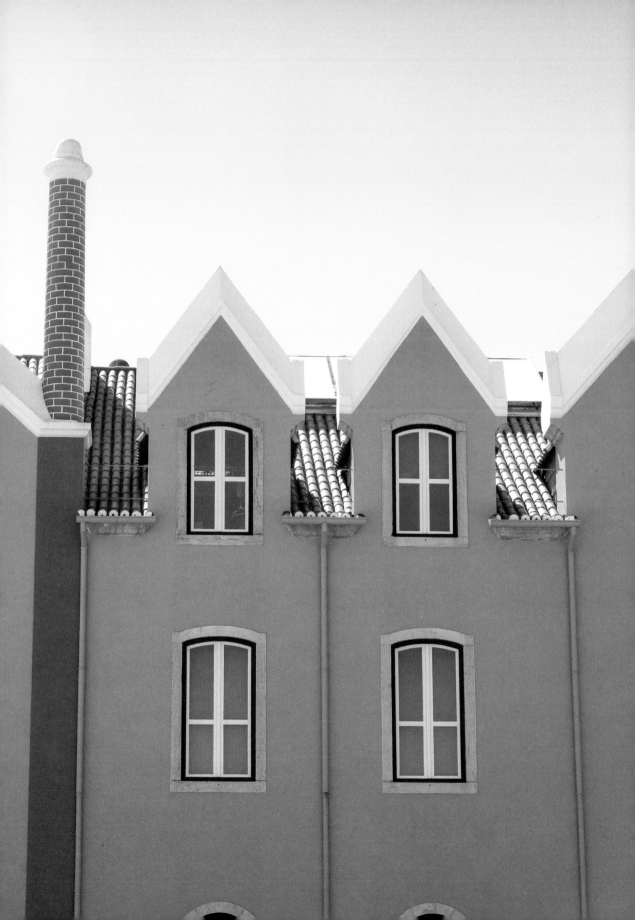

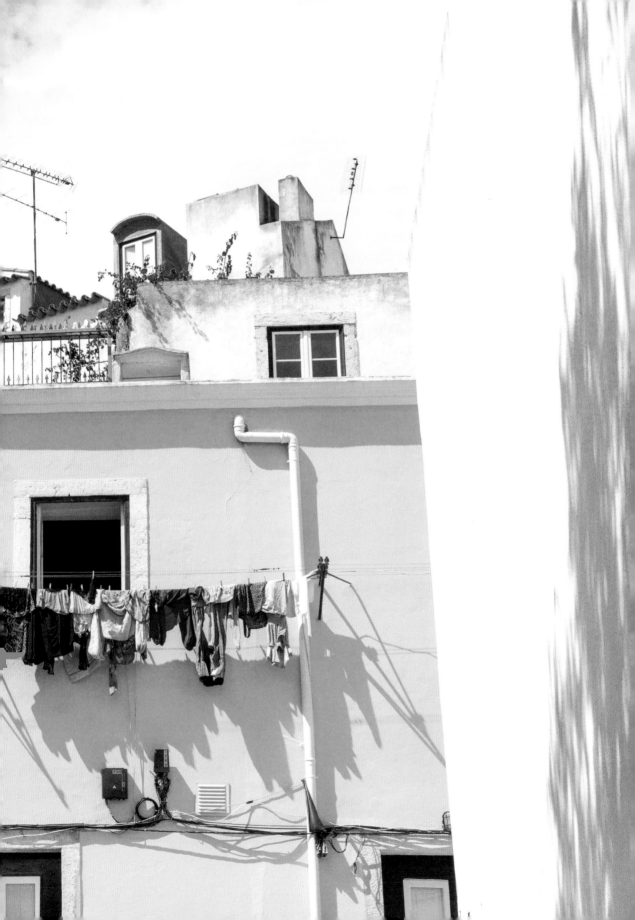

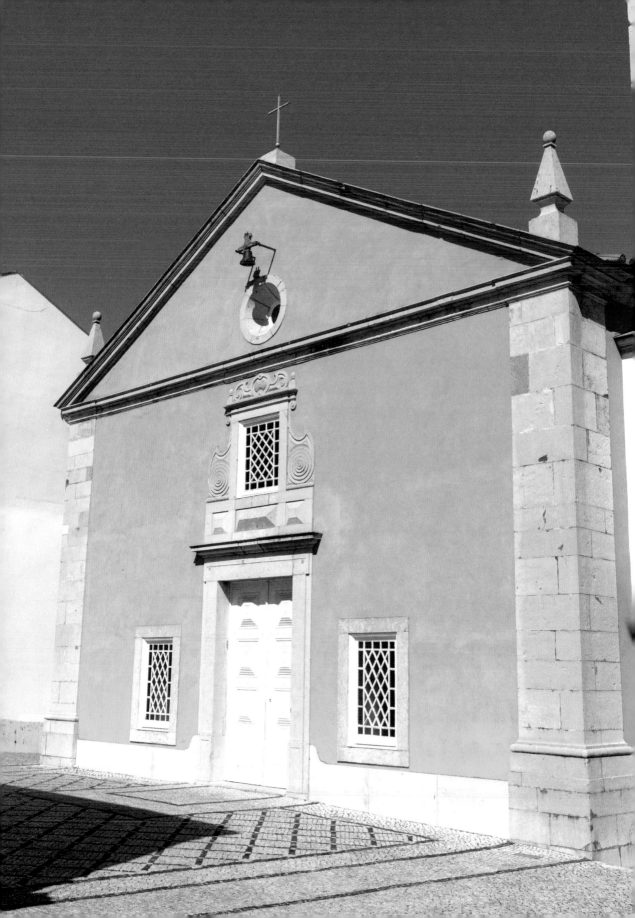

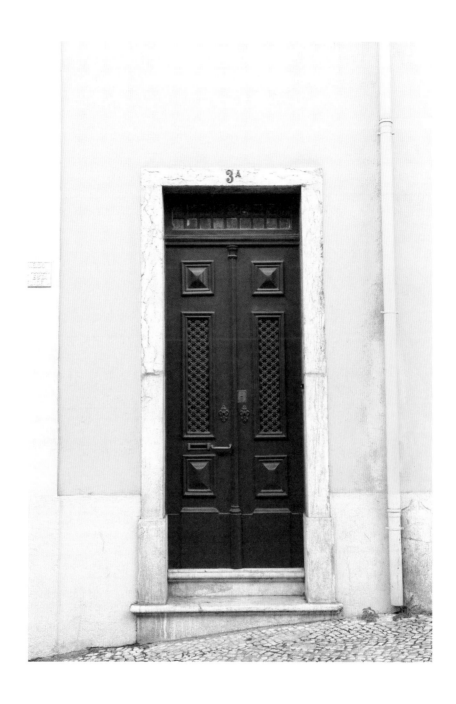

← Throughout Portugal, the black-and-white limestone pavers, seen here in front of a small chapel in Cascais, are considered works of art. Waved patterns are often used as a reference to Portugal's maritime heritage.

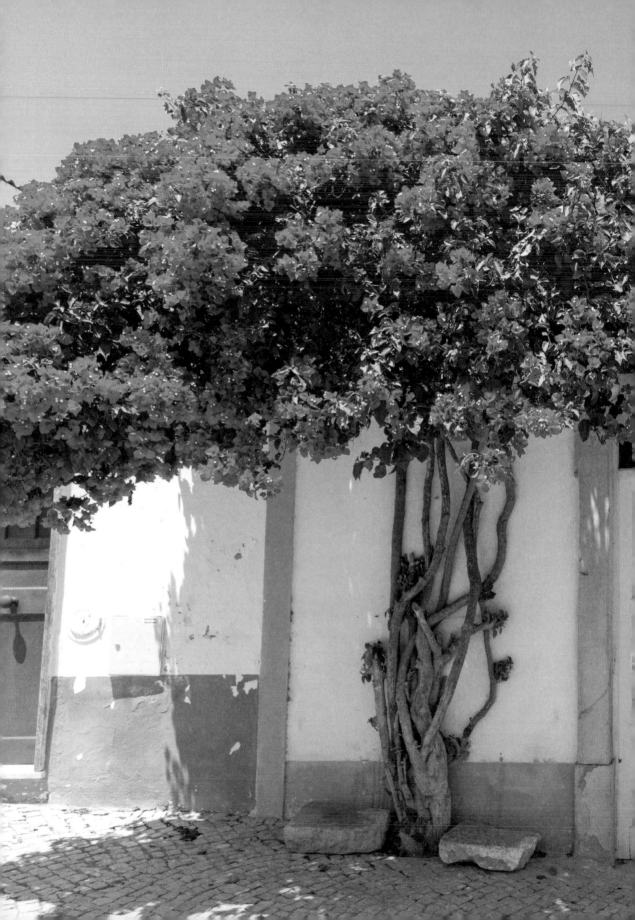

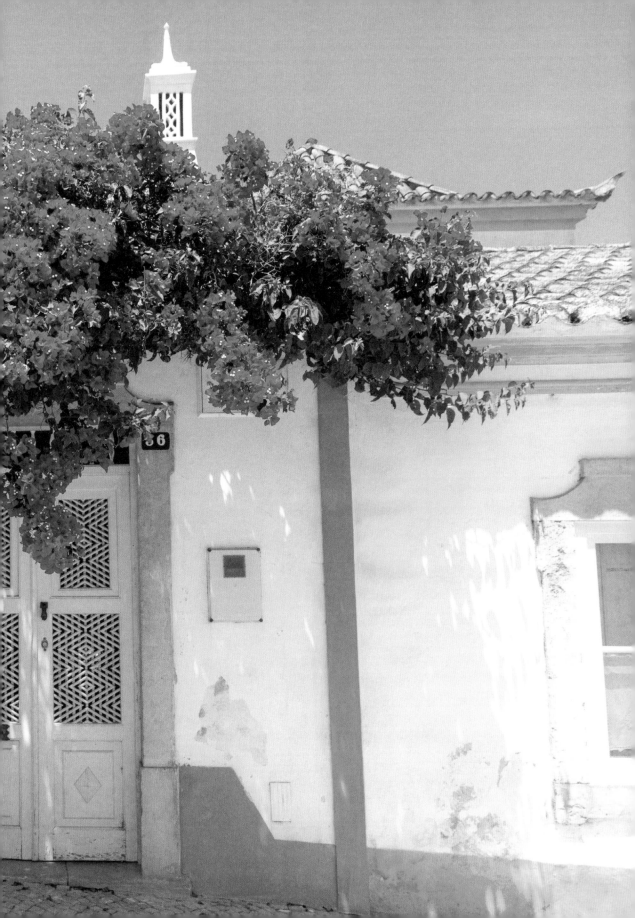

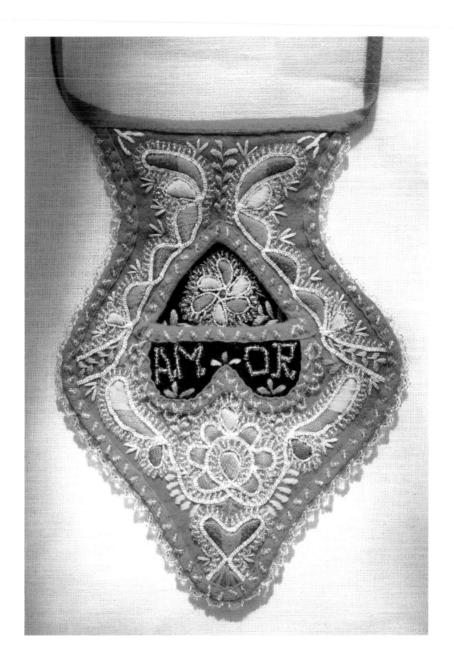

↑ The atelier of Isilda Parente has played an important role in preserving and continuing the embroidery traditions of Viana do Castelo. Motifs in this piece are inspired by the region's flora and fauna, as well as themes of love.

→ During the festival of Our Lady of Sorrow, celebratory drumbeats and traditional folk music fill the streets from dawn until dusk.

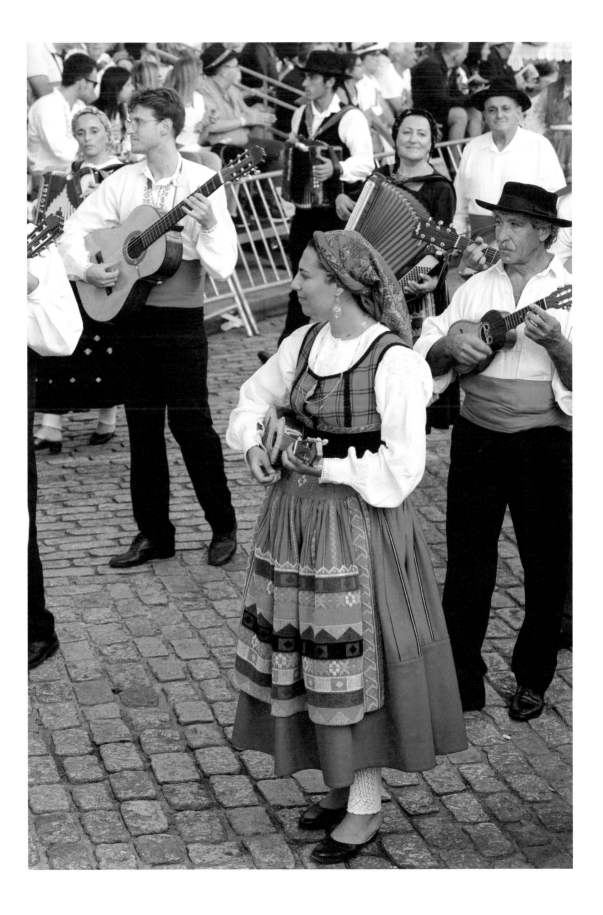

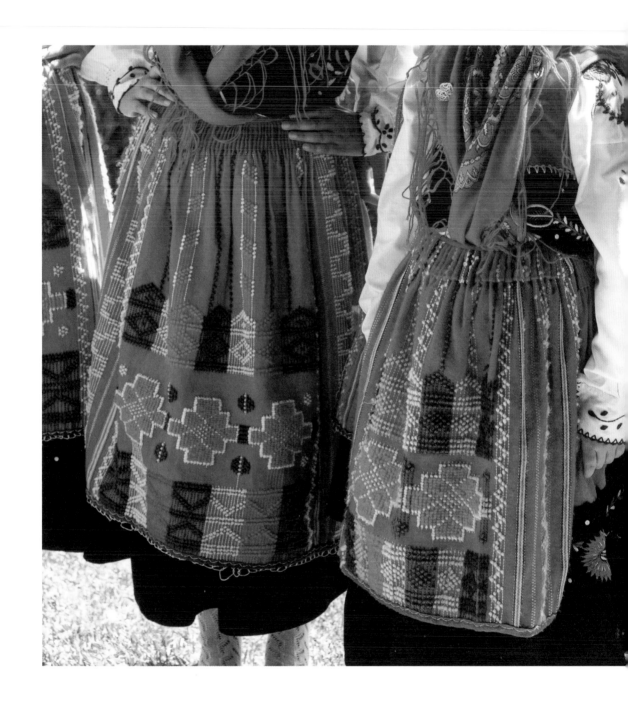

↑ Aprons that are beautifully woven on looms are often the boldest
red component of the layered Traje à Vianesa and predominantly
feature embroidered geometric patterns.

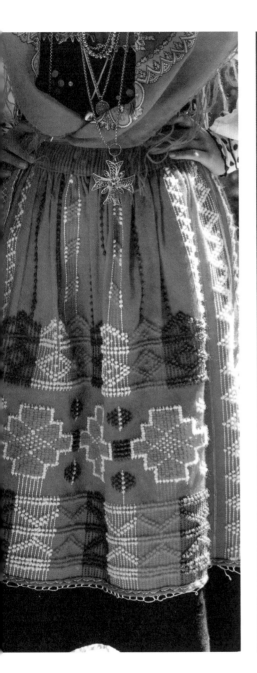
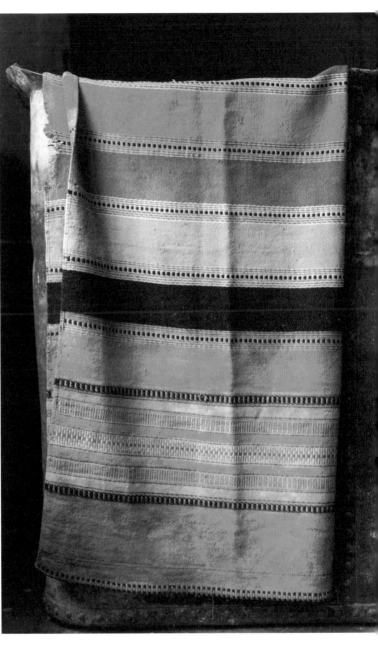

↗ A traditionally woven woolen reguengos blanket
at Fábrica Alentejana de Lanifícios

151

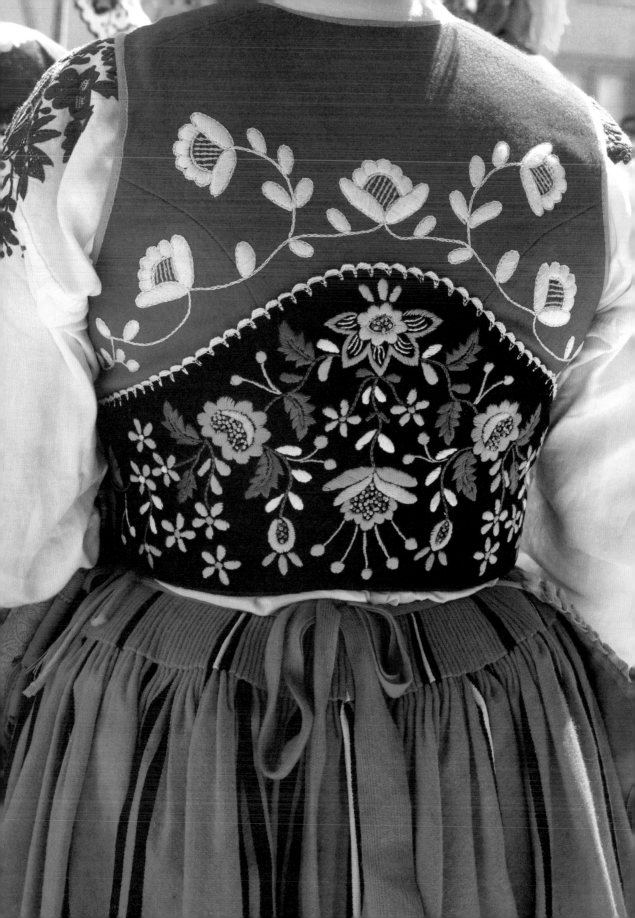

EMBROIDERY, WEAVING,
AND THE CLOTHING
OF VIANA DO CASTELO

THE STREETS OF VIANA DO CASTELO, a coastal city in Northern Portugal, echo with celebratory drumbeats during the annual Feast of Senhora da Agonia, the pilgrimage and festival of Our Lady of Sorrow. From every corner, the nostalgic, melancholy strains of the famed song "Havemos de ir a Viana," by "the Queen of Fado," Amália Rodrigues, fill the air and instill a sense of pride for the Viana region. Parades, concerts, cultural performances, and religious processions make up the weeklong summer celebration, which draws hundreds of thousands of attendees from across the country. The highlight of the week for textile enthusiasts is the Mordomia Parade, a living ethnographic display of more than six hundred women walking through the streets in traditional festive costumes known as *Traje à Vianesa*.

The Portuguese can trace their origins back to the mountainous North Region. It is here, in the land of medieval coastal villages and verdant landscapes, that Portugal is said to have been founded in the twelfth century. Because of the area's historical significance, the Traje à Vianesa is the most highly regarded of local Portuguese costumes, and it was traditionally worn by country girls from the rural villages around Viana do Castelo on special occasions, such as festivals and holidays. The floral embroidery on blouses indicated the home village of the wearer as well as her economic status.

The region's self-sufficient farming families produced the wool and linen fabrics necessary for the making of the costumes, while the skilled weavers and embroiderers added their artistry. Motifs depicting camellias, brambles, and hearts were traditionally captured in blues and reds, though as time went on, the palette expanded to include orange, yellow, green, and purple, and sequins and glass beads were often used as accents. This layered costume consists of the following items: a linen shirt with smocked shoulders, a corset, an underskirt and richly embroidered woolen skirt, scarves, an apron, lisle stockings, leather mules, and traditional gold filigree jewelry.

A must-see is the visitors is the Viana do Castelo's Museu do Traje (Costume Museum), which opened in 1997 and is dedicated to highlighting, in great detail, the costumes, artistry, and embroidery of the region.

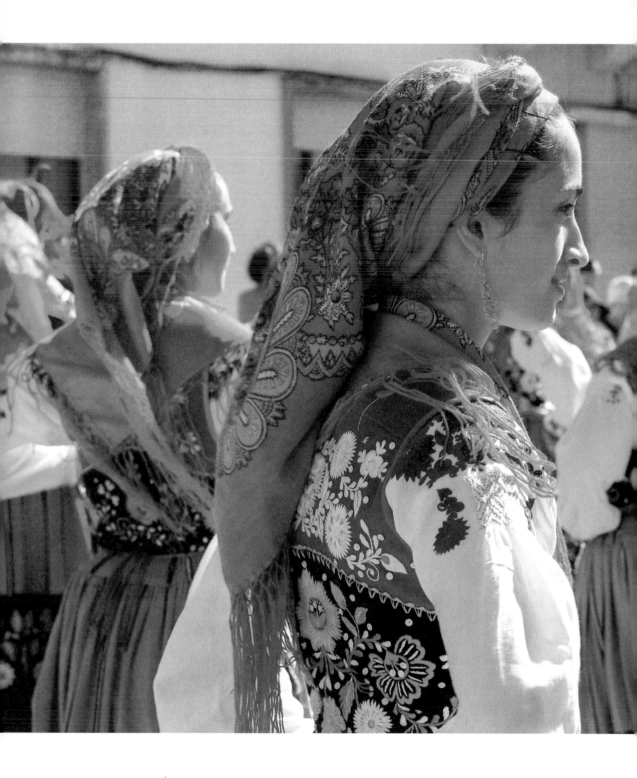

↑ → Traditional costumes evolve as fashion changes, but since the 1920s, red Trajes à Vianesa have included geometric-patterned aprons and striped woolen skirts, richly embroidered side pockets and vests, red headscarves and shawls, and white linen shirts with embroidered shoulders.

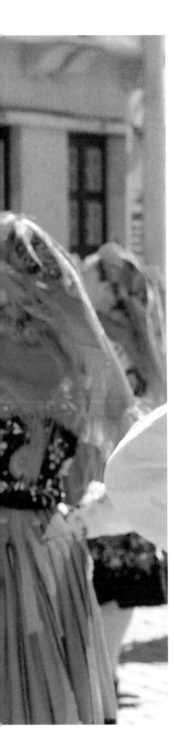
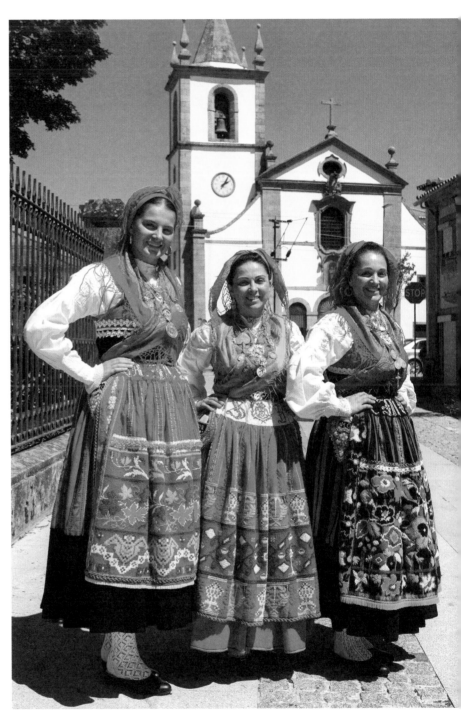

→ Villages in the Minho region select young women (called *mordoma*) to help the church prepare for festivities and pilgrimages. Here, a mordoma displays her traditional Portuguese gold jewelry, which is an important form of feminine adornment. Owning gold was considered as essential as owning land and livestock, and it reflected the social and economic background of the family.

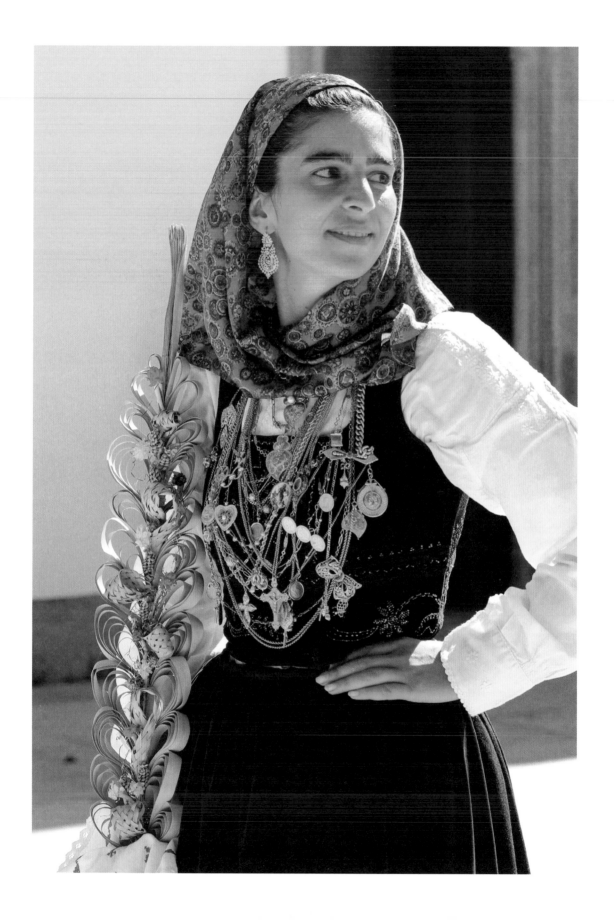

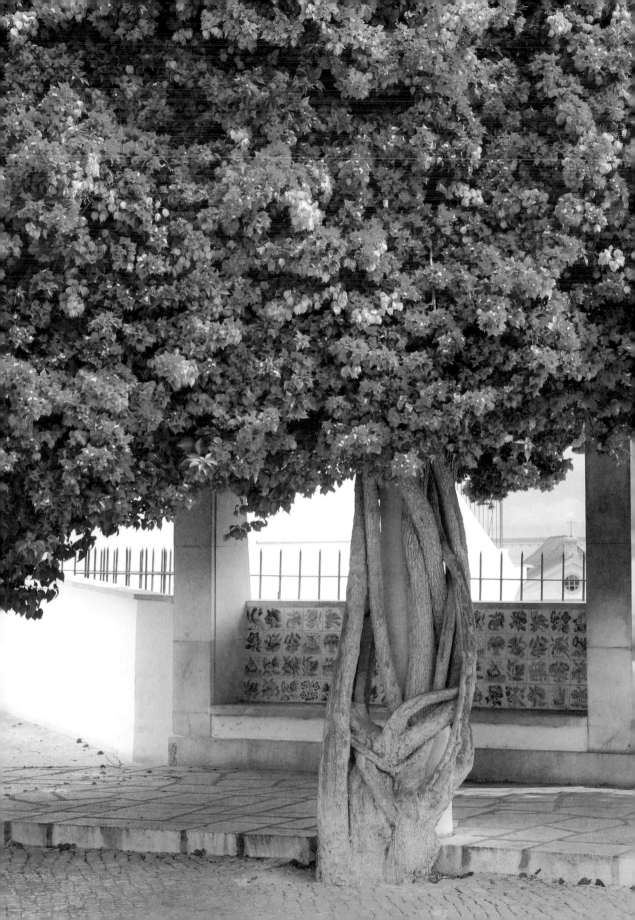

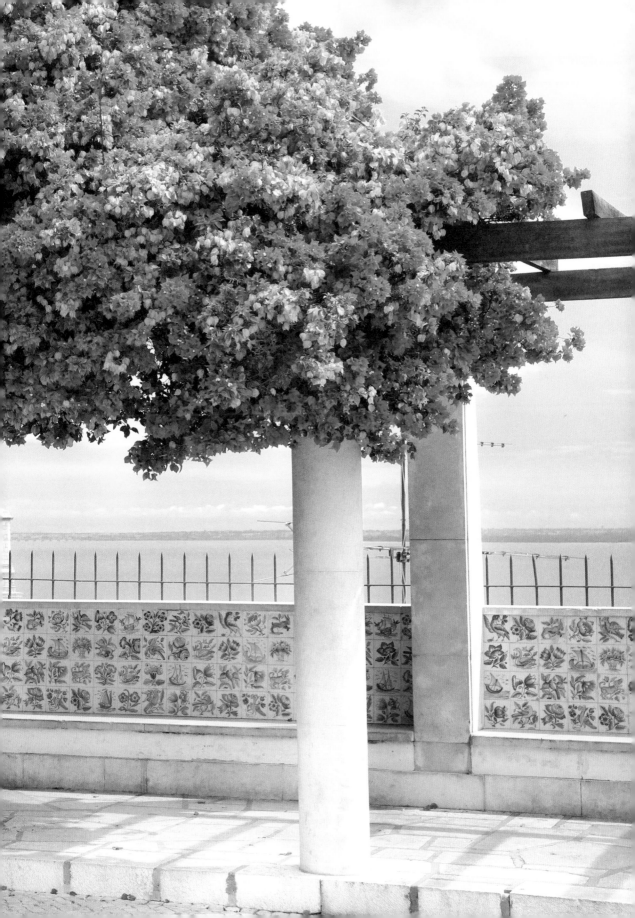

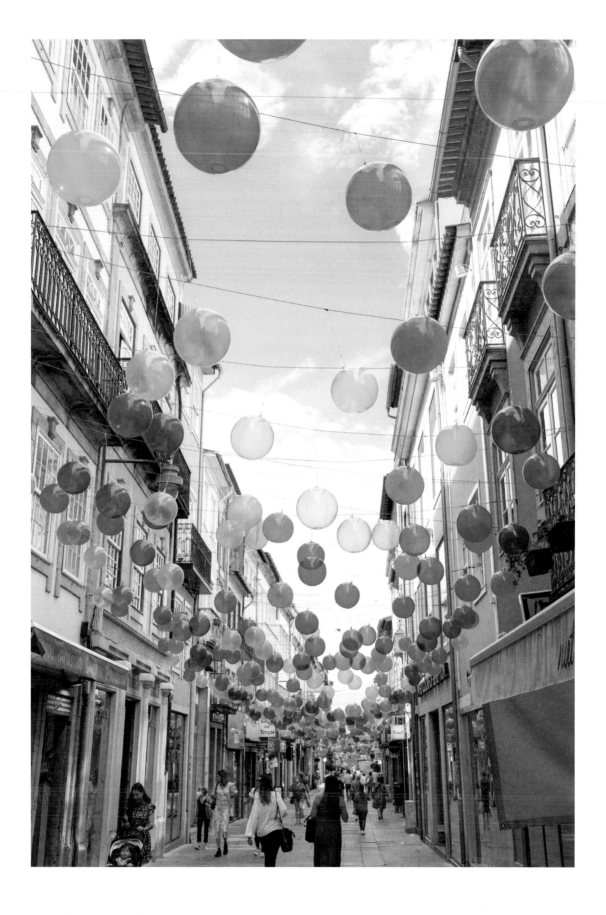

p. 158–59 This bougainvillea-draped tiled terrace at Miradouro de
Santa Luzia offers sweeping sunset views of Alfama.

← A colorful balloon installation over Rua do Souto in Braga

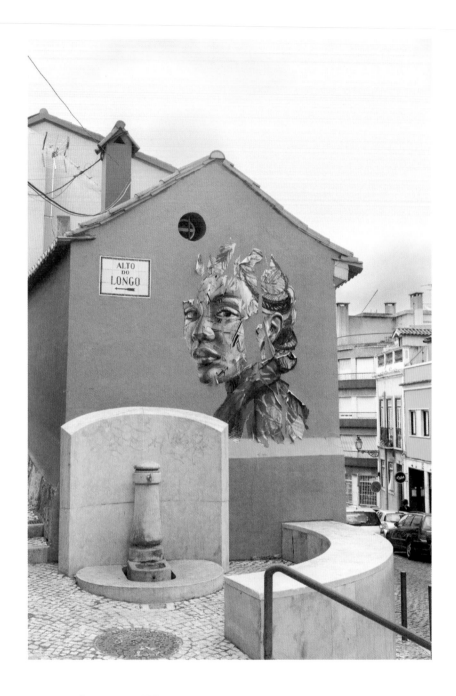

↑ A mural portrait by French street artist Alexandre Hopare Monteiro in
Lisbon's Bairro Alto neighborhood

→ The side streets of Porto reveal tucked away ateliers,
tiny cafés, and charming apartments.

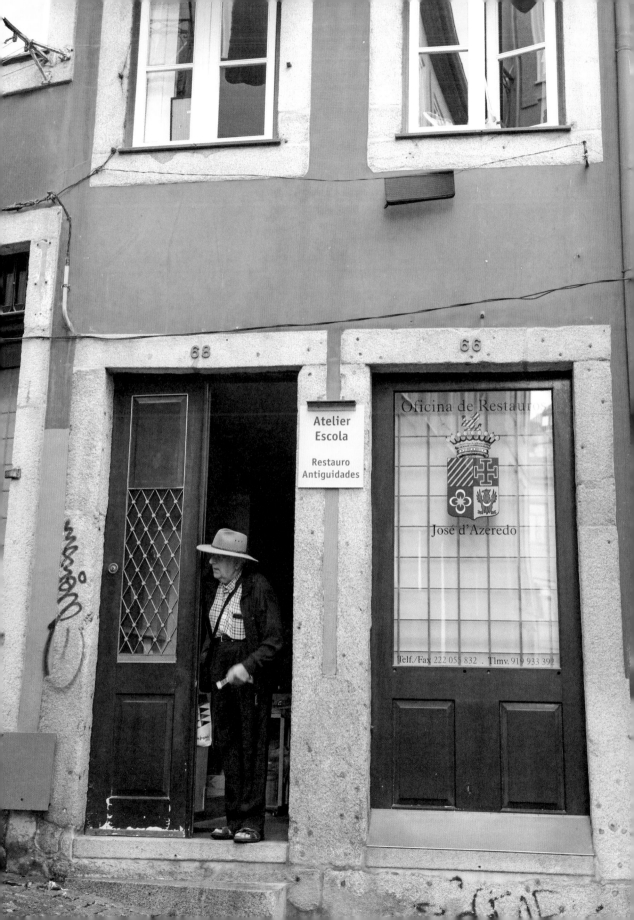

← Largo da Pena Ventosa is a colorful cobblestone square in Porto.

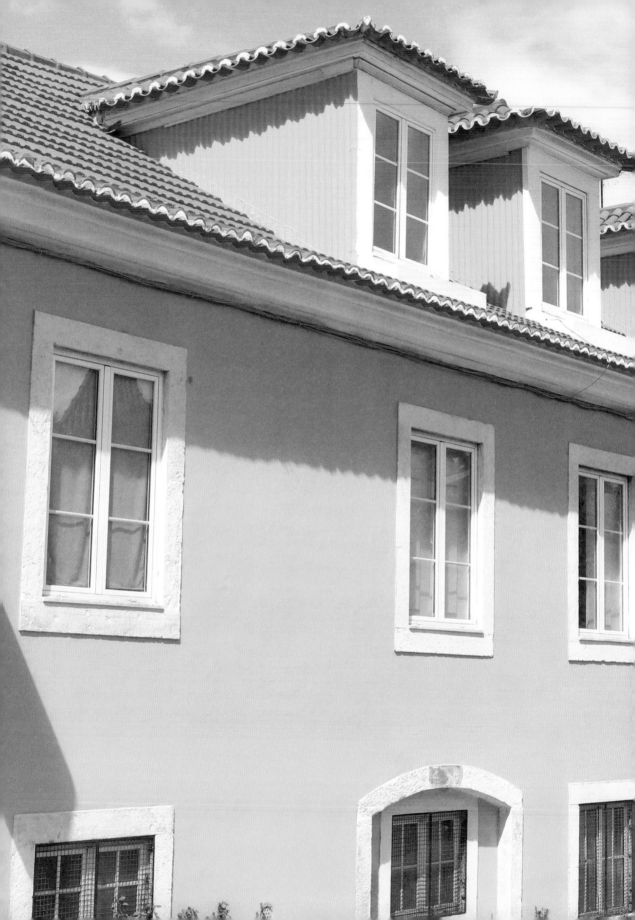

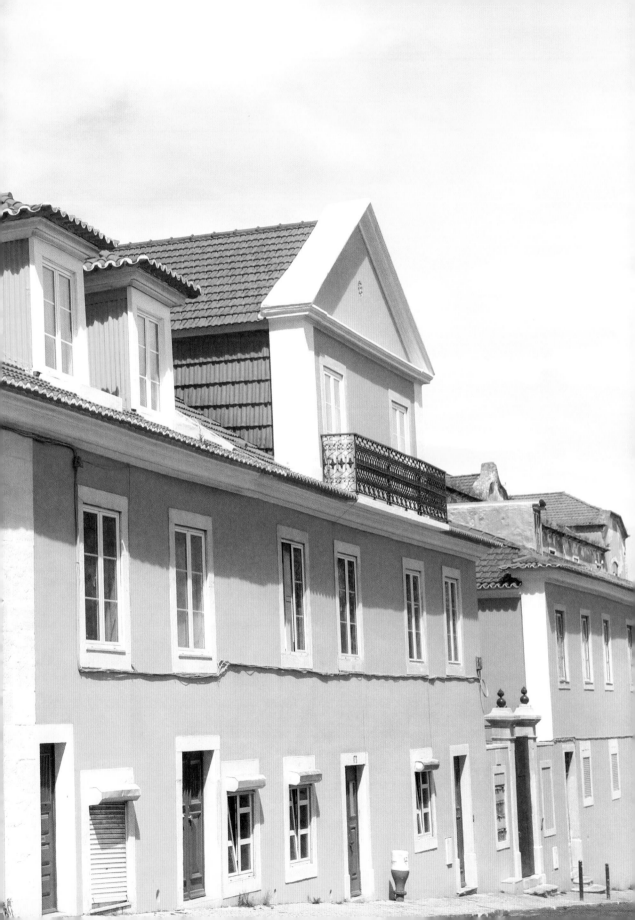

↑→ Casa de Serralves, a palatial pink Art Deco villa, was originally conceived as a private residence but now serves as part of the Serralves Museum of Contemporary Art. It was designed by architect José Marques da Silva.

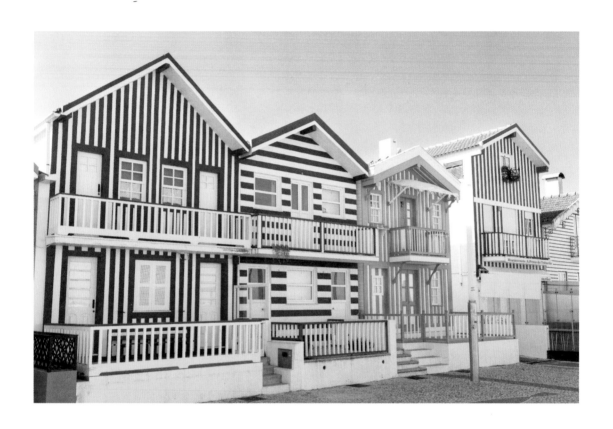

↑ → *Palheiros*, the colorful striped homes that line the boardwalk in Costa Nova, are traditional houses specific to this coastal region. In the past, they provided shelter for fishermen, as well as storage for the machinery and animals that were used to haul the fishing boats onto the beach.

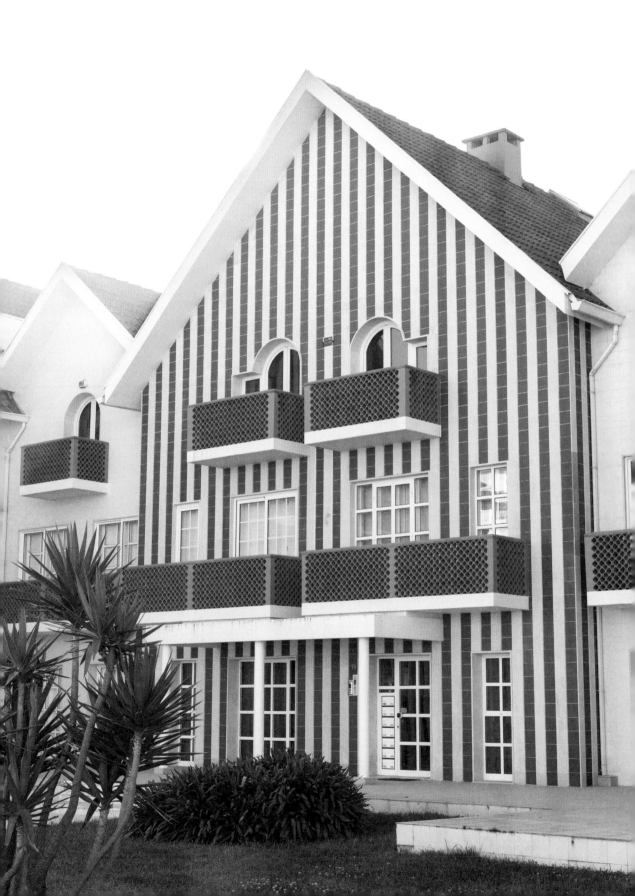

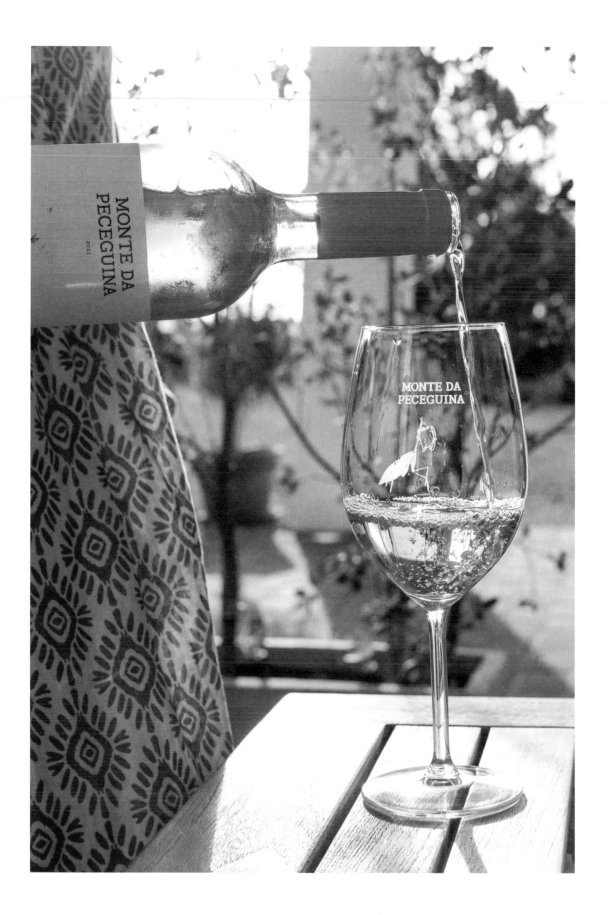

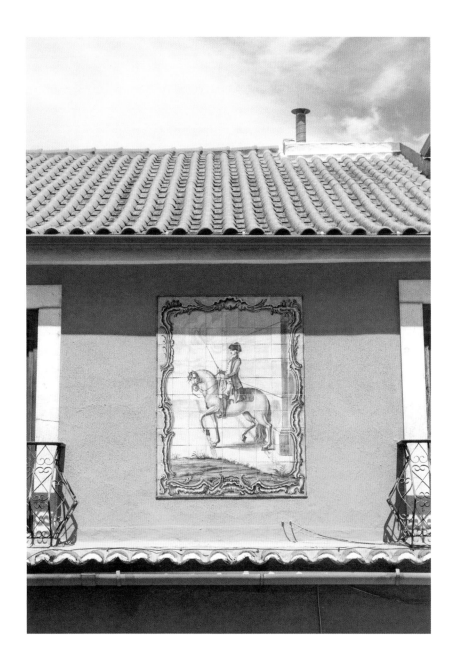

← Monte da Peceguina wine from Herdade da Malhadinha Nova

↑ During the sixteenth century, as Portuguese rulers embraced tilework
and the production of azulejos became localized, trends shifted from
motifs to scenography. If an entire building could not be covered in tiles,
mosaics or small panels were often utilized.

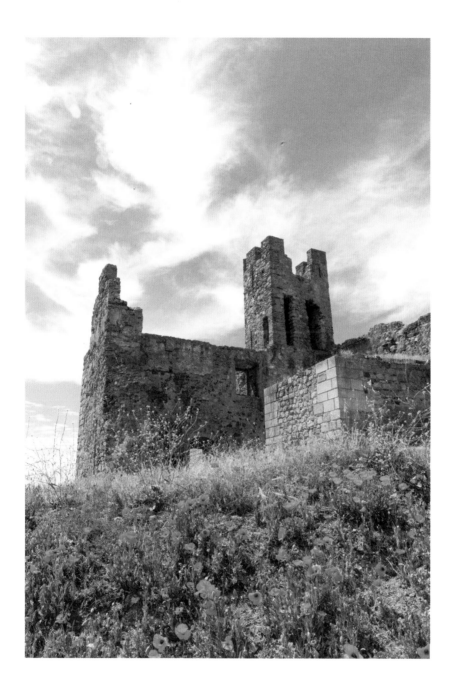

↑ The Castelo de Arraiolos sits atop Monte de San Pedro, a hill north of the town of Arraiolos. Built in the fourteenth century by King Dinis, much of it is now in ruins.

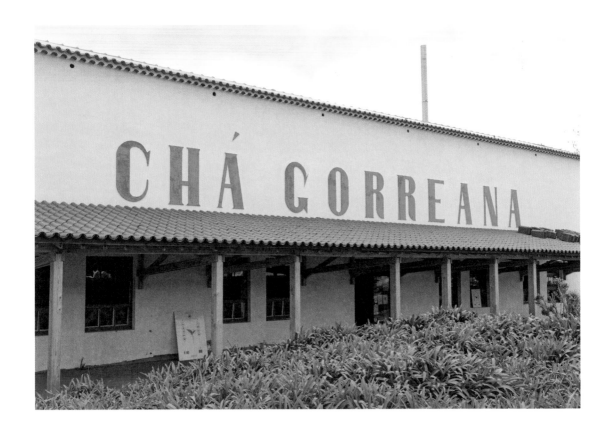

↑ → The Gorreana Tea Factory, founded in 1883, is the oldest and last remaining tea plantation in Europe. Located on the island of São Miguel, the humid and rainy climate, mild temperatures, and unique volcanic soil create the perfect conditions to produce green and black tea.

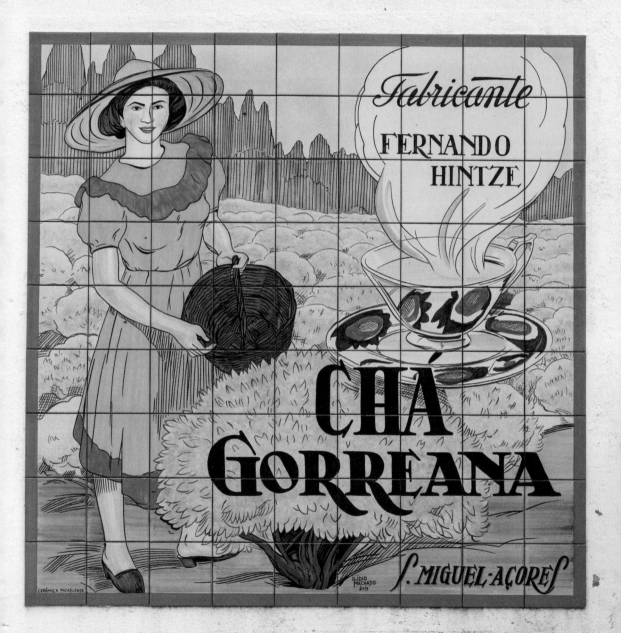

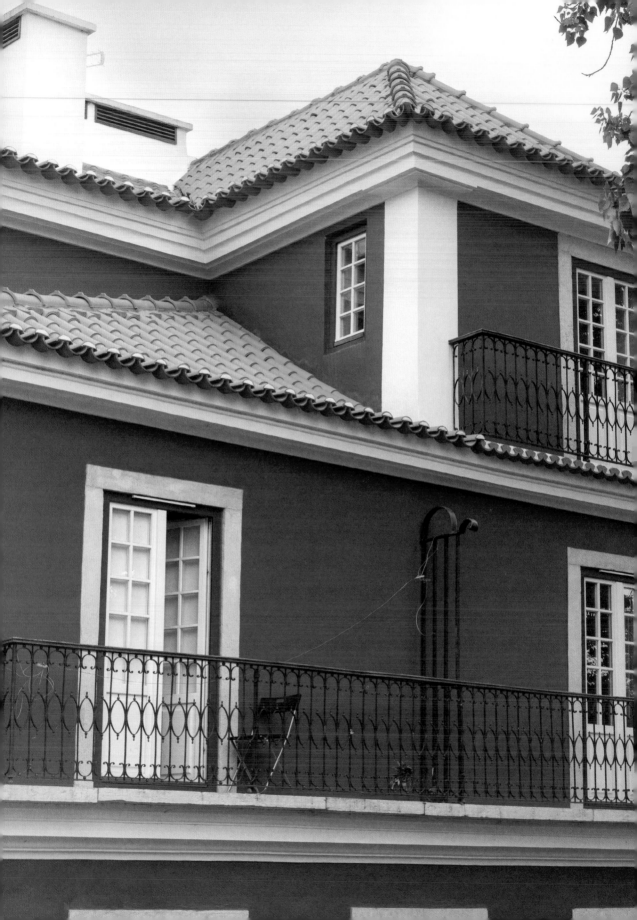

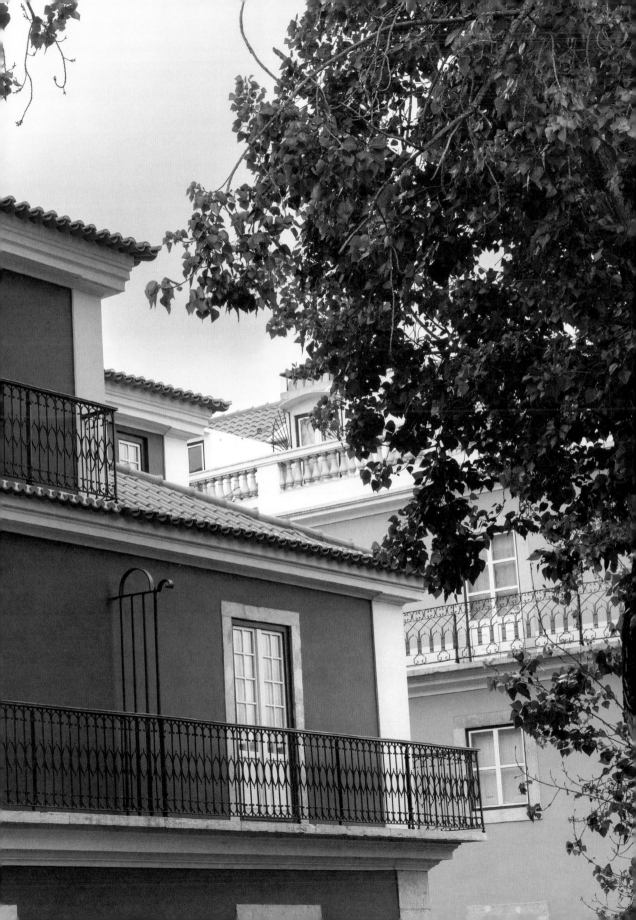

TERRA-COTTA

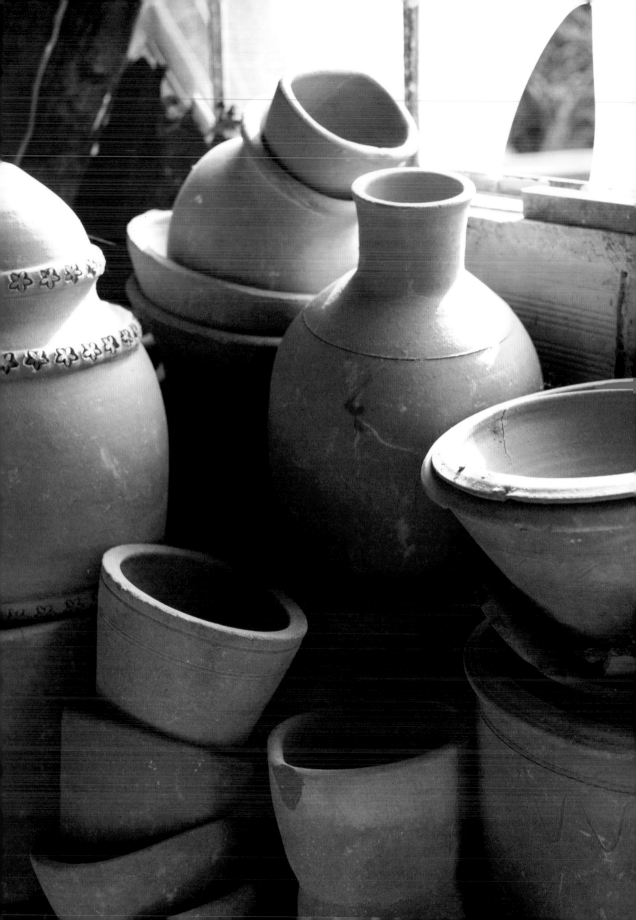

The Alentejo region of Portugal sparkles with a golden light that dances off olive groves and gnarled, ancient cork trees. With one of the lowest population densities in Europe, it feels like a well-kept secret—a charming throwback to a slower, gentler pace of life. The landscape is arid yet fertile; the region is known for its wine, olive oil, cork, wheat, and heritage livestock breeds; and the soil is dense with the red clay that is essential for creating terra-cotta. The wine here is distinct from that of the Douro Valley, and the hot, dry climate creates perfect conditions for full-bodied reds and aromatic whites. Talha wine—made using a traditional amphora winemaking technique developed by the Romans—has historically been produced throughout the region. Large clay vessels, called *talha*, are used for the fermentation and filtration process resulting in a less refined, turbid wine. The talha winemaking process, along with the artistry required to produce the enormous clay vessels, has been passed down from generation to generation throughout history.

In the tiny town of Beringel, pottery traditions run deep, and it is here, in an unassuming studio, that I had the pleasure of meeting António Mestre, one of the few master potters in the country who still handcrafts wine amphorae. The large vessels, along with the array of other pottery he crafts, are made from the red clay that he digs from the ground and hand processes. It is an incredibly physical and laborious operation just to extract the clay from the ground—using only hand tools, no machines—and that is just the beginning. On a manual kick wheel he throws the towering, six-foot-plus pots, carefully carrying them over to be fired in the wood-burning oven that he built and stokes by hand. Although he has mentored other potters, António has yet to teach someone how to produce wine amphorae, and he worries aloud during my visit that it is a dying art form. The same concern is shared by the shrinking number of artisans still handcrafting terra-cotta roof tiles, which are ubiquitous in Portugal. The half-tubular shape of the tiles not only creates an aesthetically pleasing roof, but also allows water to easily drain and helps cool the house.

← Wheel-thrown terra-cotta pots stacked inside the workshop of António Mestre

The Alentejo is rich with other crafting traditions beyond just pottery, including the famed hand-embroidered rugs from Arraiolos, an art form thought to originate with the Moors. Archaeological excavations in the town square uncovered ancient vats used to dye wool that date back before the fifteenth century. The tapestry-like carpets are made from wool rug yarn that is hand embroidered using a long-legged cross-stitch onto a heavy jute canvas. The decorative motifs seen on some of the oldest rugs, which now hang in the Arraiolos Rug Interpretive Center, were influenced by Oriental rugs imported by Portuguese mariners starting in the fifteenth century. Nowadays, motifs include stylized birds, animals, and flowers drawn from Portuguese folklore, as well as maritime themes paying homage to the great voyages of discovery. As a textile enthusiast, I dedicated an afternoon to strolling through the town and visiting each of the tapestry cooperatives, of which there are only a handful left in town. The Arraiolos Rug Interpretive Center is an essential visit, and its collections highlight the value of the Arraiolos rug as a form of artistic heritage.

→ Embroidered Arraiolos rugs are one of the oldest expressions of the Portuguese decorative arts. Production was centered in the town of Arraiolos, where archaeological excavations have uncovered ancient vats used to dye wool that date back to the fifteenth century. A visit to the Arraiolos Rug Interpretative Center illuminates the handicraft's rich history.

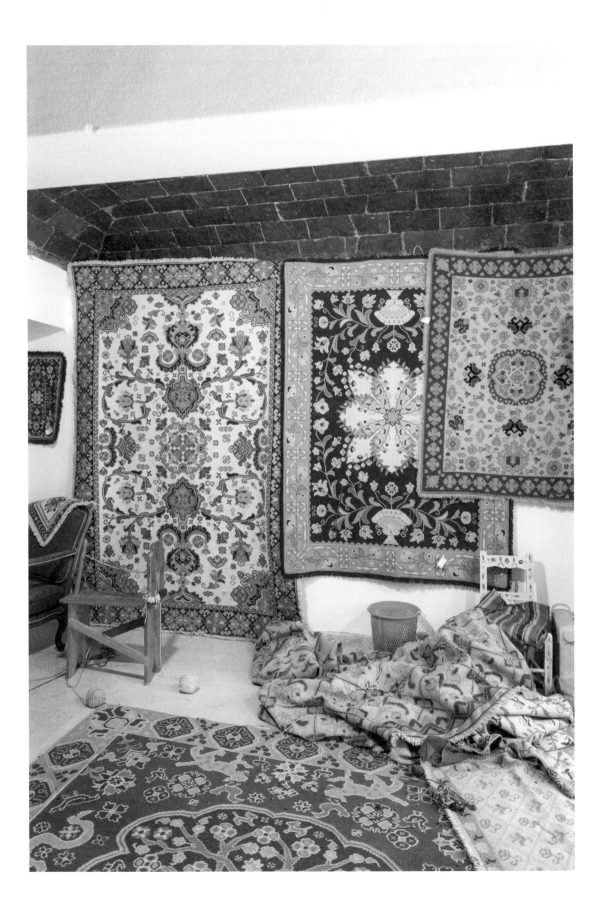

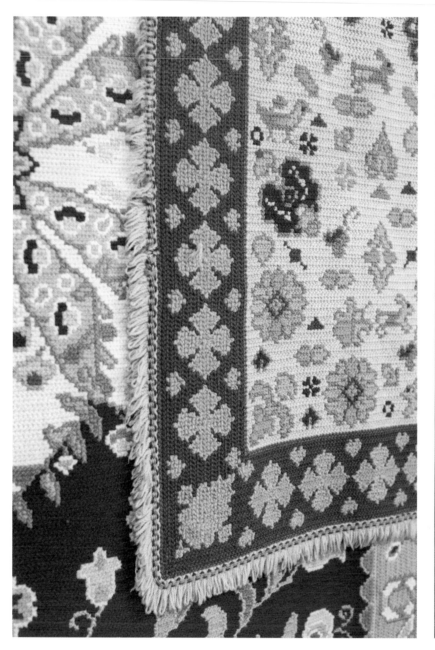

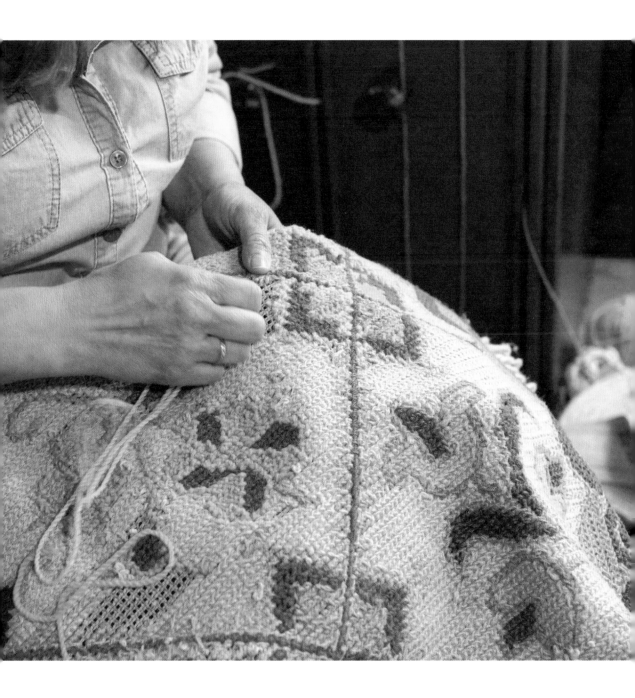

→ The Cathedral of Évora is the largest of the medieval cathedrals in
Portugal and one of the country's best examples of Gothic architecture.
Through the years, additions were added in the Manueline (early sixteenth
century) and Baroque (early eighteenth century) styles.

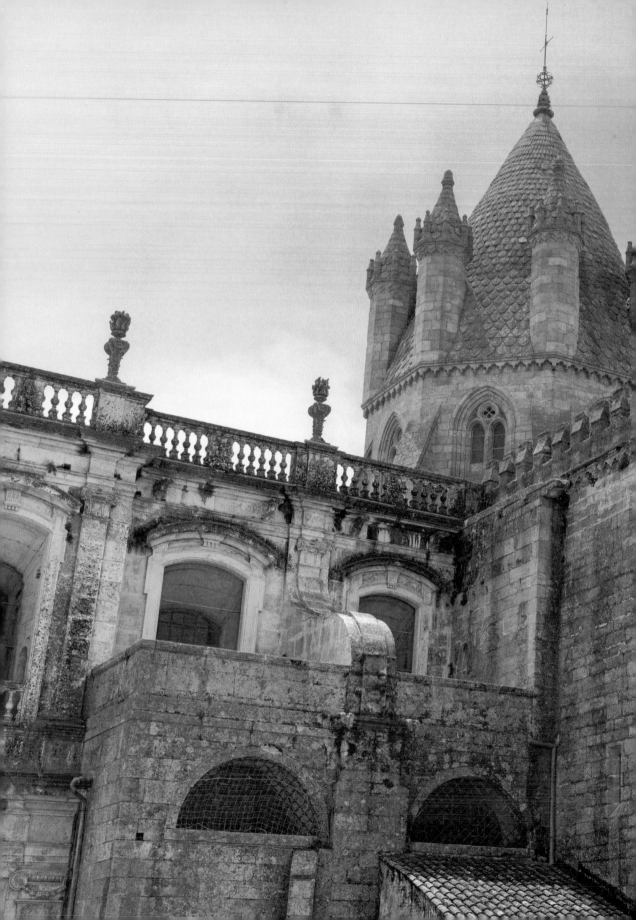

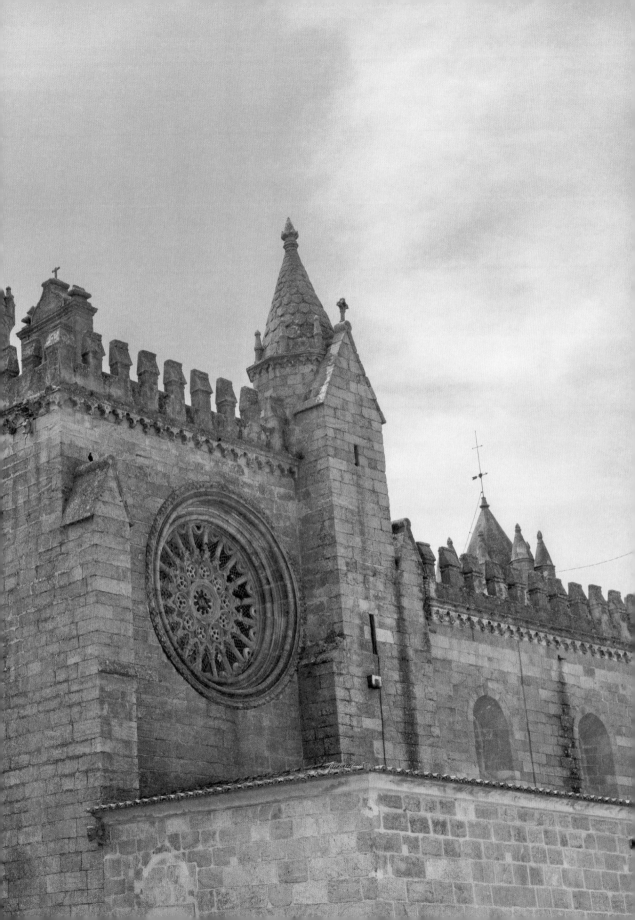

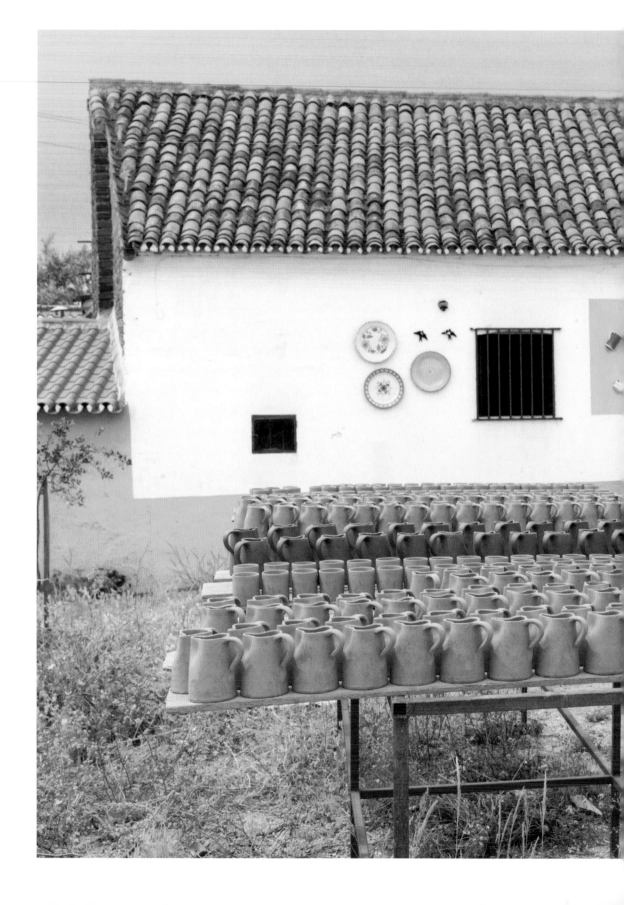

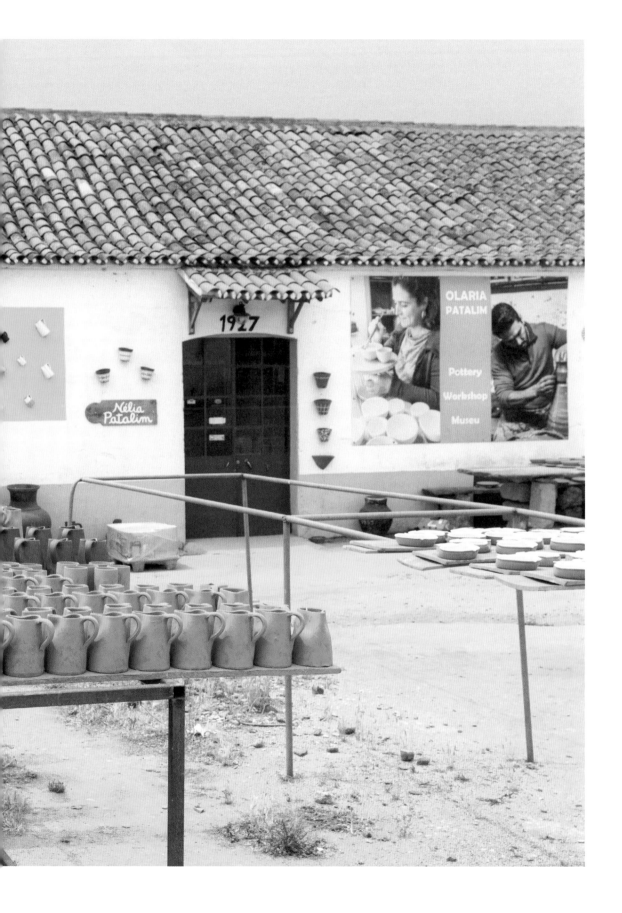

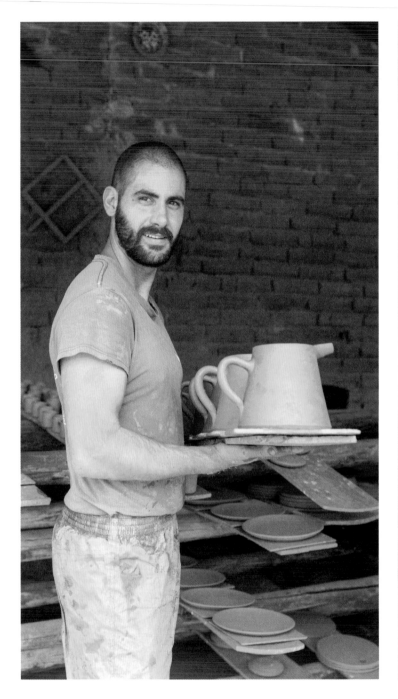
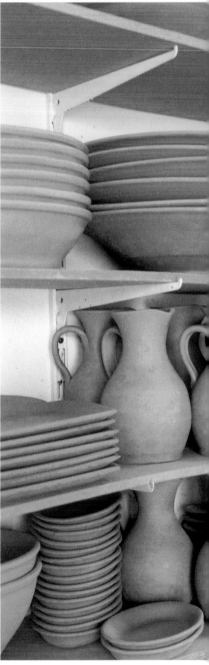

←— São Pedro do Corval is home to more than twenty artisanal pottery workshops, including Olaria Patalim.

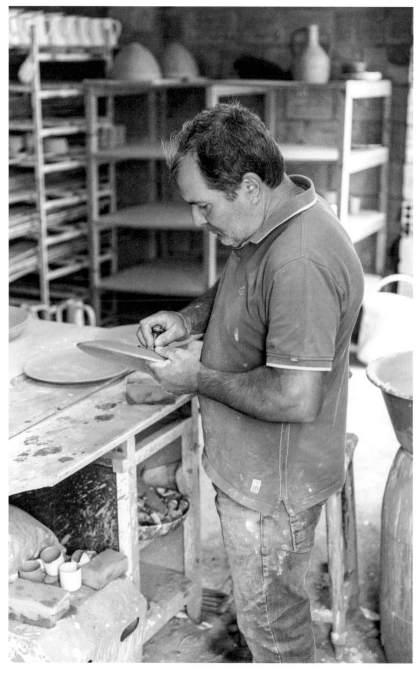

↗ At Olaria Patalim each piece is made entirely by hand—from the throwing to the stamping to the glazing—and honors the rich pottery traditions and artistry of the region.

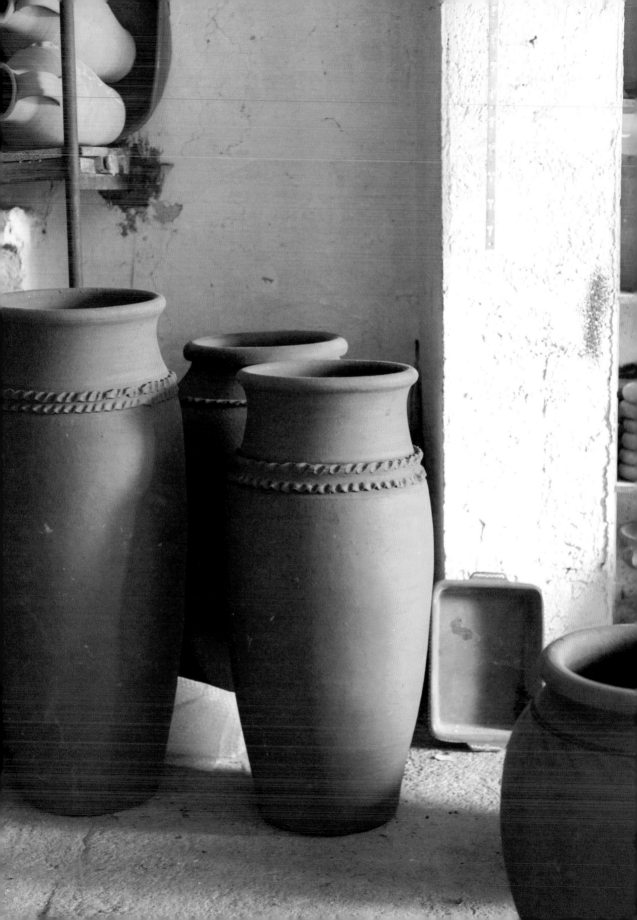

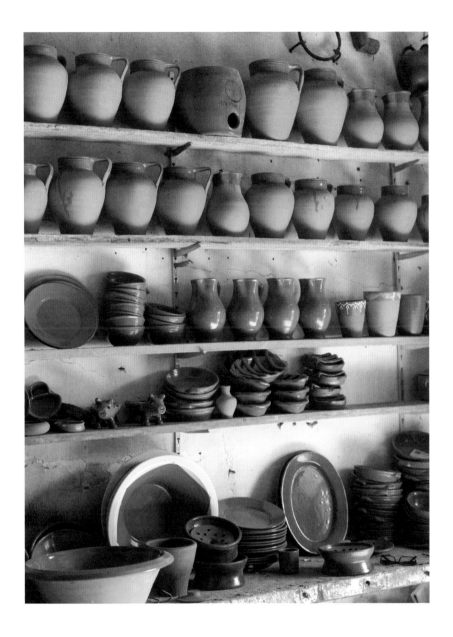

← Using impressive technical mastery and strength, António Mestre throws these six-and-a-half-foot pots on a kick wheel before firing them in a wood-fire oven.

↑ Glazed and unglazed wheel-thrown terra-cotta pottery lines the shelves of António Mestre's workshop.

⟶ Sandstone cliffs and golden sand beaches dominate the coastal landscape of the Algarve.

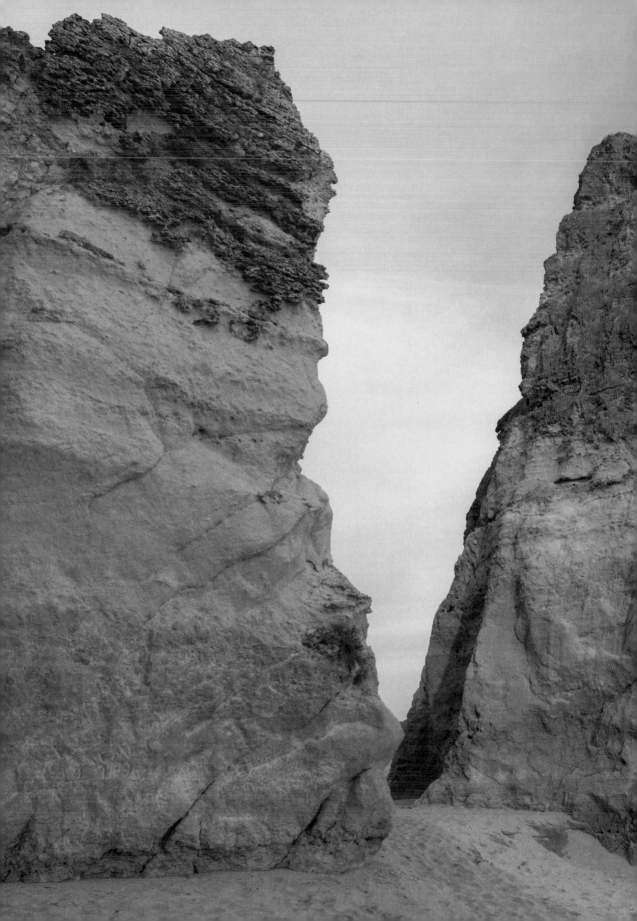

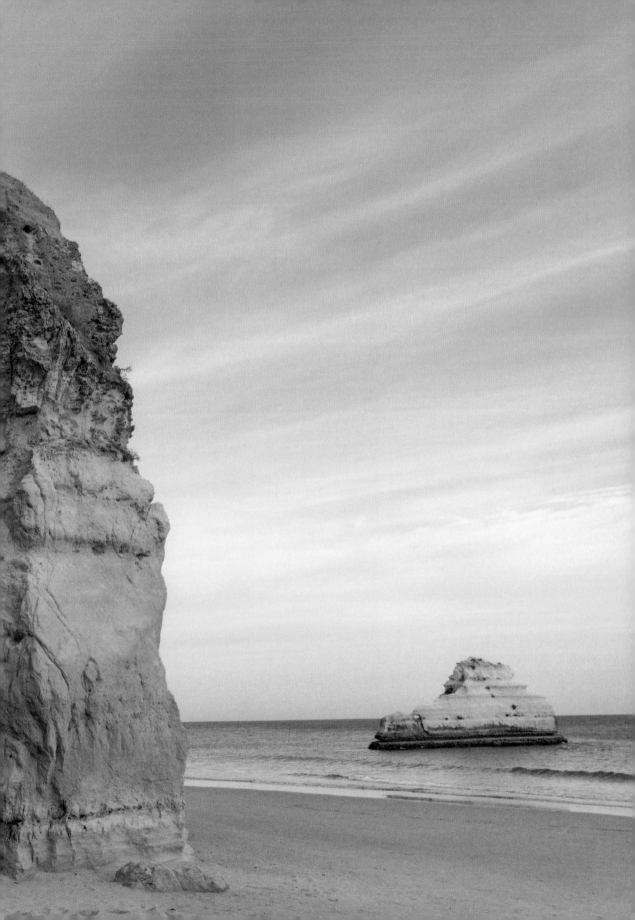

p. 200–203 Conceived by renowned Portuguese architect Manuel Aires Mateus, Pa.te.os is a quartet of dramatic vacation homes tucked away at the end of a country road in the Alentejo region. With uninterrupted views of the Arrábida hills with the Atlantic shimmering on the horizon, Pa.te.os is located in the rural Serra de Grândola outside the town of Melides.

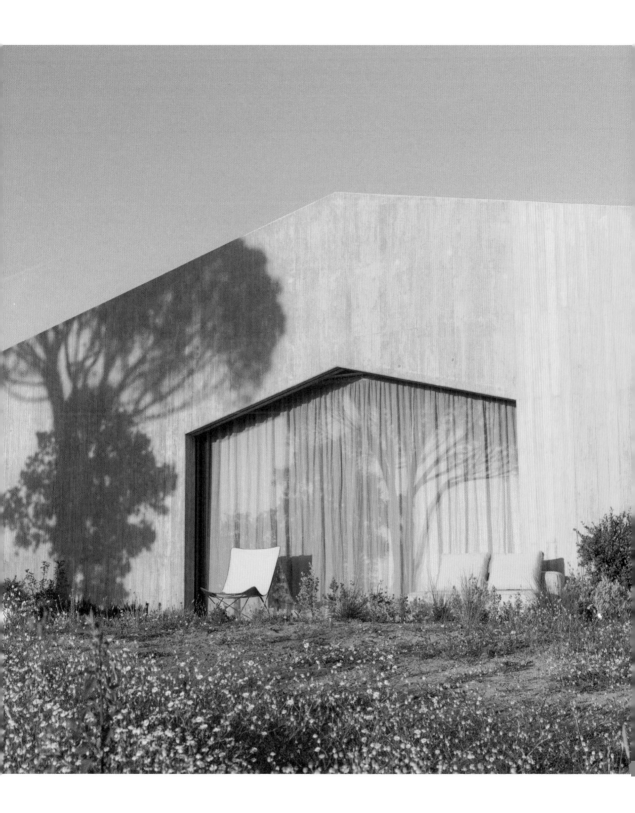

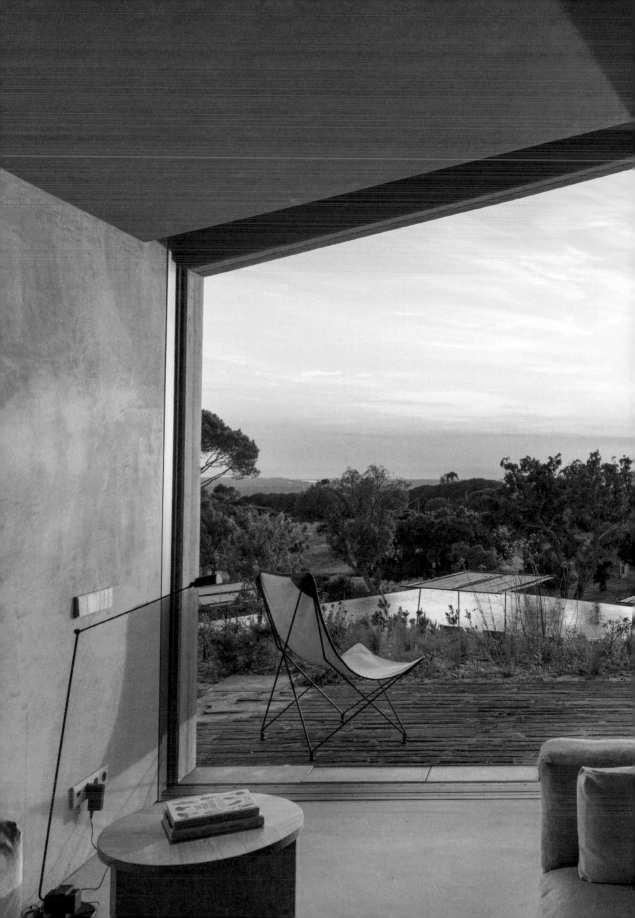

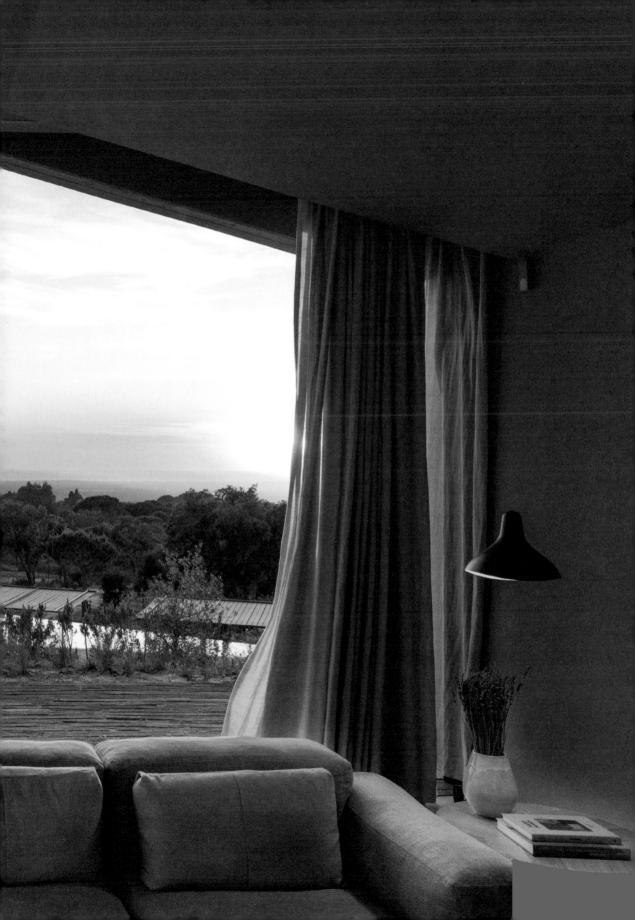

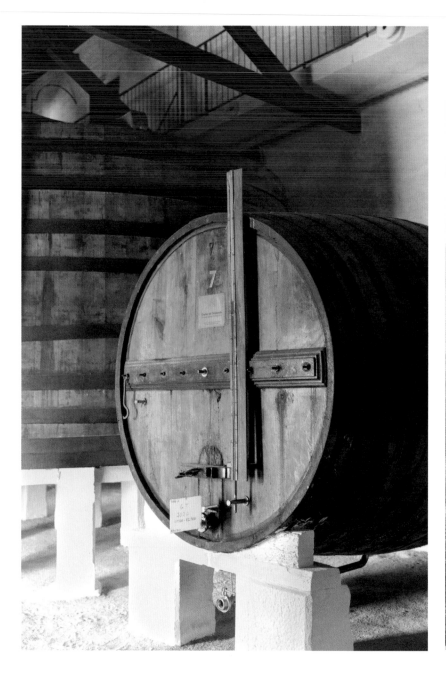

↑ → With nearly 1,000 acres of land and 500 years of history, Ventozelo Hotel & Quinta is one of the oldest and largest farms in the Douro Valley. Guest rooms are housed in converted farm buildings with striking modern additions.

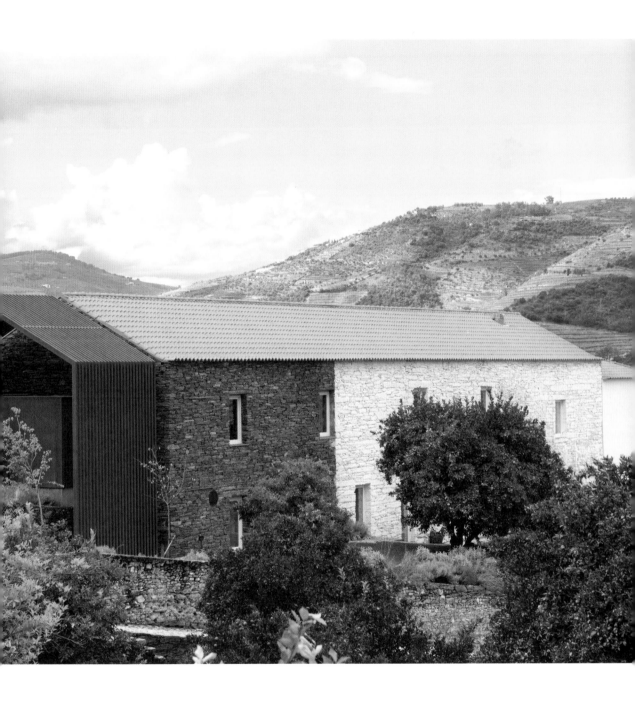

→ Herdade da Malhadinha Nova contains gardens, vineyards, and
an olive grove, along with several guest houses. The terra-cotta features
of the Casa do Ancoradouro villa were made out of the reddish soil
extracted from the ground on which the villa stands.

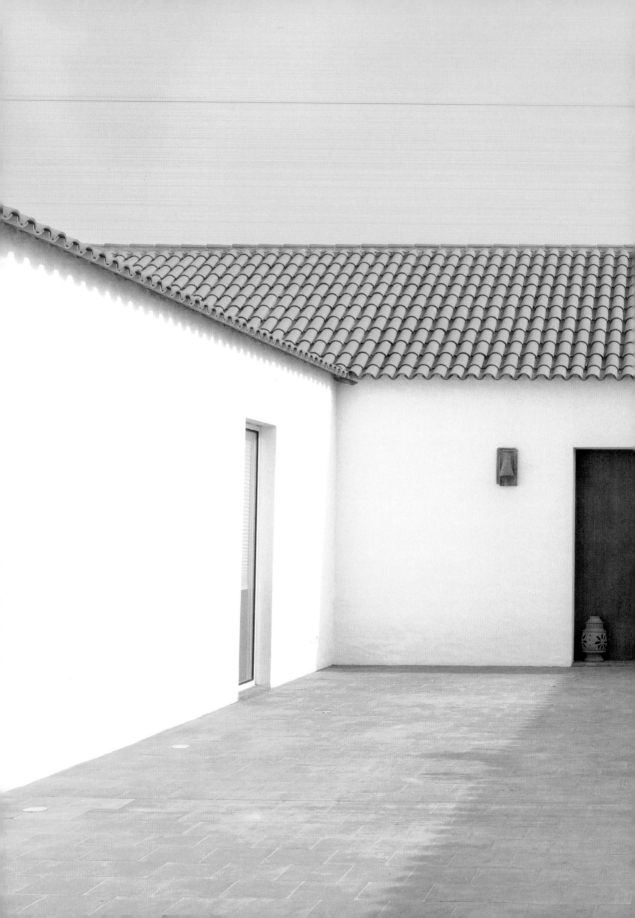

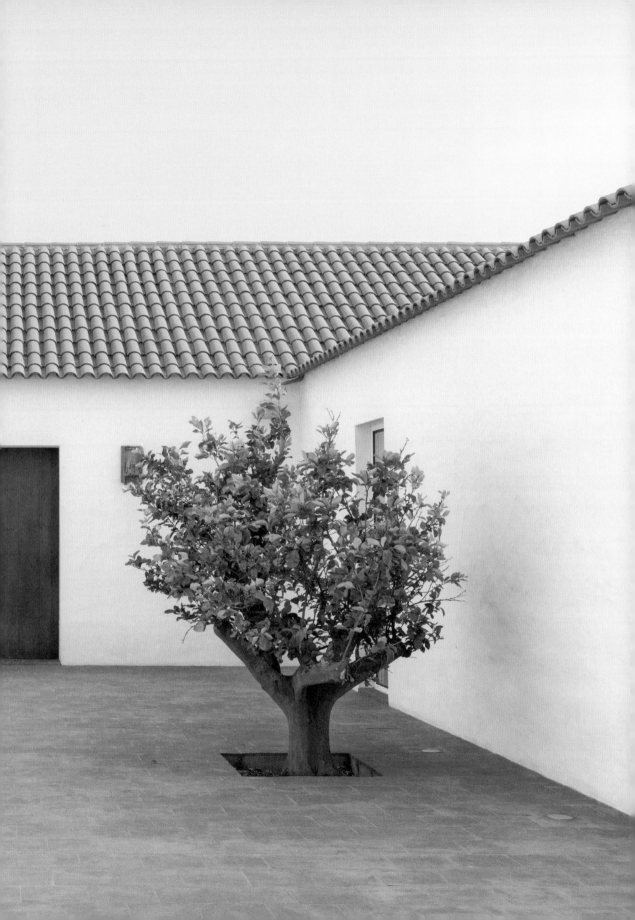

← The Casa das Histórias Paula Rego, designed by famed architect Eduardo Souto de Moura, is a museum dedicated to the works of artist Paula Rego.

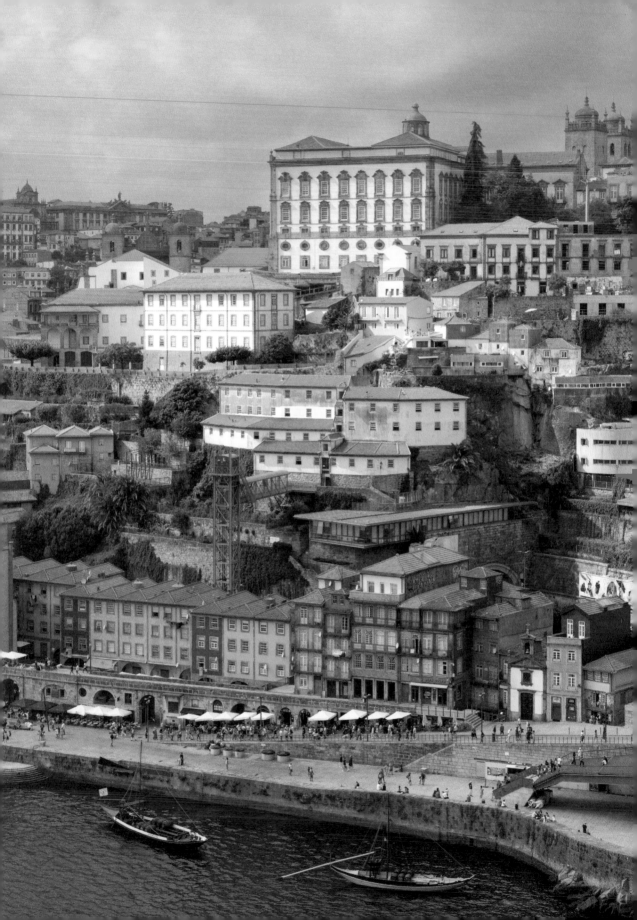

PORTUGUESE ARCHITECTURE

PORTUGAL'S ARCHITECTURE, LIKE ALL aspects of its culture, is marked by its history, from the time when riches poured in from its colonies to the ingenuity it took to rebuild Lisbon after the devastating earthquake in the mid-eighteenth century. Across the country, examples of nearly every classic style of architecture can be seen, from Romanesque, Moorish, and Gothic to Baroque, Rococo, and Pombaline.

In the sixteenth century, the Portuguese developed Manueline architecture, an ornate style that incorporated nautical elements and represented the voyages, conquests, and subsequent riches of Vasco da Gama and Pedro Álvares Cabral. Because Portugal's wealth was dependent on sea trade, Manueline decorations paid homage to the ocean quite literally with carved barnacles adorning ornate moldings, and anchors and buoys depicted in carvings above doors and windows. In Lisbon, the Tower of Belém, Estação do Rossio, and Jerónimos Monastery are prime examples of Manueline architecture.

It's nearly impossible to walk more than a block in Lisbon without coming upon an architectural wonder. Soaring over the city is Castelo de São Jorge, which long provided fortification against invaders and dates back to the first century B.C. The ruins of Convento do Carmo, which was once one of the most affluent churches in the city, offer a dramatic glimpse of the earthquake's destruction. Its remaining convent walls, Gothic arches, and attached museum now serve as a place of remembrance. The oldest church in the city, the Cathedral of Saint Mary Major, widely called the Lisbon Cathedral, was built in the twelfth century atop a spot that once held a Moorish mosque. One of the most notable features of this striking mix of Roman, Gothic, and Baroque architecture is the stained-glass rose window set between the two soaring bell towers. Lisbon's notable modern landmarks include the waterfront Museum of Art, Architecture and Technology (MAAT), the Álvaro Siza–designed Portuguese National Pavilion, and the futuristic Vasco da Gama Tower.

Home to a renowned school of architecture, Porto is especially known for its celebrated local architectural talent, including Pritzker Prize–winning architects Eduardo Souto de Moura and Álvaro Siza. The city's architectural attractions range from the Neoclassical-style Palácio da Bolsa to contemporary standouts like the Serralves Foundation, Casa da Música, and Porto Leixões Cruise Terminal.

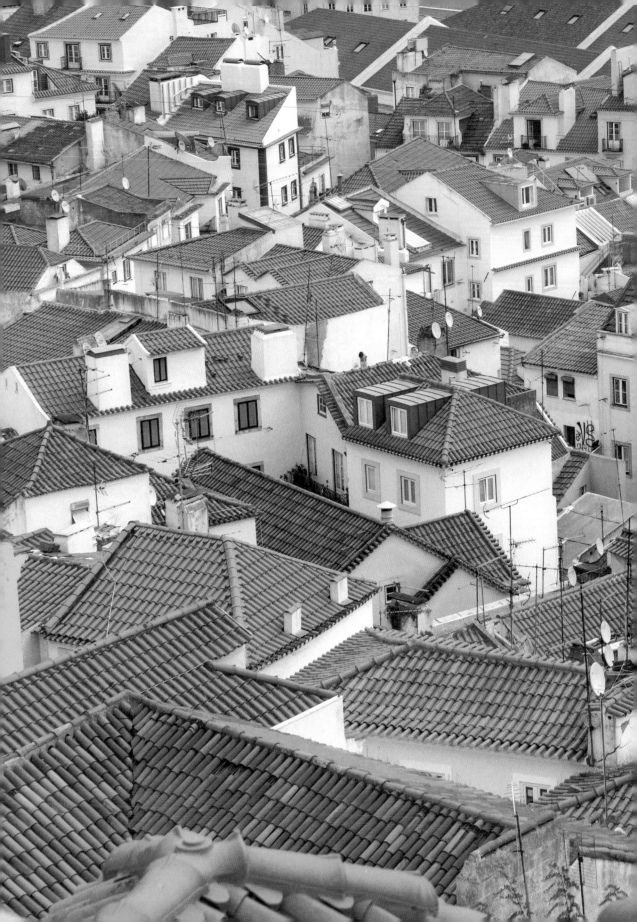

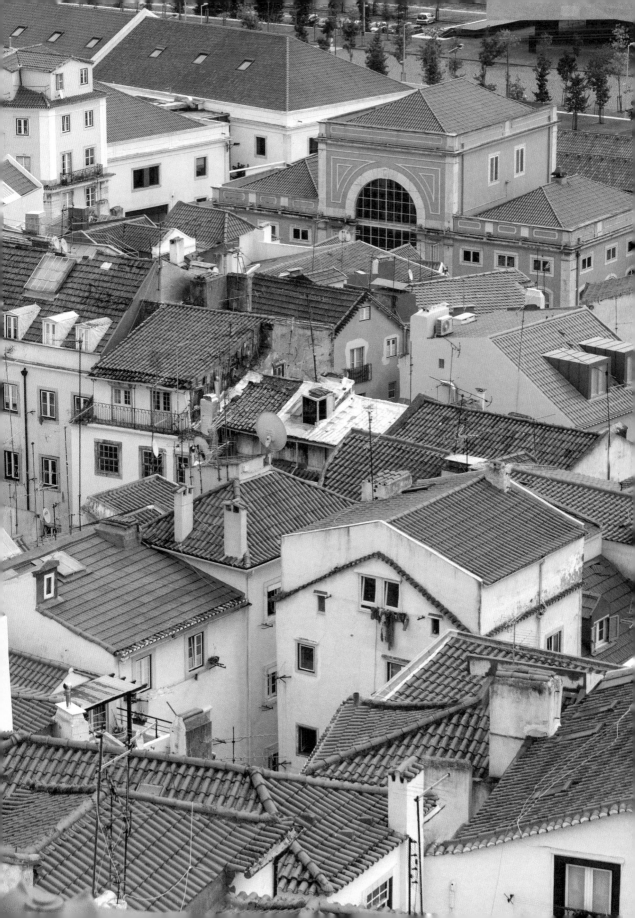

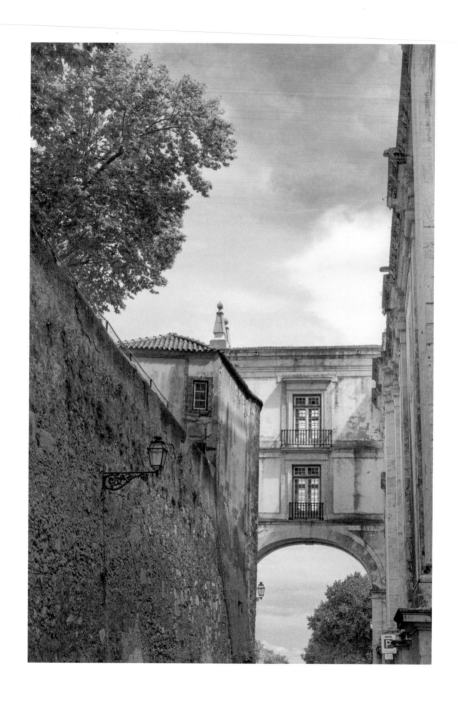

⟵ The traditional clay roof tiles synonymous with Portugal are more than just aesthetically pleasing, their shape allows water to drain easily and helps cool the house.

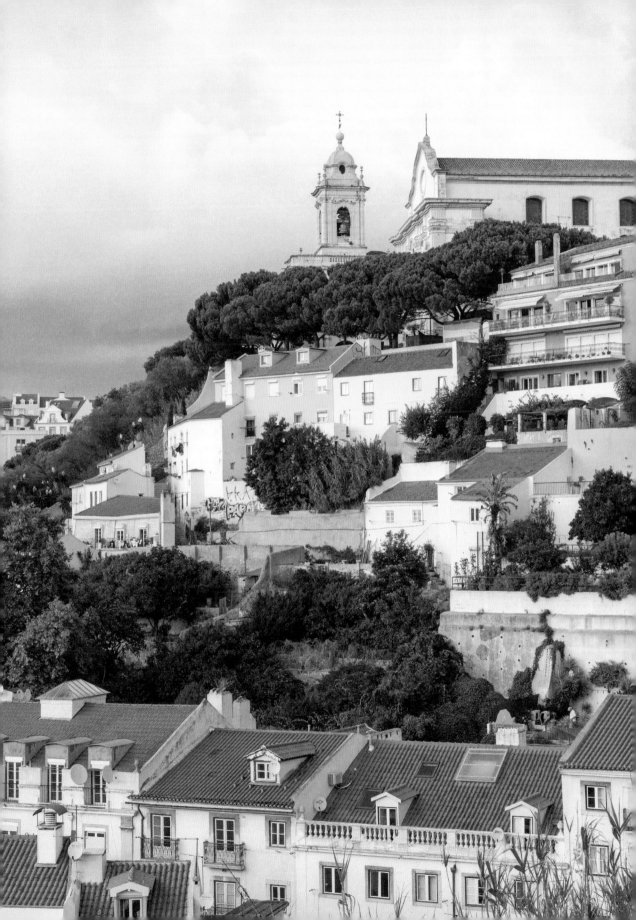

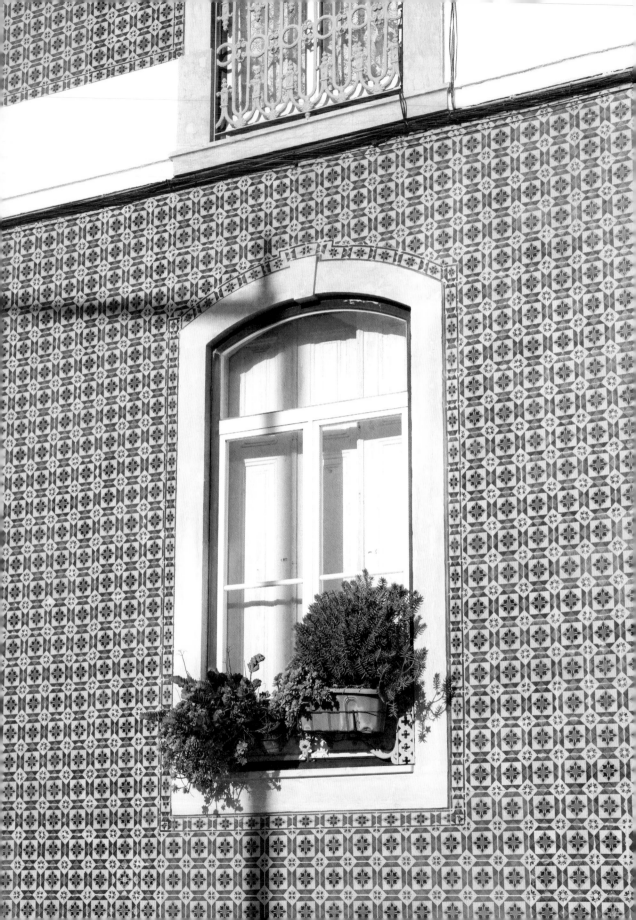

← During the reconstruction of Lisbon after the great earthquake of 1755, azulejos started to follow the Pombaline style. The ceramic tiles, known as *azulejos pombalinos*, were moved from the interior of churches to the exterior of buildings and homes.

↑ The upper floors of the Museu Nacional do Azulejo feature panels of modern and abstract tile designs of the twentieth century.

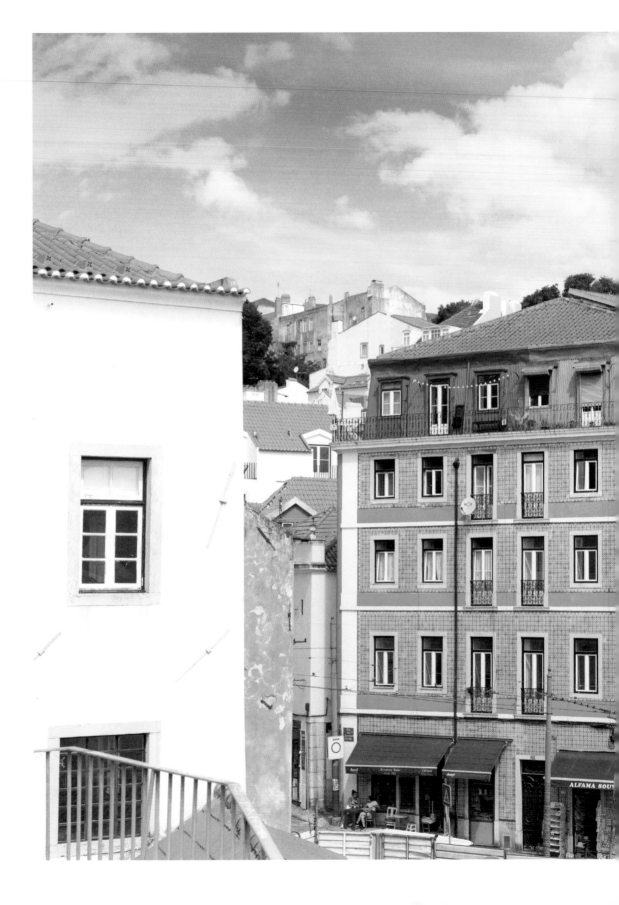

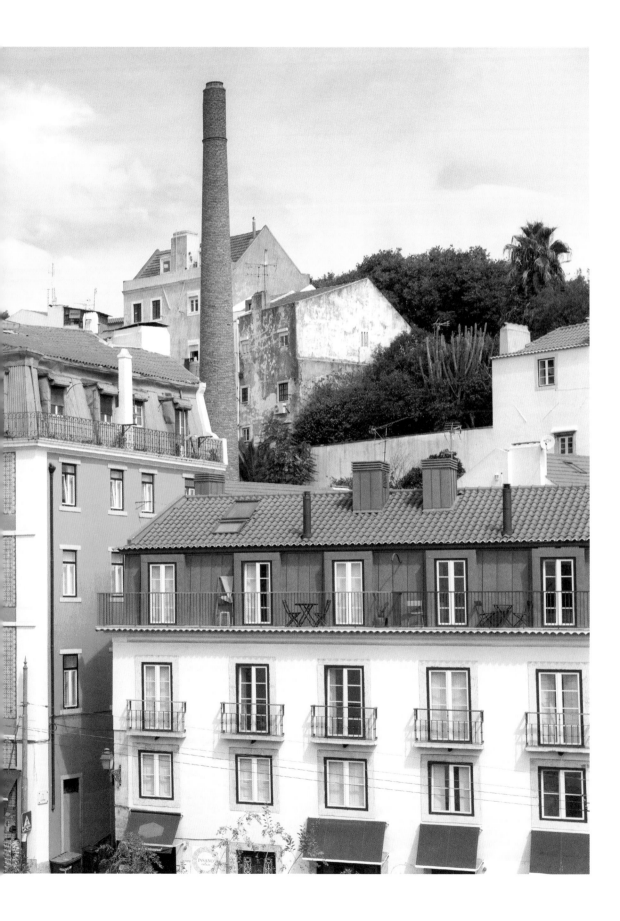

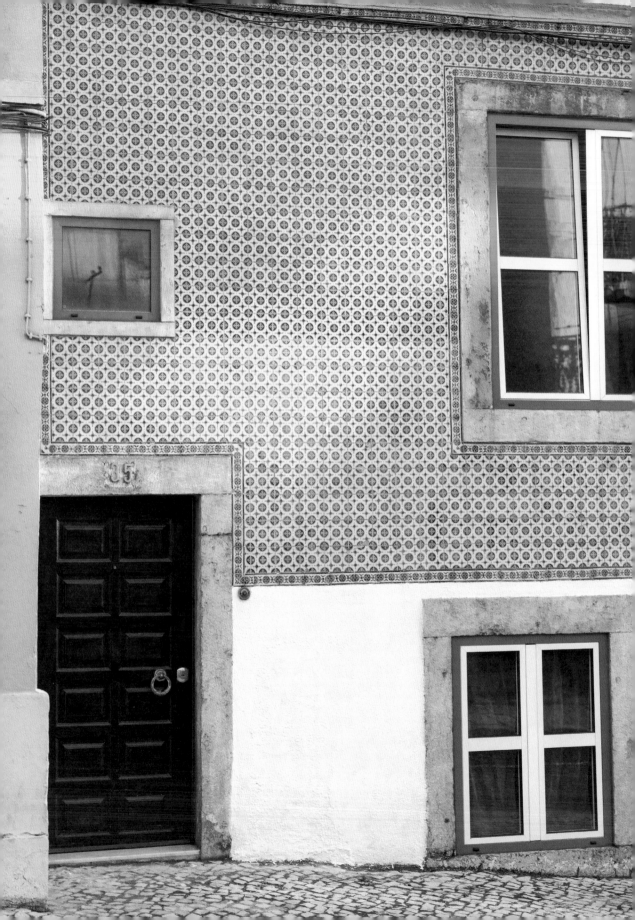

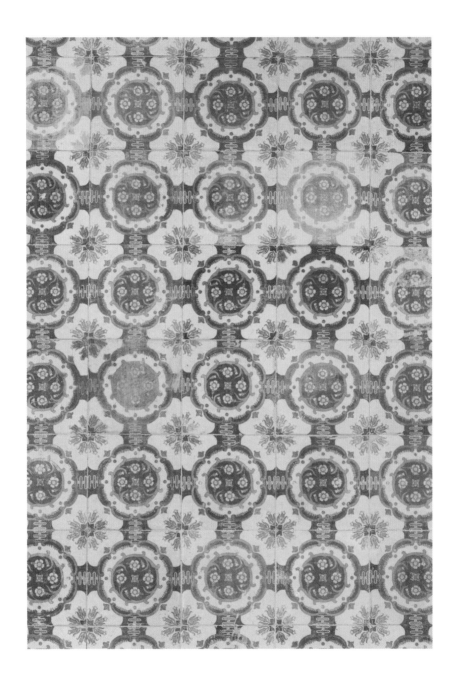

←↑ It's not uncommon to see azulejos with errant paint drops or bleeding colors, which is a nod to the handmade nature of historic tiles. Incorporating practicality into something so artistic seems to perfectly capture the Portuguese sensibility.

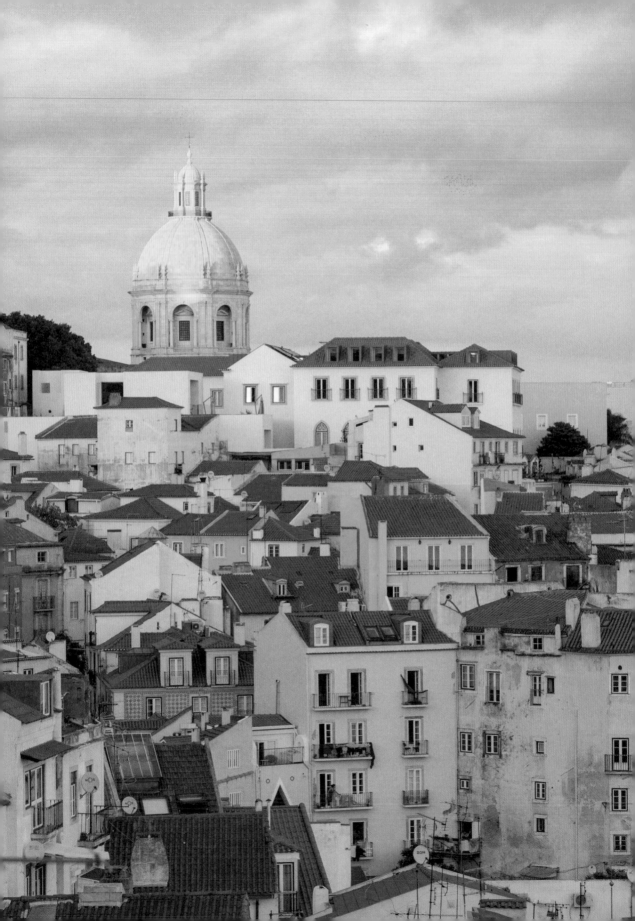

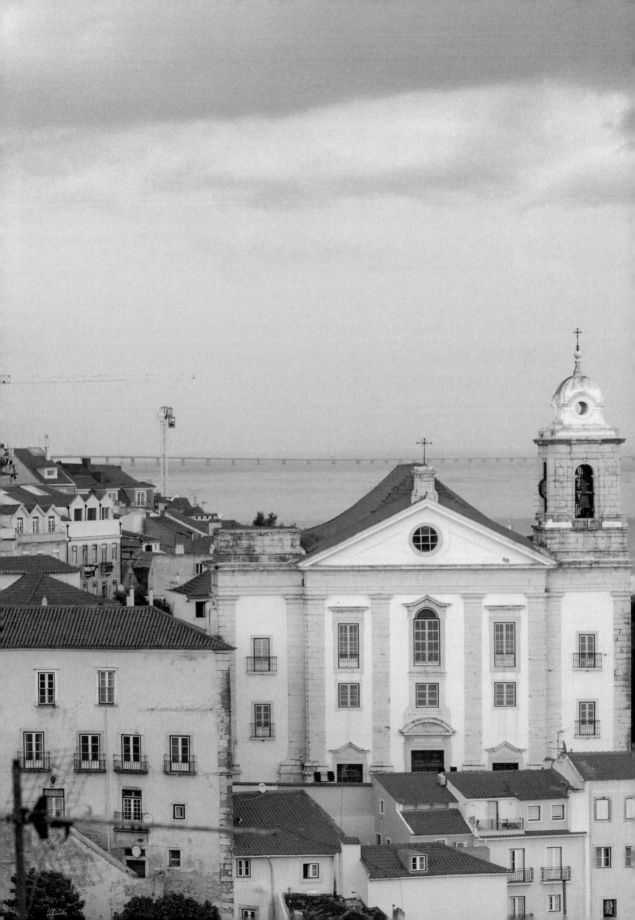

←— Lisbon, "The City of Seven Hills," offers sweeping sunset views from endless vantage points, including here at Jardim Júlio de Castilho.

→ Slate, a stone formed from clay that has transformed under metamorphic conditions, is found in quarries in Northern Portugal. It is common to see it used as siding, like on this house in the village of São Cristóvão de Nogueira.

p. 226–27 Views of the Alentejo landscape from the tiny walled village of Monsaraz

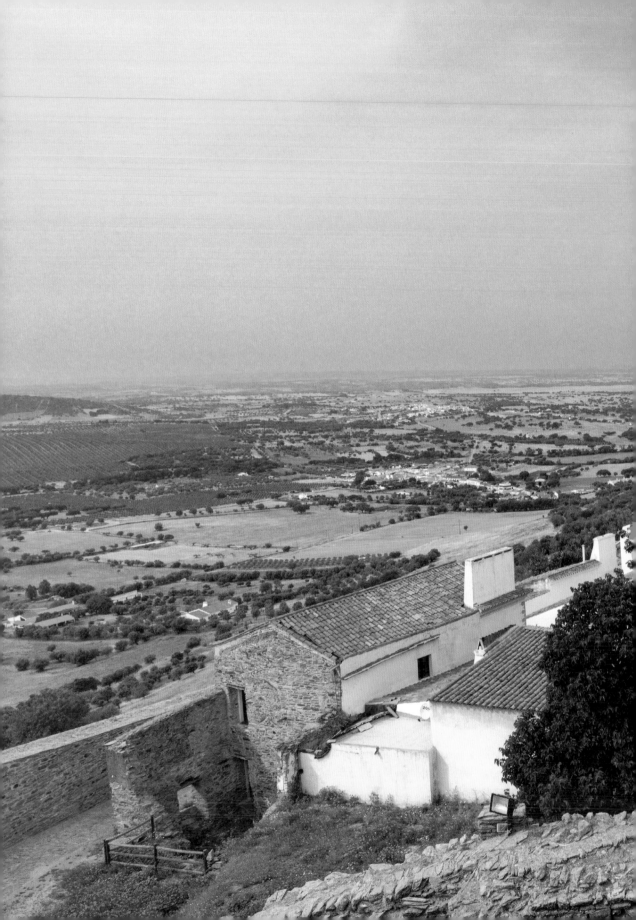

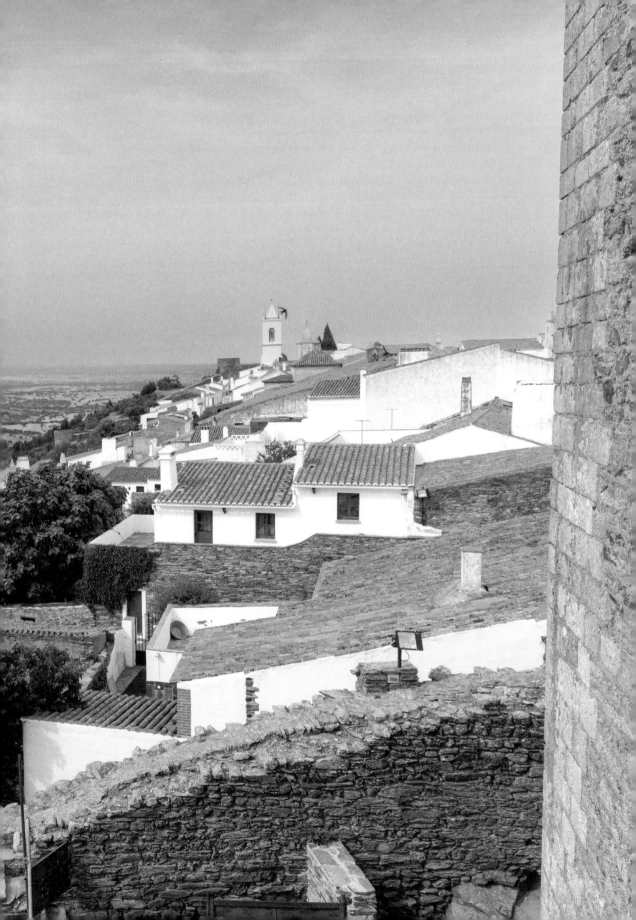

VERDE

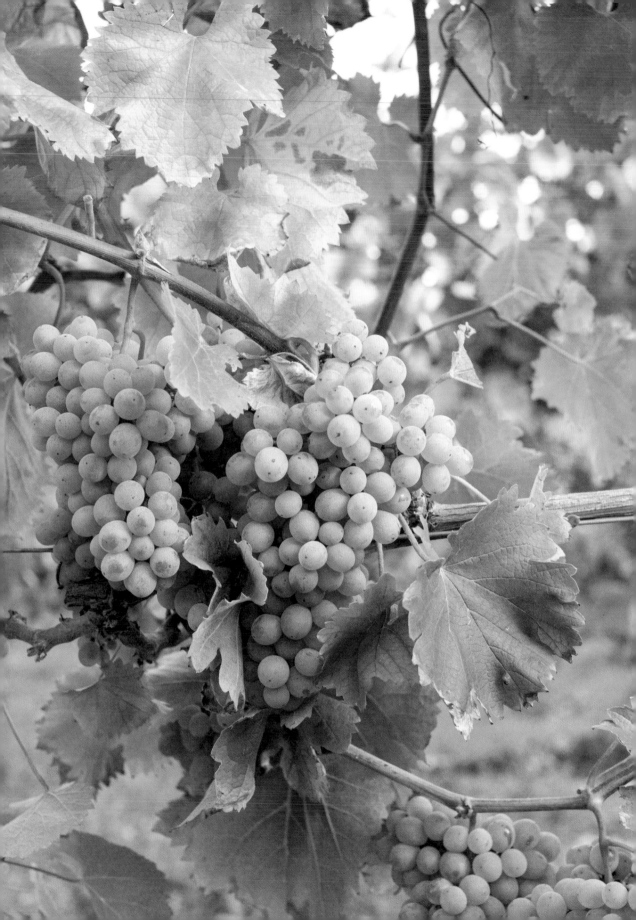

Food is so much more than what we eat; it is an expression of the culture, just as much as history, art, architecture, and music. Tastes change and evolve over time, transformed through trade and immigration, colonization, and commerce. And while that is true in Portugal, much of its culinary legacy is firmly rooted in the soil and sea: the golden fields of wheat, dusky olive groves, industrious fishing villages, and terraced vineyards.

In the tiny, lush village of São Cristóvão de Nogueira, through which the Douro River flows, I spent a few nights at a guesthouse in a thoughtfully restored bakery. On my first morning, my host, Maria, and her mother, Jacinta, served a made-from-scratch breakfast with ingredients gathered from around their farm: juicy kiwis and crisp apples from the orchard, moist yogurt cake made with their olive oil and fragrant with just a touch of citrus, crusty bread still warm from the oven, and tiny glass jars of homemade raspberry, apricot, and sour cherry preserves bottled up the previous fall. Maria's family has lived here for three generations and traditions around the land abound.

Similarly, down south in the Algarve, I stayed at a family-owned boutique hotel located on one hundred sprawling, golden acres of cork oaks, olive groves, carob trees, and fig orchards in the Castro Marim Nature Reserve, just a few miles from the charming town of Tavira. The memorable breakfast spread included a bounty of local produce: freshly picked apricots, homemade bread thickly spread with their olive oil and fig preserves, eggs simmered in tomatoes picked from the vegetable garden, and farmer cheese.

These experiences are not unique in Portugal, where 40 percent of the country is classified as agricultural land. I experienced firsthand the richness of the local bounty while partaking in the olive harvest, picking Azal branco grapes destined to become Vinho Verde wine, visiting fishing ports and watching the daily catch laid out to dry on the beach, and horseback riding through the Alentejo grassland where the famous Alentejana cattle, Black Iberian pigs, and Merino sheep

← Azal branco is one of the most widely planted grape
varieties in the Vinho Verde region.

graze freely. If ever proof was needed of how deliciously wonderful the world is, it is in the flavorful bounty of Portugal.

It is impossible to talk about Portugal's agricultural scope without focusing the spotlight on the Douro Valley, one of the most picturesque landscapes in the entire country. The valley has been shaped by more than two thousand years of viniculture, with steep terraces carved into the hills along the banks of the Douro River, which runs more than 550 miles from central Spain to Porto. In the summer months, the valley is lush and verdant, while in autumn, during the grape harvest, the colors change to fiery reds and blazing oranges. This UNESCO World Heritage Site is the oldest demarcated wine region in the world; only grapes grown here can be used to legally produce port wine.

Not to be overlooked, the Vinho Verde wine region is the largest in the country, located in the northwest corner of Portugal. The crisp, subtly carbonated wines from this coastal area rich in water resources, with mild temperatures, abundant rains, and fertile soils, pair beautifully with lighter seafood fare.

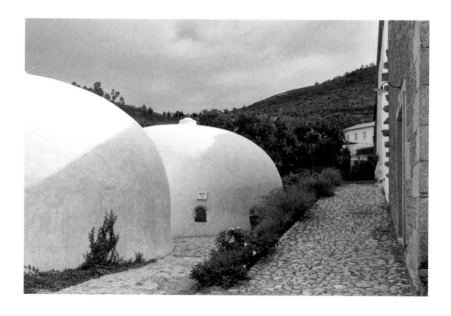

↑ The *balões* (balloons), with their curved whitewashed walls, are two of the most unusual guest rooms at Ventozelo Hotel & Quinta. The large, rounded concrete vats were once used for wine storage.

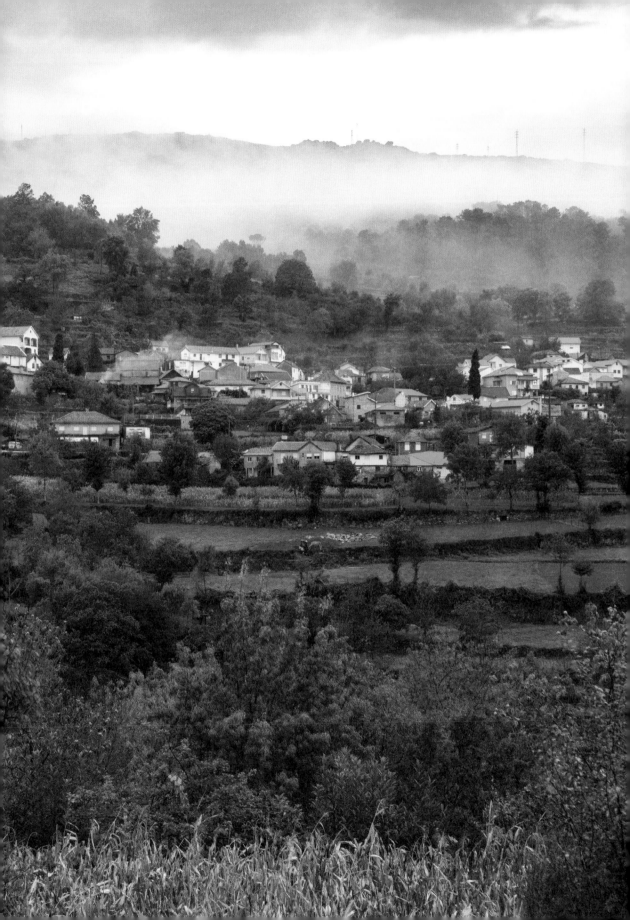

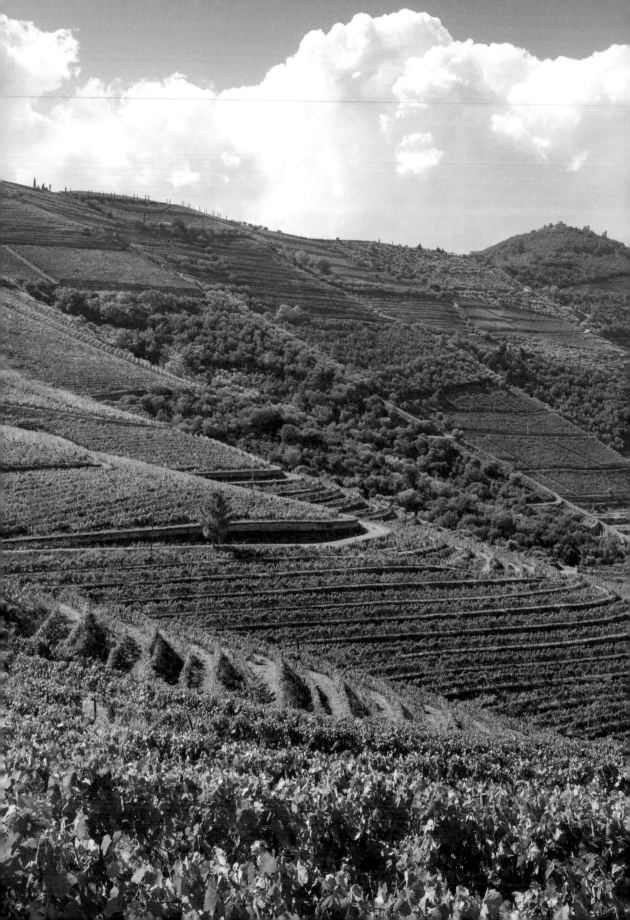

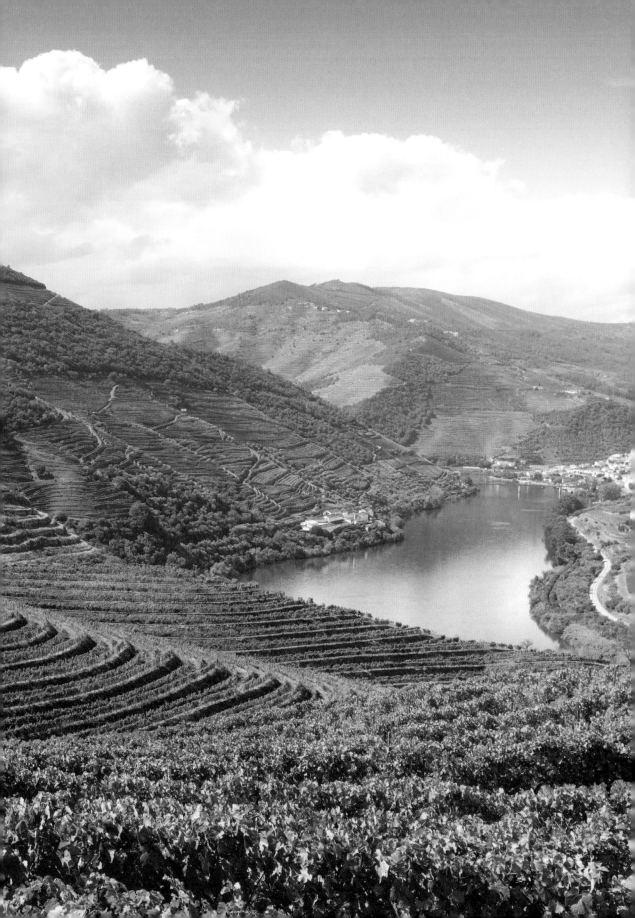

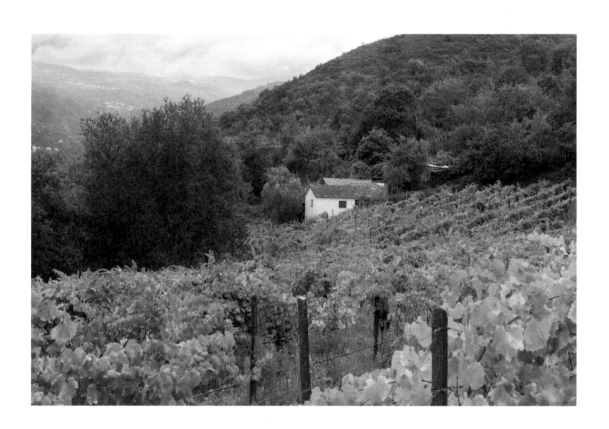

⟵ The verdant, terraced Douro Valley is the oldest demarcated wine
region in the world and a UNESCO World Heritage Site.

↑ → In the tiny, lush village of São Cristóvão de Nogueira, through which
the Douro River flows, vineyards and orchards abound.

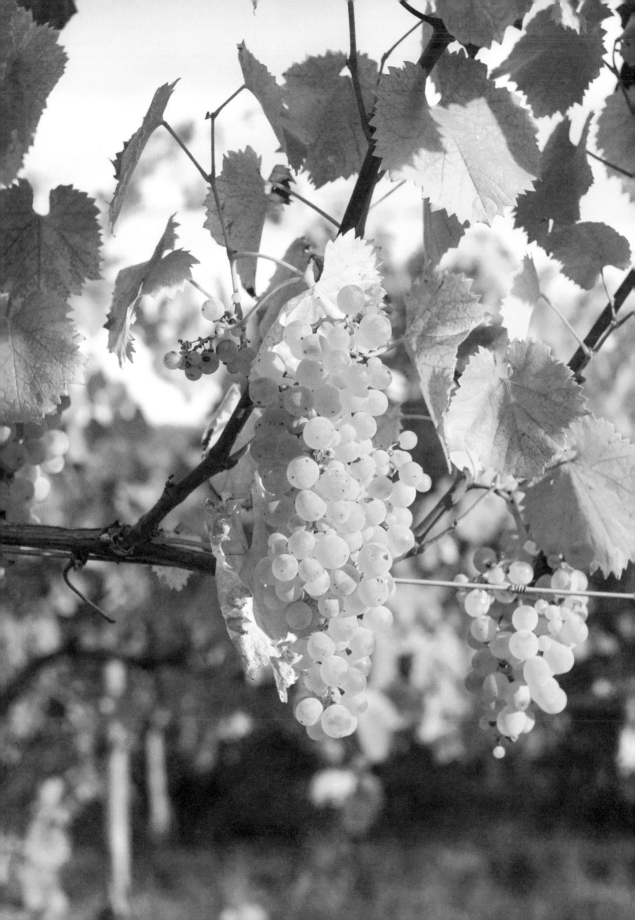

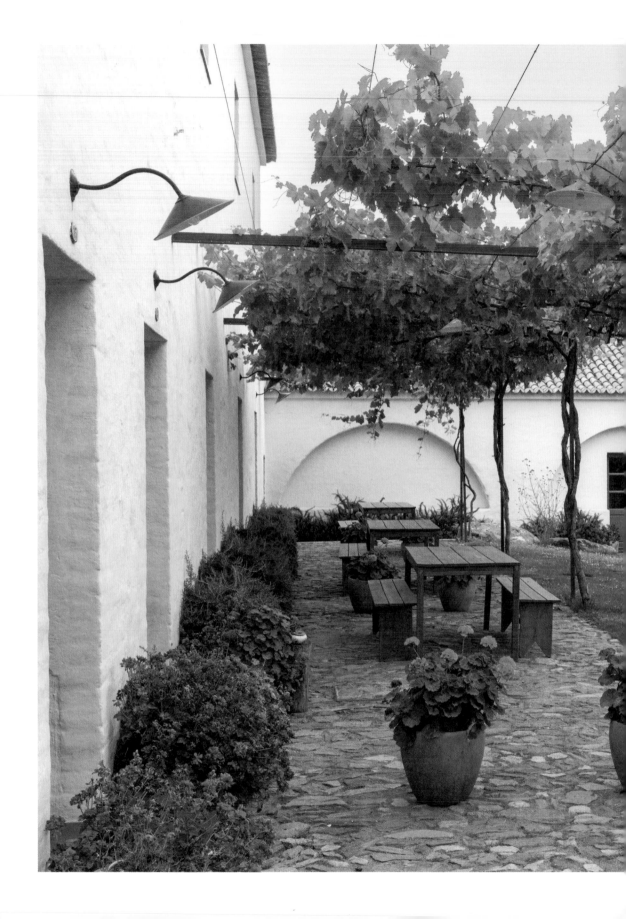

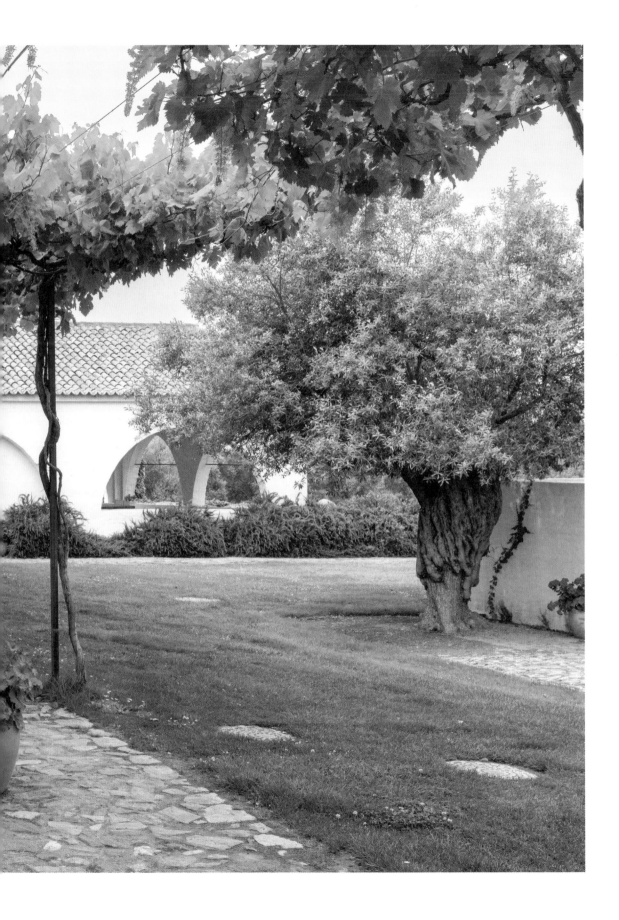

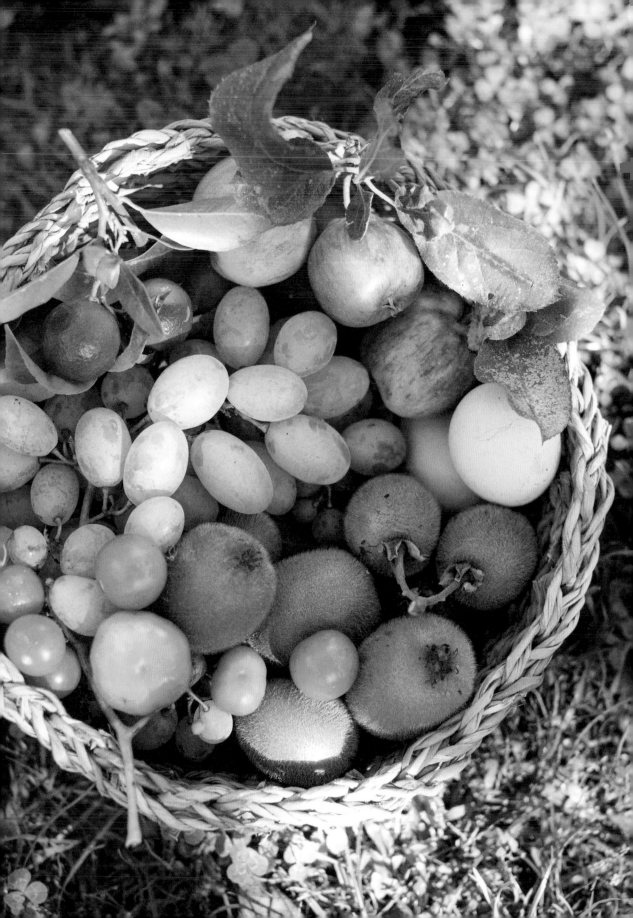

CUISINE:
INFLUENCES AND FLAVORS

A MIX OF ATLANTIC AND Mediterranean flavors peppered with the seasonings of the spice route, Portuguese cuisine relies heavily on seafood, bread, cheese, olive oil, and of course wine, the most notable of which hails from the famously fertile Douro Valley, though Alentejo and Vinho Verde wines are also deserving of attention. *Bacalhau*—the Portuguese word for cod—dominates most menus, and my favorite preparation is *bacalhau com natas* (cod with cream). Sardines dusted with coarse sea salt, grilled over charcoal, and served on top of toast are a Portuguese delicacy, as is the fragrant dish *amêijoas à Bulhão Pato* (clams made with olive oil, white wine, coriander, plentiful garlic, and a drizzle of lemon juice).

For a spicier kick, piri-piri chicken, a popular dish that perfectly encapsulates the far-flung influences of Portuguese food, fits the bill. While the searingly hot piri-piri chili was originally in the Americas, early Portuguese explorers came across the pepper in Brazil and brought the seeds to its African colonies of Mozambique and Angola. It was here that the chili was crushed, mixed with lemon juice and garlic, and turned into a marinade. Piri-piri chicken evolved and eventually made its way to Portugal, where it is now one of the country's most popular dishes. Bottles of piri-piri sauce—a spicy, salty, slightly sweet flavoring—can be found on nearly every table.

At the heart of every village is a *pastelaria*, or pastry shop, that serves an array of homemade sweet and savory delicacies, and it is here, over strong shots of espresso (*um café*), that daily life unfolds. Indeed, life in Portugal revolves around coffee, and no break is complete without an accompanying sweet. Try *pão de Deus* (a bread roll covered in coconut, egg cream, and sugar), *pastel de laranja* (a sticky orange tart), or *pastel de feijão* (a crispy tart filled with creamy navy bean jam). These are just a few of my favorites from the vast selection of Portuguese pastries.

But when it comes to sweets, nothing tops a *pastel de nata* (egg tart) pulled warm from the oven and dusted with cinnamon and powdered sugar. Pastéis de Belém, a historic sweetshop in Belém, is famous for its version of the Portuguese egg tart, which it has been making since 1837, following the secret recipe from the nearby Jerónimos Monastery. Each bite is a taste of pure heaven.

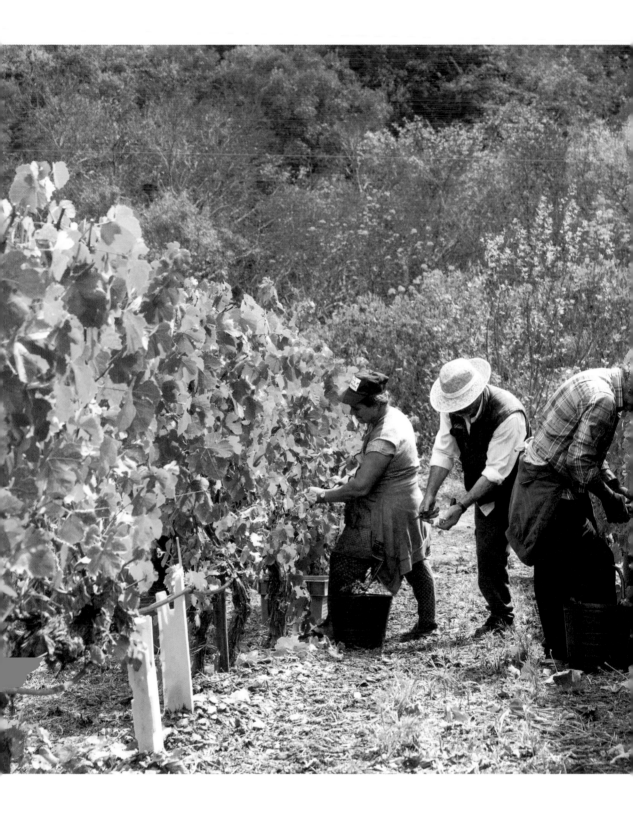

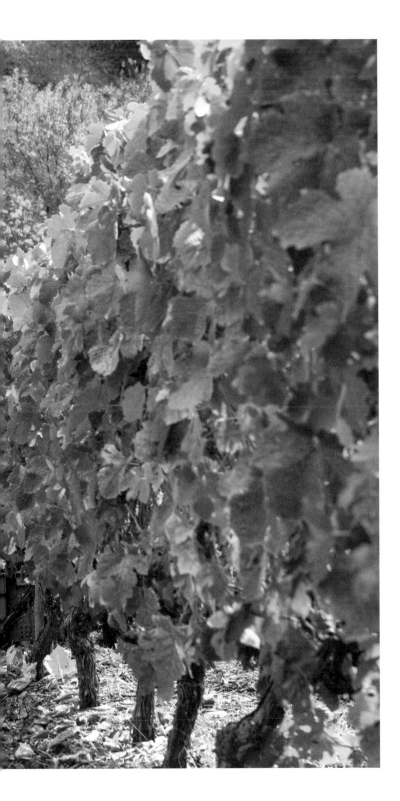

p. 238–41 Surrounded by olive groves and gnarled, ancient olive trees, São Lourenço do Barrocal was once a thriving nineteenth-century farming village in the foothills of Monsaraz. The 780-acre property eventually fell into disrepair until José António Uva (whose family owned the property for over 200 years) commissioned Pritzker Prize–winning architect Eduardo Souto de Moura to turn the traditional farm buildings into an elegant hotel.

⟶ The small parish of Furnas is situated within a volcanic basin on the island of São Miguel. Throughout the area, which is dotted with natural hot springs, large plumes of sulfuric steam create a dramatic landscape.

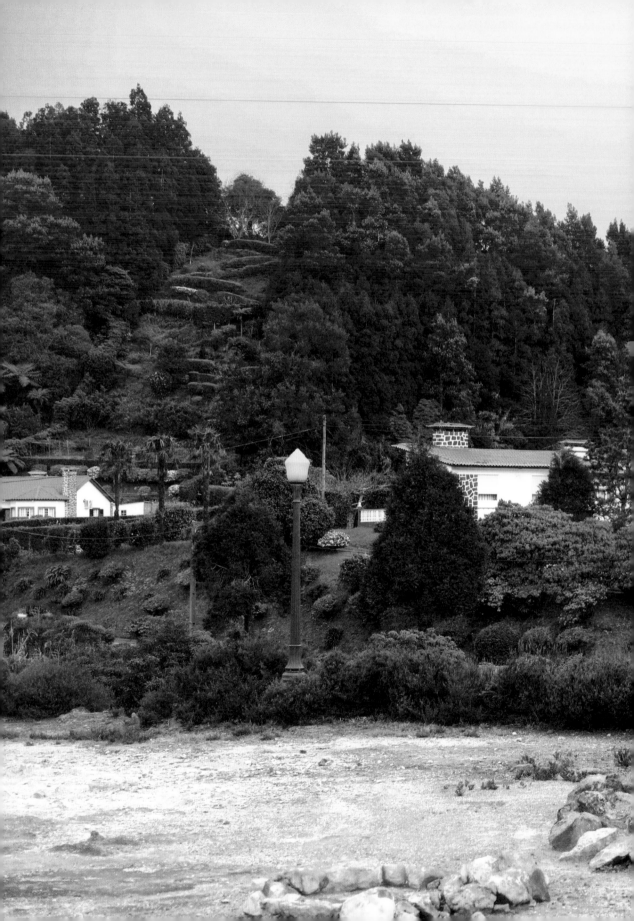

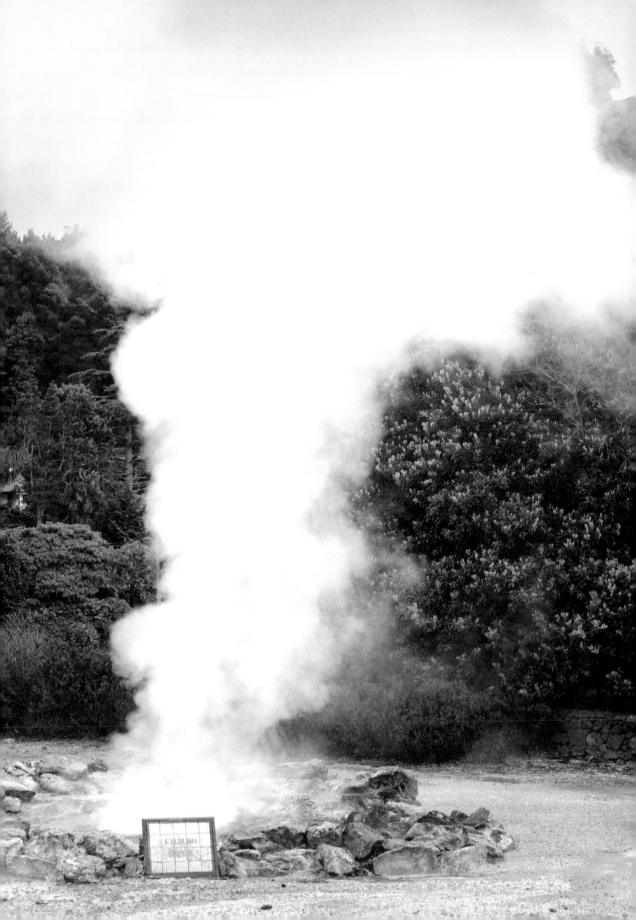

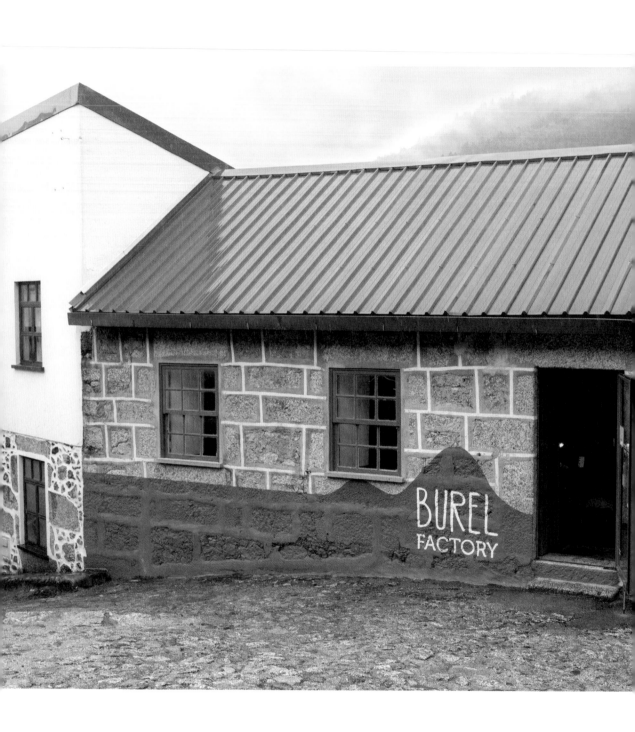

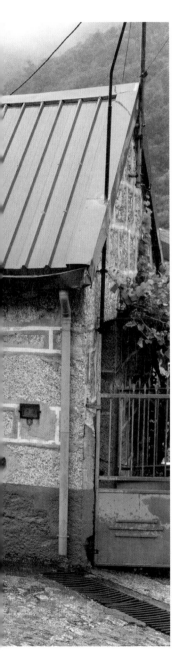
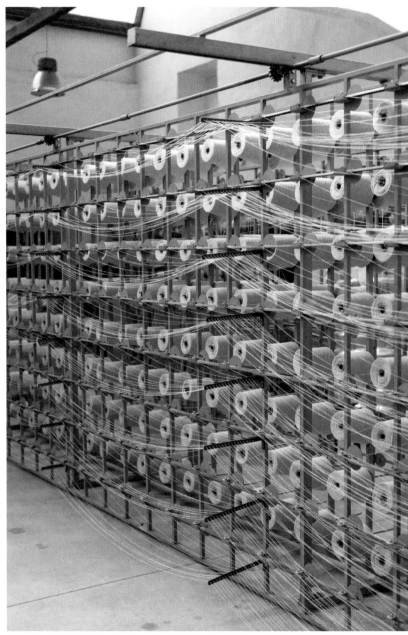

↖ ↑ ⟶ The Burel Factory, located in the mountainous village of Manteigas,
is dedicated to recovering and preserving the artisan techniques associated
with the production of burel, Portugal's most traditional wool fabric.

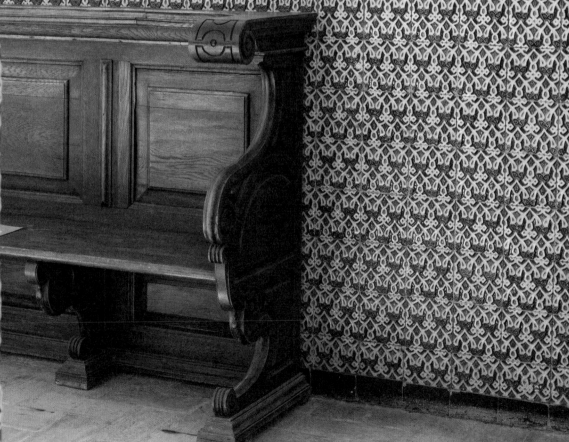

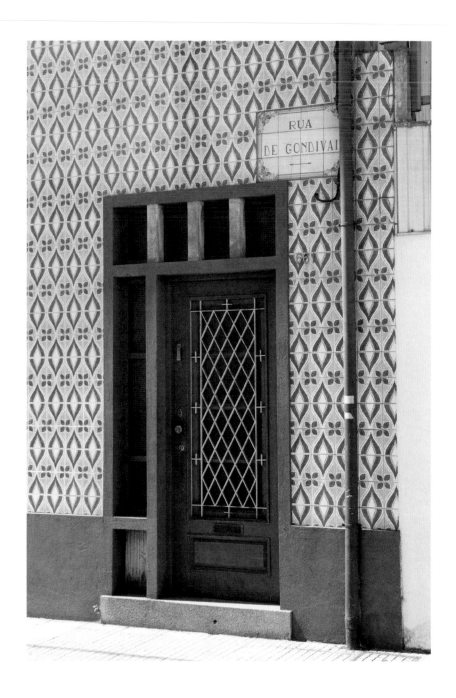

<----- The Museu Condes de Castro Guimarães in Cascais was once
an aristocratic summer home but is now a museum that features
polychromatic tilework in the cloisters.

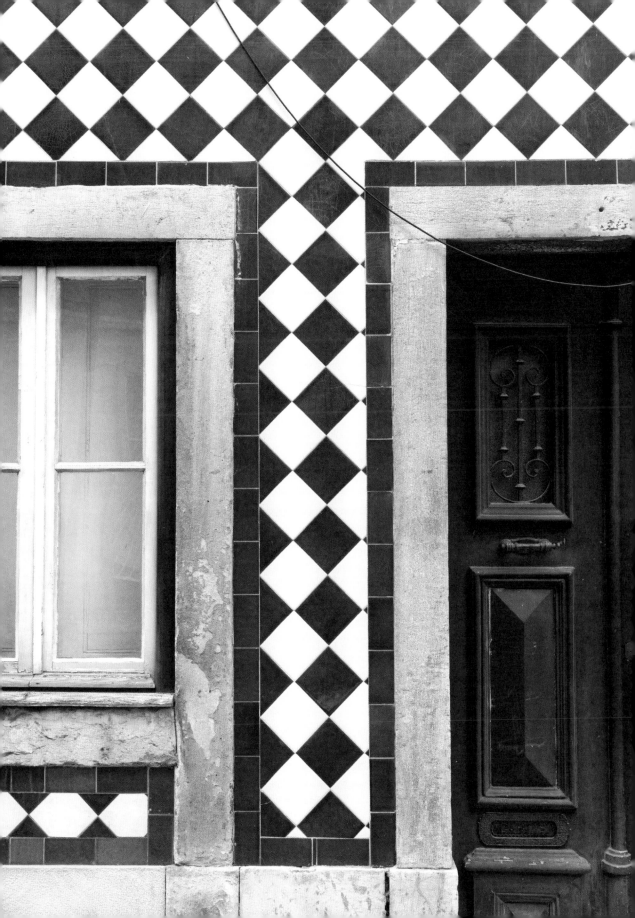

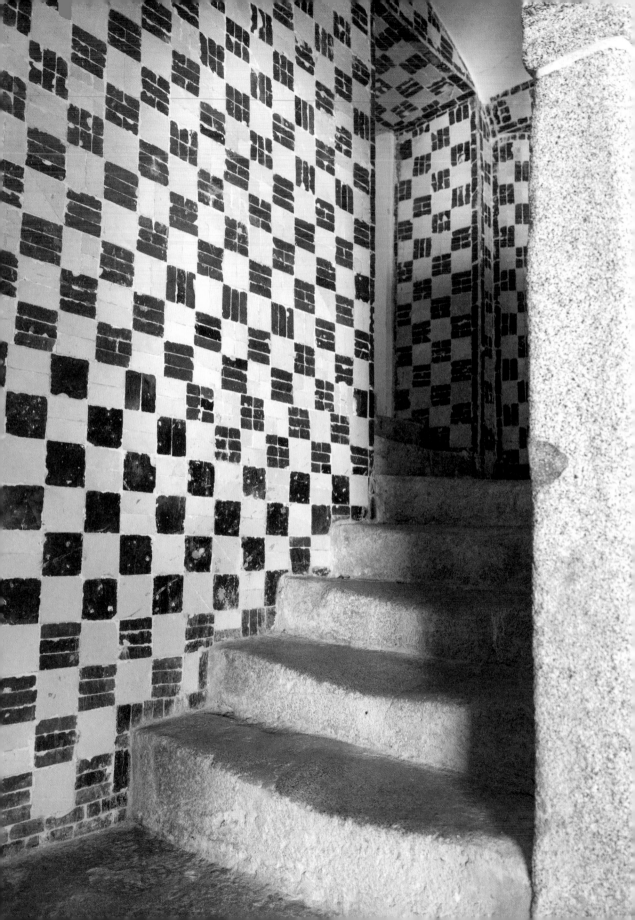

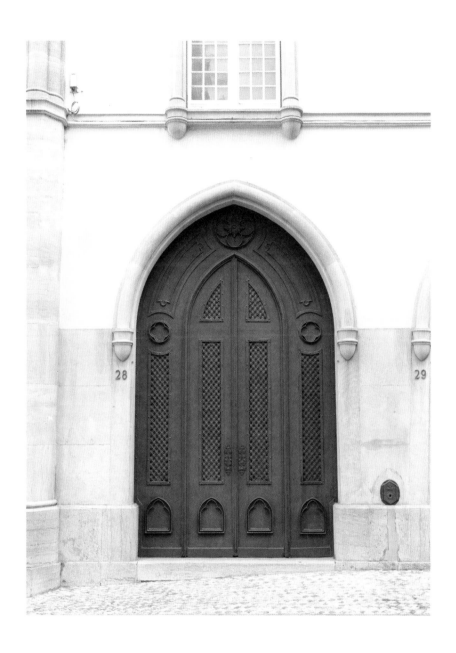

p. 253–54 Cities across Portugal, from Lisbon and Porto to Aveiro and Ovar, have created tile banks, which collect and store thousands of historic tiles from demolished, damaged, or condemned buildings. Preservation and appreciation for tiled facades reached a crescendo in August of 2017 when a law was passed prohibiting the demolition of buildings with tiled facades.

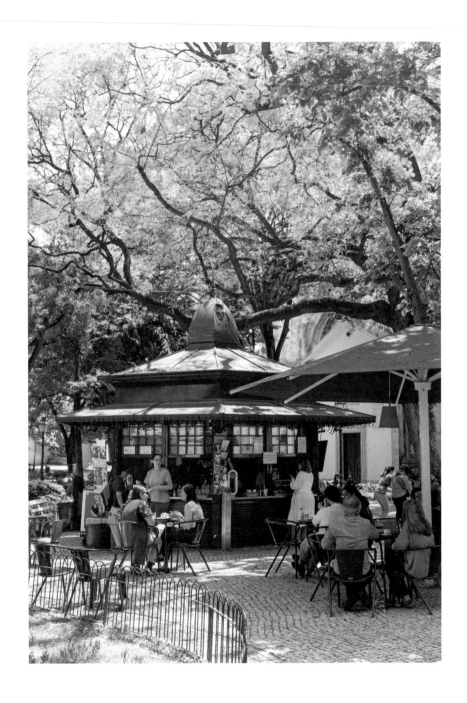

↑ *Quiosques de refrescos* (refreshment kiosks) are small, often ornate and colorful structures that serve traditional Portuguese snacks, drinks, and coffee. They play an important role in the street life and social fabric of the city.

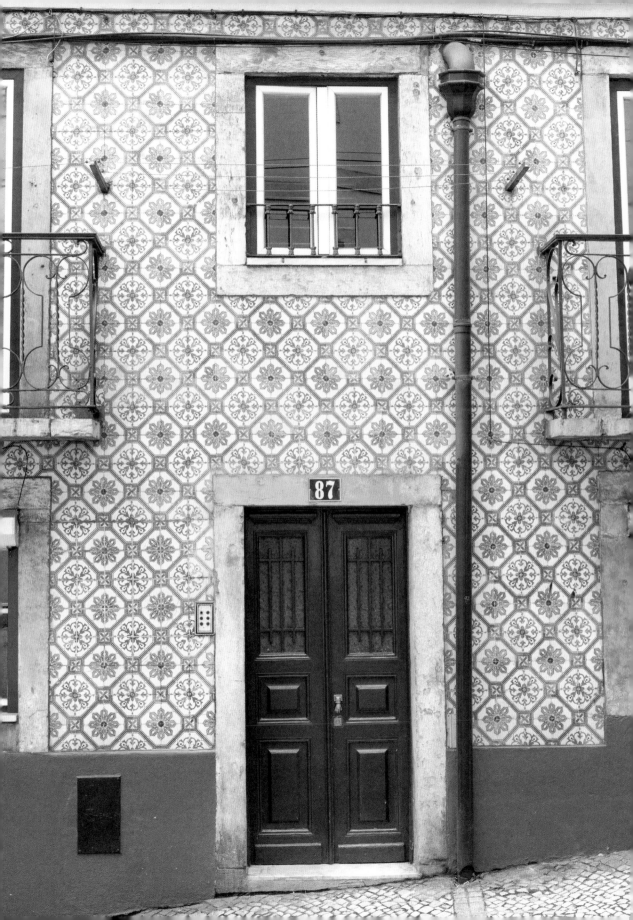

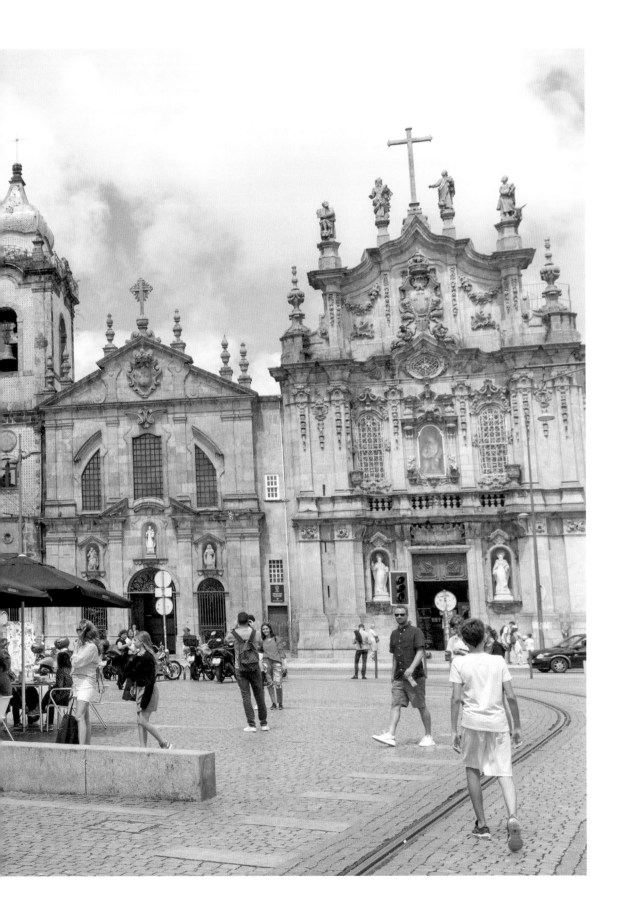

← The Igreja do Carmo (right) and Igreja dos Carmelitas (left) are two churches in Porto that are separated by an incredibly narrow three-foot-wide house that was built to discourage contact between the nuns and the monks.

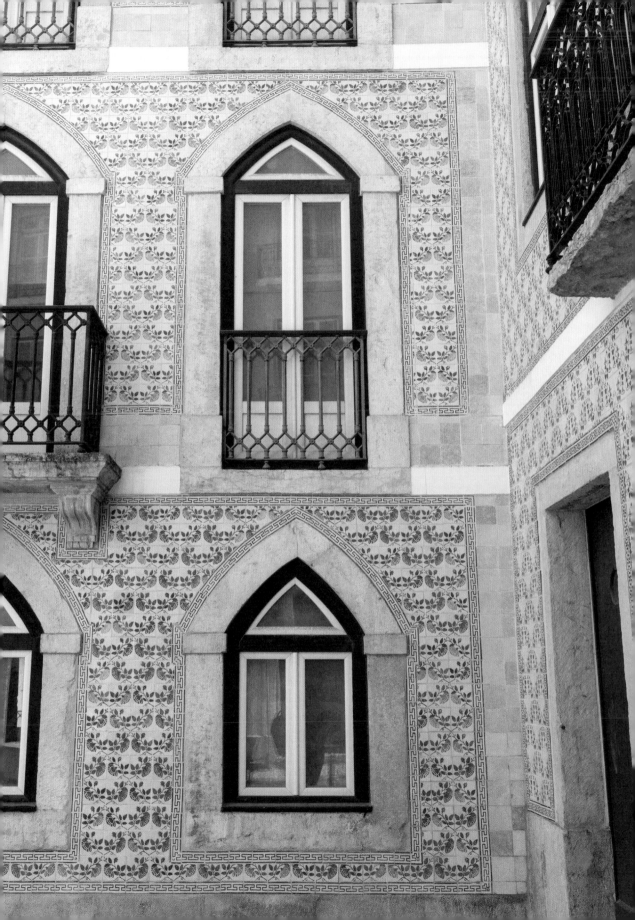

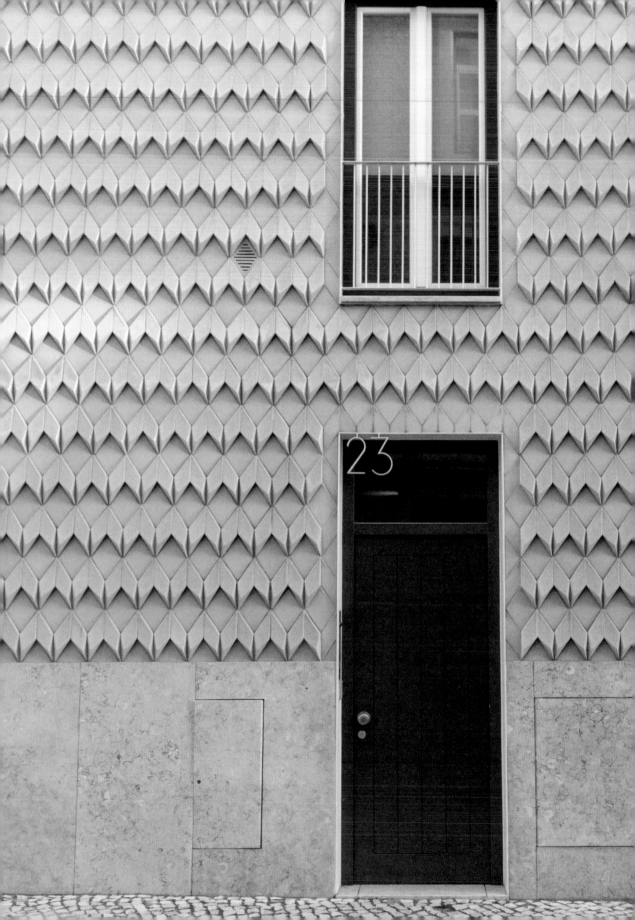

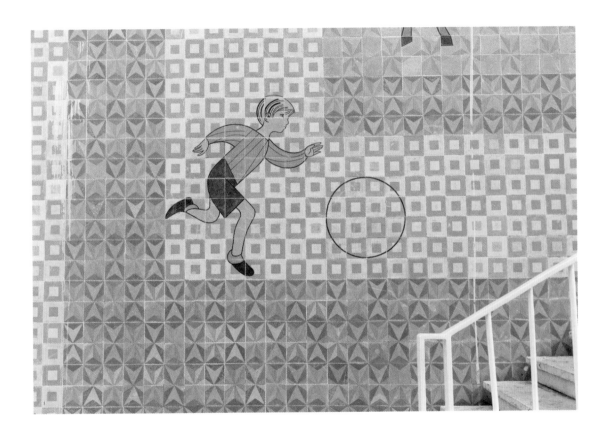

← The hand-glazed three-dimensional tiles by artist Maria Ana Vasco Costa add a sculptural feel to the facade of a residence in Lisbon's Estrela neighborhood.

↑ The Estrela neighborhood in Lisbon boasts incredible street art, including this modernist panel by Alice Jorge and Júlio Pomar on Avenida Infante Santo.

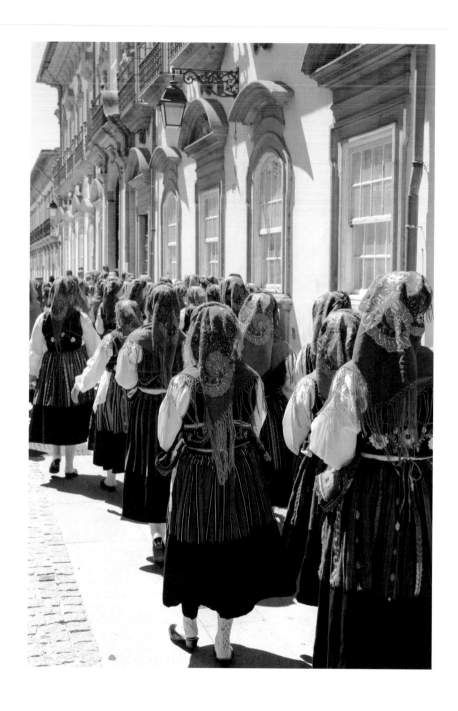

↑ Terras de Geraz's Trajes à Vianesa are distinguished from other
parish's costumes by their predominant tone of green.

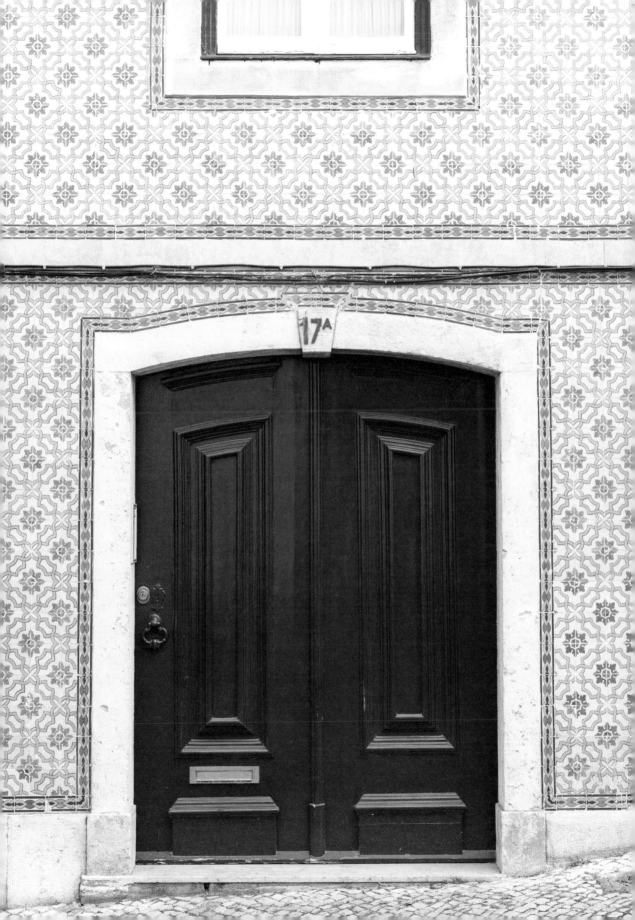

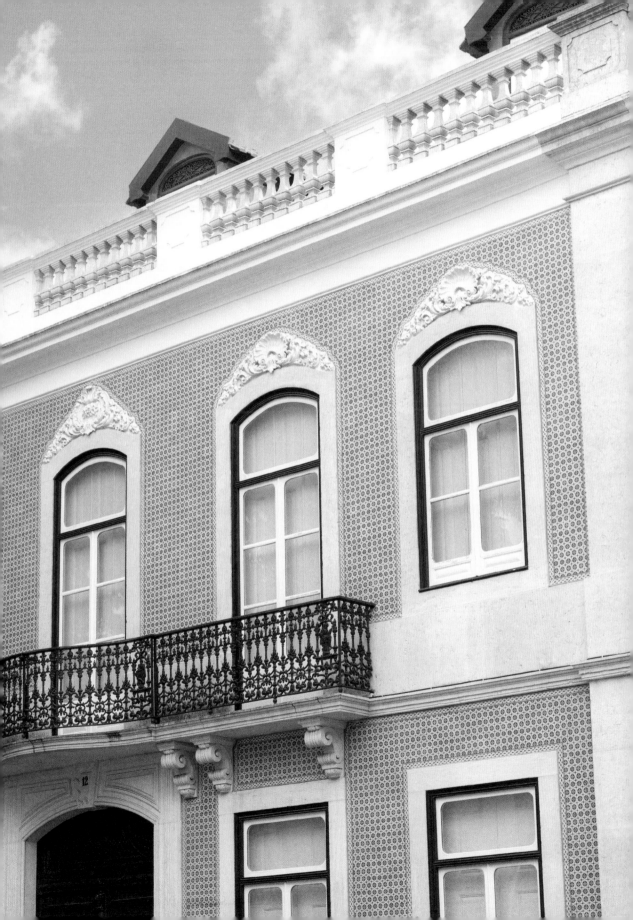

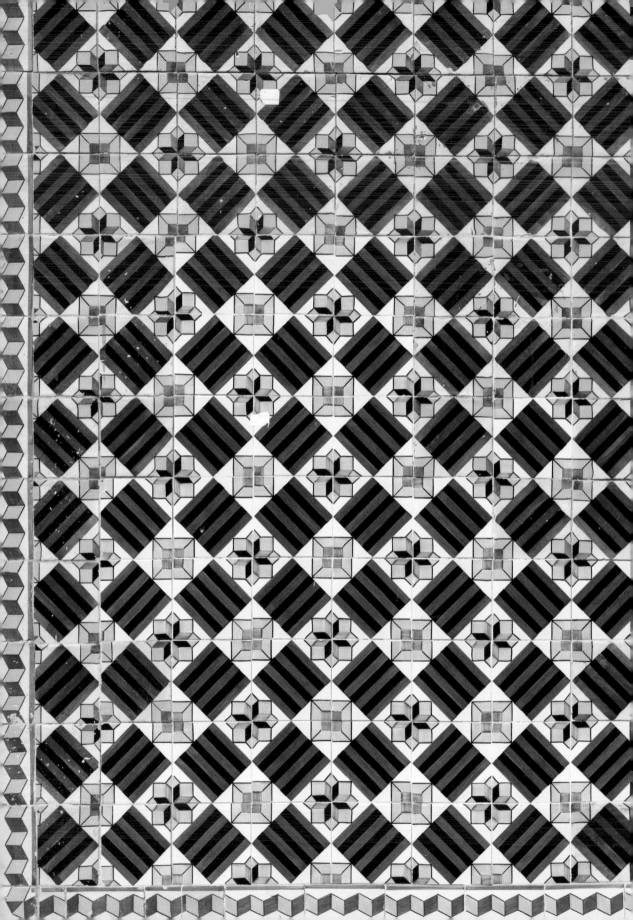

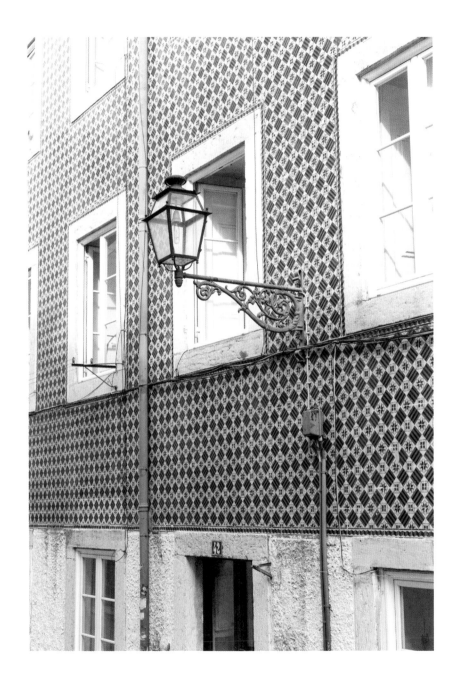

←↑ While the azulejos shown on pages 265 to 275 all adhere to the same dominant green color palette, distinct historical influences can still be seen in the designs, with motifs varying between polychromatic depictions of flora and fauna and Islamic-influenced monochromatic geometric patterns.

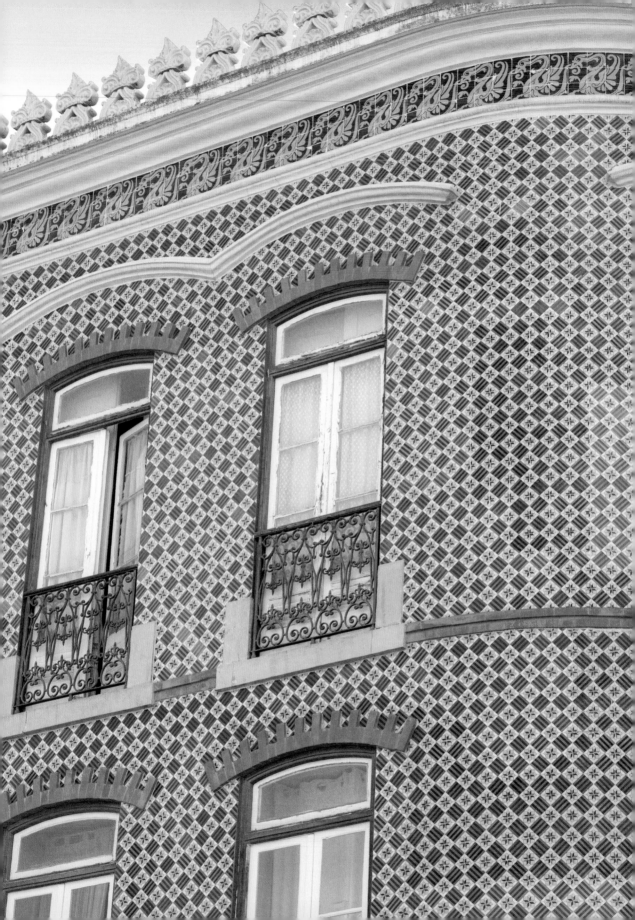

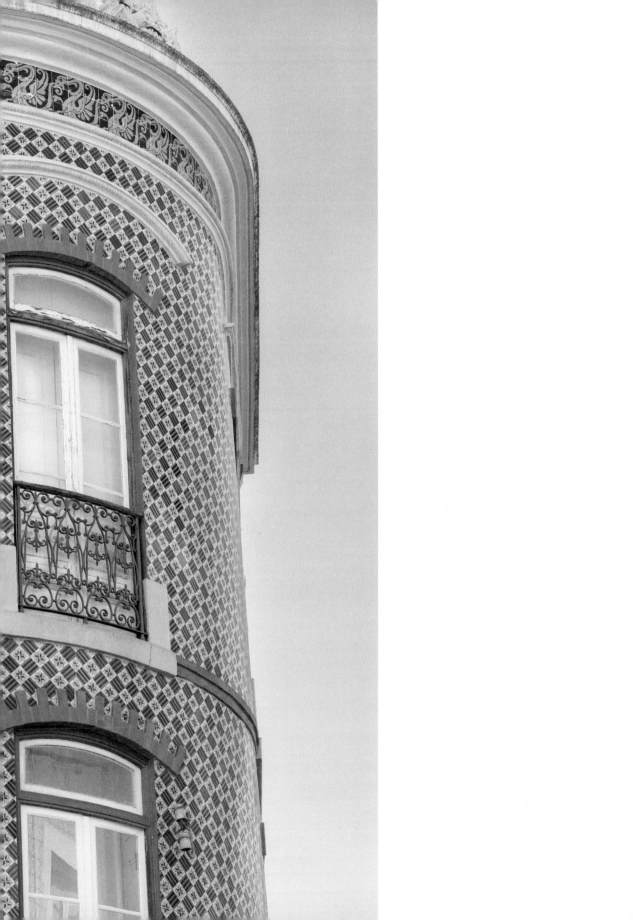

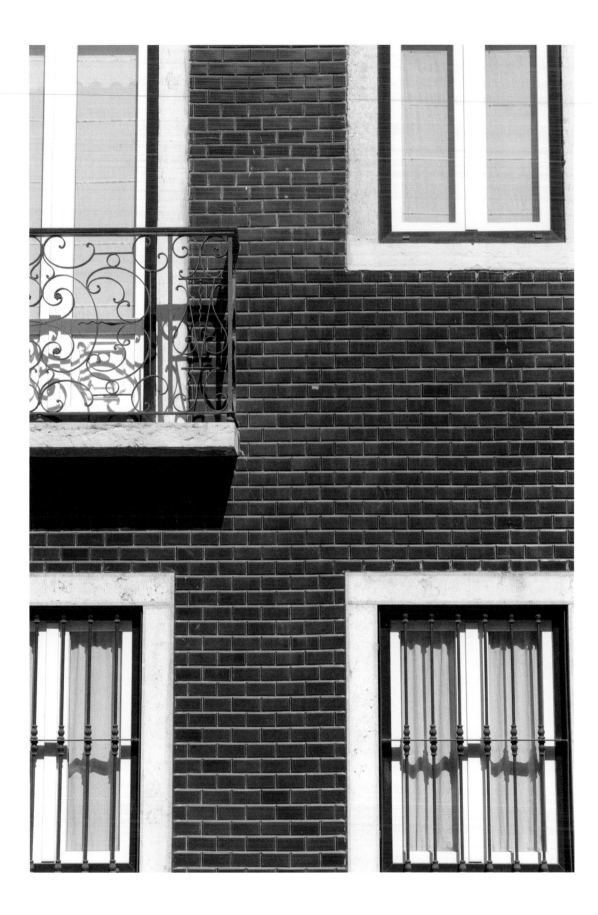

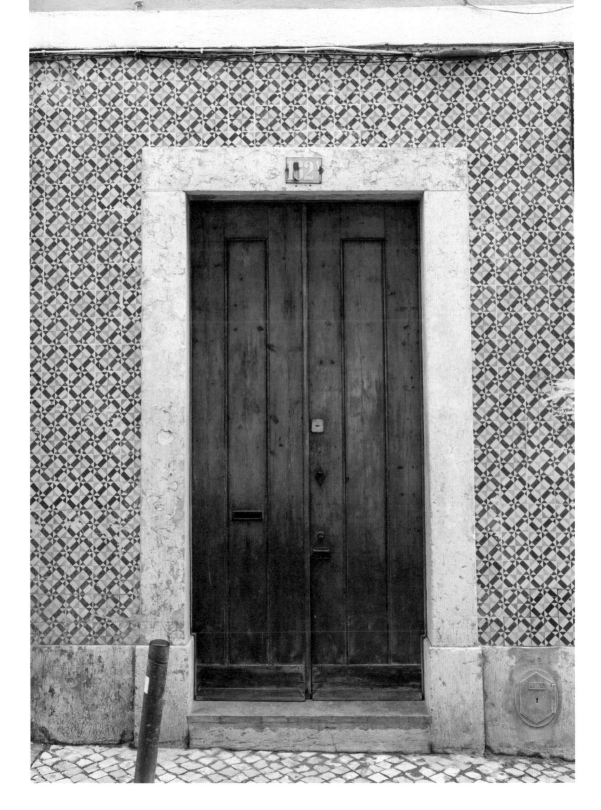

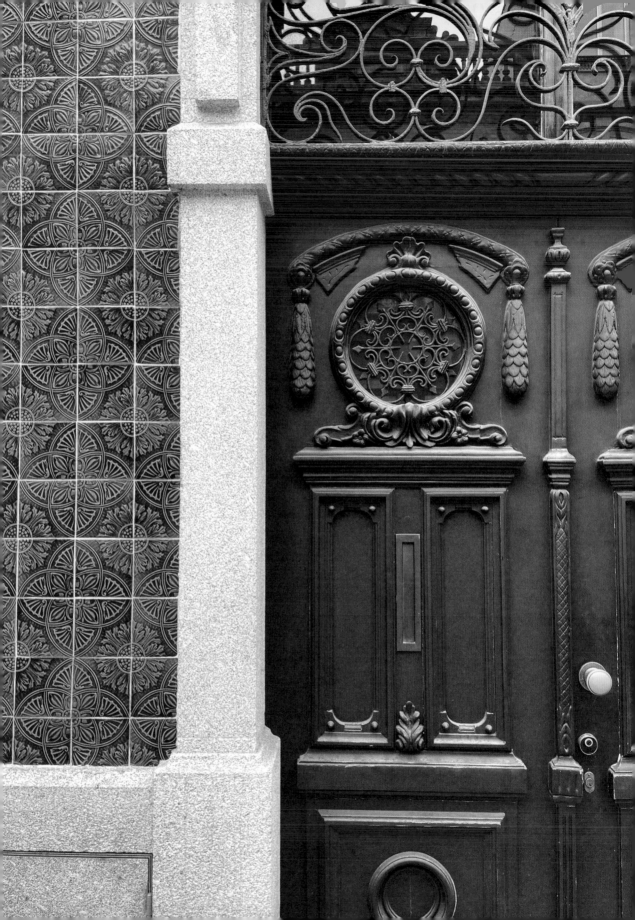

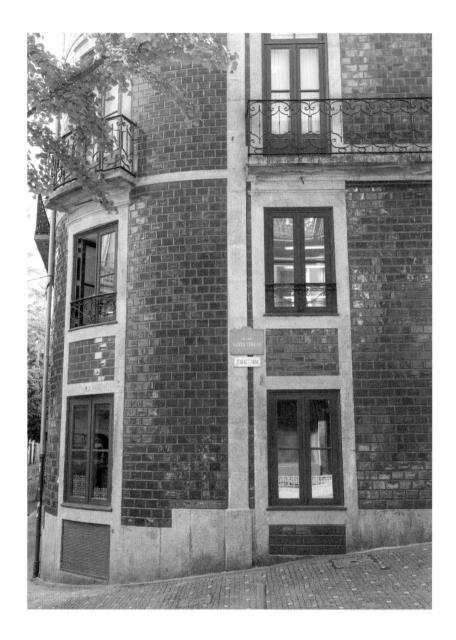

← It is thought that the popularity of green doorways originated from the durability of the pigment Bremen green, which contains copper hydroxide. This pigment was mixed with heated linseed oil and created a strong and long-lasting outdoor paint.

⟶ Perched over the cliffs of Praia da Rocha, with stunning beach views, Bela Vista Hotel & Spa was once the private home of a local fishing and canning industry businessman. It was turned into the Algarve's first hotel in 1934.

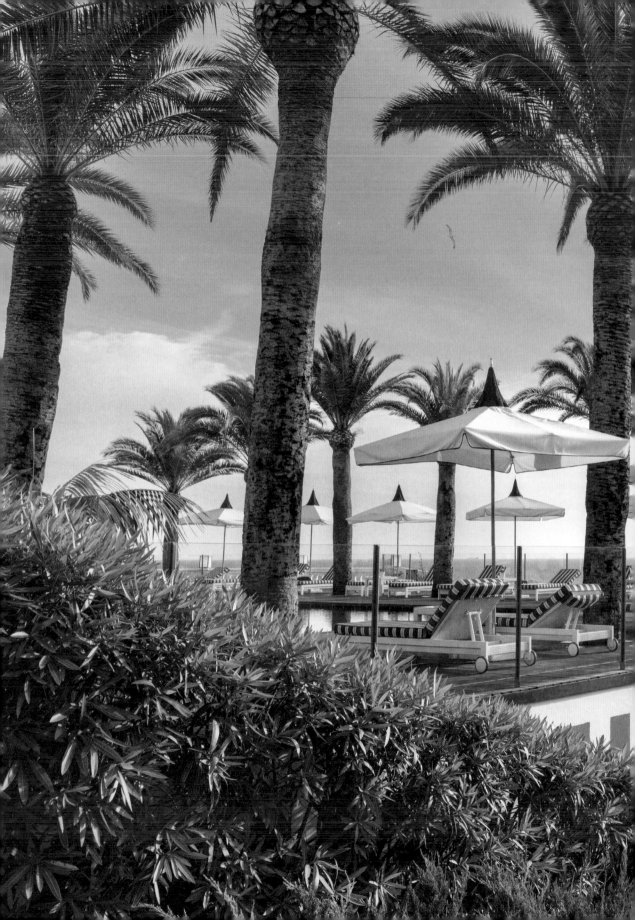

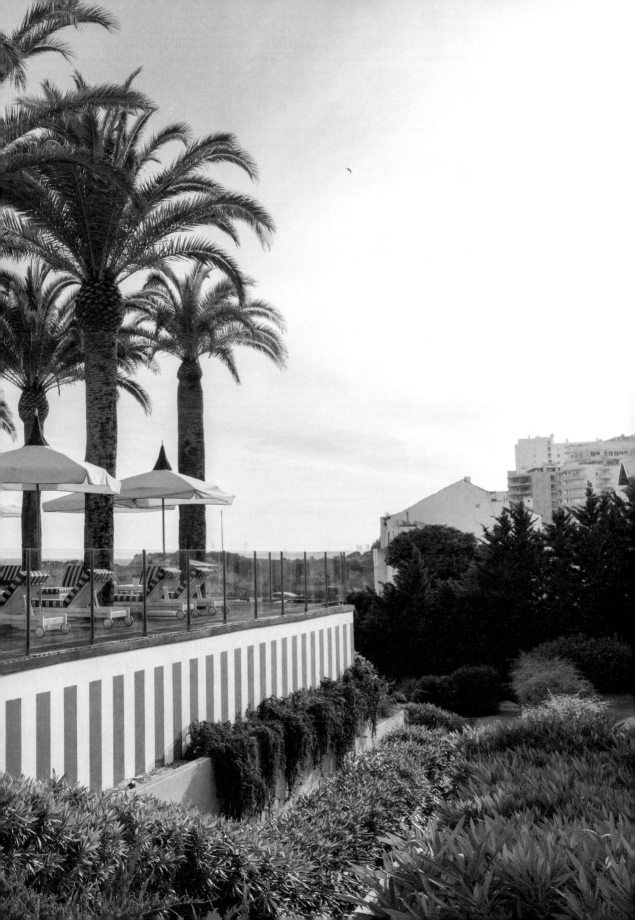

↑ Portugal owes its craft ethos to its unique history. In the late 1900s, when other European countries were embracing modernity, the Portuguese were struggling under a dictatorship and mired in poverty. "We had to find a way to use what we had: local tools and materials. Our style was plain, but it had its own poetry," explains Luisa Souto de Moura, owner of Duas Portas Townhouse in Porto and daughter of Pritzker Prize–winning architect Eduardo Souto de Moura.

p. 280–81 Lagoa do Fogo, the Lake of Fire, is a striking jewel-toned crater lake within the Água de Pau volcano on São Miguel Island.

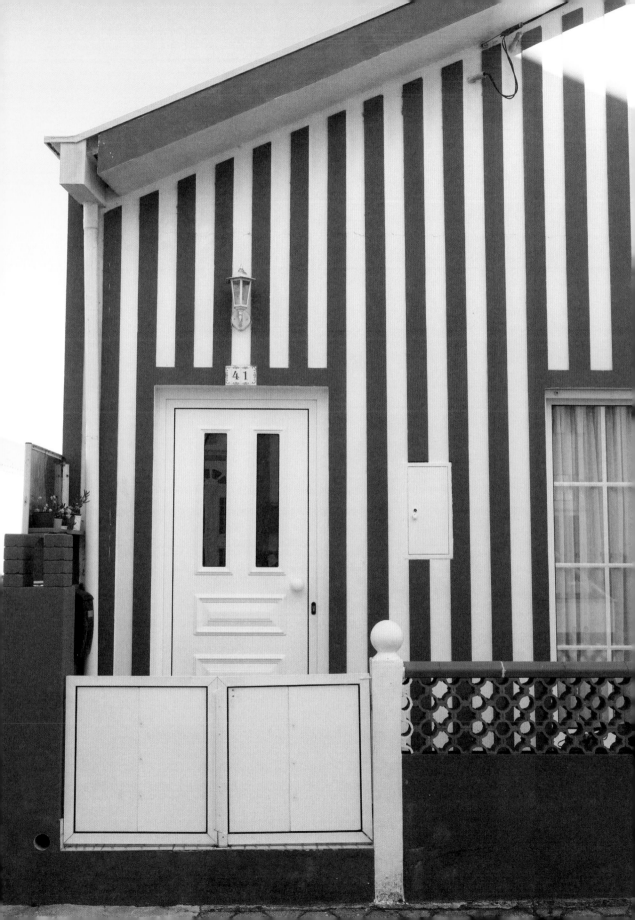

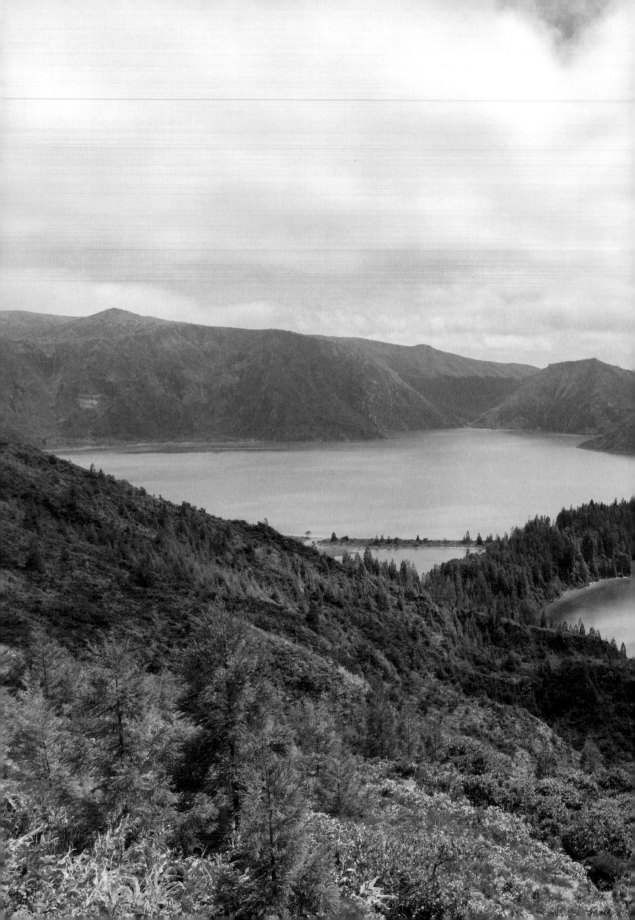

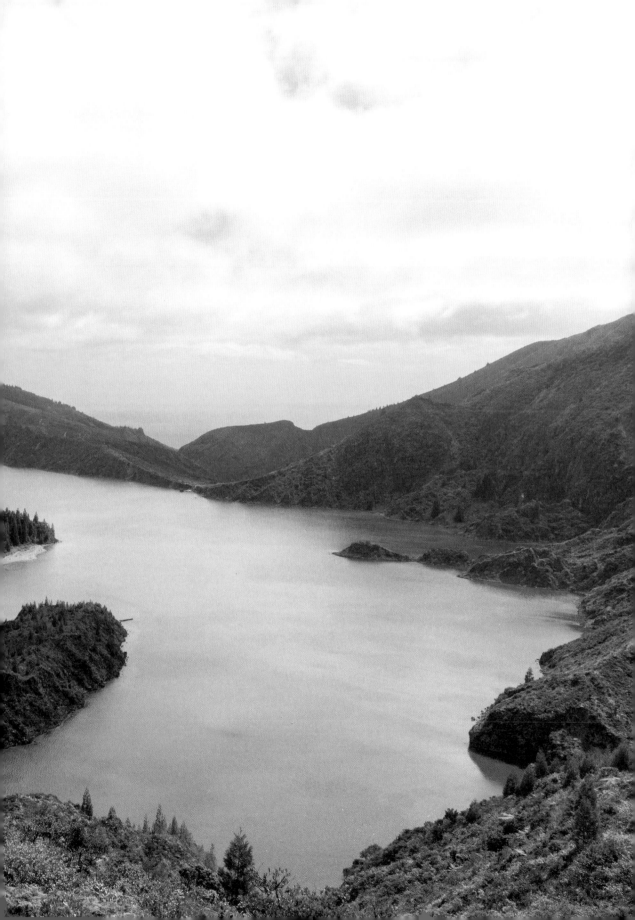

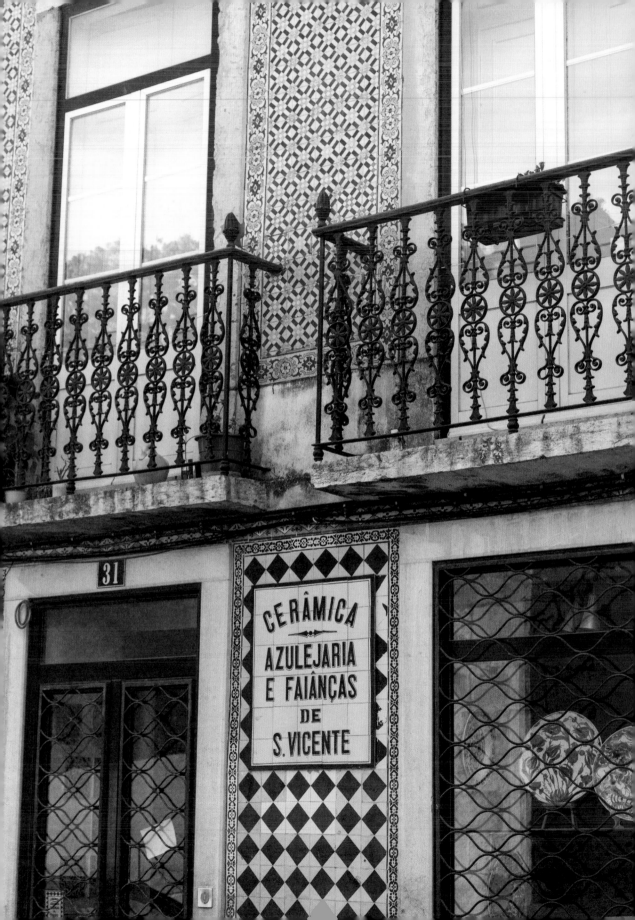

RESOURCES

The following books have served as both references and inspirations for my travels through Portugal and for this book:

- Andresen, Sophia de Mello Breyner. *Shores, Horizons, Voyages: Selected Poems*. Hong Kong: Orchid Press, 2005.

- Birmingham, David. *A Concise History of Portugal*. New York: Cambridge University Press, 1993.

- Cardoso, Dulce Maria. *The Return*. London: MacLehose Press, 2016.

- Carreira, Leandro. *Portugal: The Cookbook*. New York: Phaidon Press, 2022.

- Hatton, Barry. *Queen of the Sea*. New York: Oxford University Press, 2018.

- Mendes, George, and Genevieve Ko. *My Portugal*. New York: Stewart, Tabori & Chang, 2014.

- Mendes, Nuno. *My Lisbon: A Cookbook from Portugal's City of Light*. New York: Ten Speed Press, 2018.

- Saramago, José. *Journey to Portugal*. New York: Harcourt, 2000.

- Torga, Miguel. *Tales and More Tales from the Mountain*. Manchester, U.K.: Carcanet, 1995.

ACKNOWLEDGMENTS

Vijay, as always, I owe you my deepest gratitude. Without your love and support at home this book never would have come to fruition. Thank you for being my partner in adventure, travel, and life, and for supporting my dreams even when they take me far from home.

Vijay, Vikram, and Meera, I owe you all a huge amount of gratitude for your patience and love as my travel schedule interrupted the flow of our lives. I know you missed me, but not half as much as I missed you!

I was shown such generous hospitality during my travels through Portugal, and I had the honor of staying in some of the country's most stunning hotels, including The Ivens (Lisbon), Bairro Alto Hotel (Lisbon), Convento do Espinheiro (Évora), São Lourenço do Barrocal (Alentejo), Bela Vista Hotel & Spa (Portimão), Outpost (Azenhas do Mar), and Areias do Seixo (Santa Cruz).

An extra special thank-you to the following hosts for their exquisite hospitality. You brought to life a side of Portugal I never would have experienced as a solo traveler. I hope I did your beautiful country justice:

- Tânia Fonseca of The Lisboans and Prado (Lisbon)

- Maria João Sousa Montenegro of A Padaria Farmhouse (São Cristóvão de Nogueira)

- Sofia and Miguel Charters of Pa.*te*.os (Melides)

- Eglantina Monteiro of Companhia das Culturas (Castro Marim)

- The Soares family of Herdade da Malhadinha Nova (Beja)

- Luísa Souto de Moura of Duas Portas Townhouse (Porto)

- Paula Cosme Pinto and the entire O Apartamento team

- Maria Ana Vasco Costa

I have been generously supported by an incredible team since the inception of this book. First and foremost, a huge thank-you to my agent, Alison Fargis; your belief in me and my work has changed my life. It would be impossible to express the depths of my gratitude. Lauren Bates, founder of Wild Terrains, thank you for connecting me to the talented Portuguese women who are redefining the country's hospitality scene. My Clarkson Potter team, whose impeccable aesthetic and unwavering commitment to excellence brought this book to life, has my deepest appreciation: Sahara Clement, Mia Johnson, and Stephanie Huntwork. Thank you to the rest of the Clarkson Potter team for all of your support in launching this book.

Finally, I encourage anyone who visits Portugal to explore the road less traveled and to do so with a deep respect for this small but mighty country with a big history and an even bigger heart.

ABOUT THE AUTHOR

Writer and photographer, **Christine Chitnis** is the author of *Patterns of India* and a contributor to *The New York Times*, *Condé Nast Traveler*, *Elle*, *Travel + Leisure*, and more. She lives in Providence, Rhode Island, with her husband and their three children, Vijay, Vikram, and Meera. You can find her at christinechitnis.com and on Instagram at @christine_chitnis.

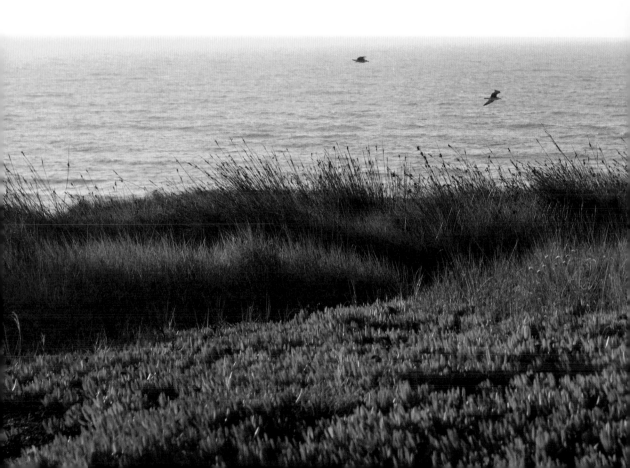

I have been generously supported by an incredible team since the inception of this book. First and foremost, a huge thank-you to my agent, Alison Fargis; your belief in me and my work has changed my life. It would be impossible to express the depths of my gratitude. Lauren Bates, founder of Wild Terrains, thank you for connecting me to the talented Portuguese women who are redefining the country's hospitality scene. My Clarkson Potter team, whose impeccable aesthetic and unwavering commitment to excellence brought this book to life, has my deepest appreciation: Sahara Clement, Mia Johnson, and Stephanie Huntwork. Thank you to the rest of the Clarkson Potter team for all of your support in launching this book.

Finally, I encourage anyone who visits Portugal to explore the road less traveled and to do so with a deep respect for this small but mighty country with a big history and an even bigger heart.

ABOUT THE AUTHOR

Writer and photographer, **Christine Chitnis** is the author of *Patterns of India* and a contributor to *The New York Times*, *Condé Nast Traveler*, *Elle*, *Travel + Leisure*, and more. She lives in Providence, Rhode Island, with her husband and their three children, Vijay, Vikram, and Meera. You can find her at christinechitnis.com and on Instagram at @christine_chitnis.

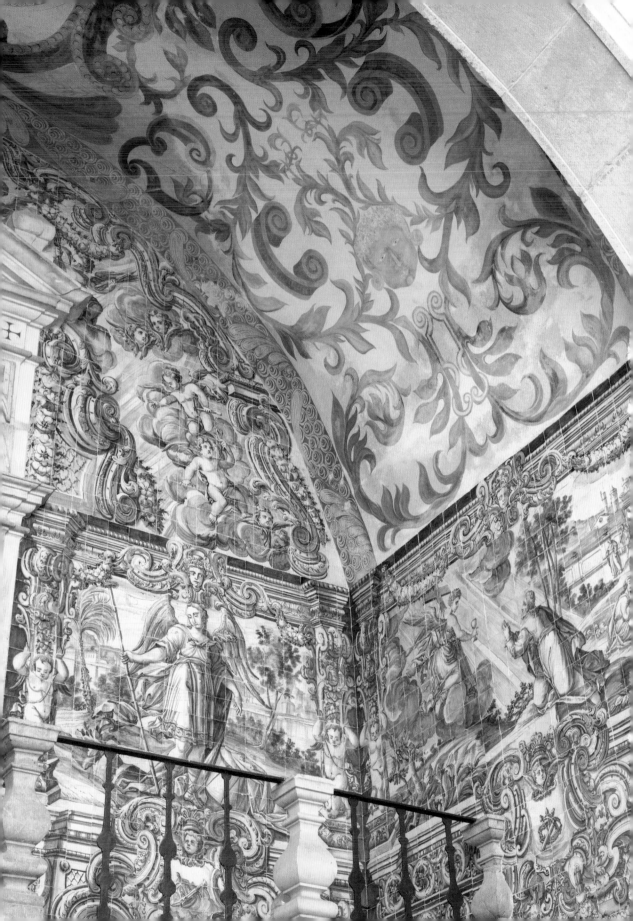

CLARKSON POTTER/PUBLISHERS
New York
clarksonpotter.com

COVER DESIGN BY MIA JOHNSON
COVER PHOTOGRAPHS BY CHRISTINE CHITNIS